MOBILE INTERFACE T

Mobile media—from mobile phones to smartphones to netbooks—are transforming our daily lives. We communicate, we locate, we network, we play, and much more using our mobile devices. In *Mobile Interface Theory*, Jason Farman demonstrates how the worldwide adoption of mobile technologies is causing a reexamination of the core ideas about what it means to live our everyday lives. He argues that mobile media's pervasive computing model, which allows users to connect and interact with the internet while moving across a wide variety of locations, has produced a new sense of self among users—a new embodied identity that stems from virtual space and material space regularly enhancing, cooperating, or disrupting each other. Exploring a range of mobile media practices, including mobile maps and GPS technologies, location-aware social networks, urban and alternate reality games that use mobile devices, performance art, and storytelling projects, Farman illustrates how mobile technologies are changing the ways we produce lived, embodied spaces.

Jason Farman is an Assistant Professor at the University of Maryland, College Park in the Department of American Studies and a Distinguished Faculty Fellow in the Digital Cultures and Creativity Program. He received his Ph.D. in Performance Studies and Digital Media from the University of California, Los Angeles. Farman's research focuses on embodied space in the digital age, including studies of mobile media, mapping technologies, videogames, digital storytelling, social media, digital performance art, and surveillance.

MOBILE INTERFACE THEORY

Embodied Space and Locative Media

Jason Farman

Routledge
Taylor & Francis Group

NEW YORK AND LONDON

First published 2012
by Routledge
711 Third Avenue, New York, NY 10017

Simultaneously published in the UK
by Routledge
2 Park Square, Milton Park, Abingdon, Oxon OX14 4RN

Routledge is an imprint of the Taylor & Francis Group, an informa business

Library of Congress Cataloging in Publication Data
Farman, Jason.
 Mobile interface theory : embodied space and locative media / Jason
 Farman.
 p. cm.
 Includes bibliographical references and index.
 1. Mobile computing. 2. Location-based services. 3. Telecommunication—
 Social aspects. I. Title.
 QA76.59.F37 2011
 004—dc23 2011025034

ISBN: 978–0–415–87890–6 (hbk)
ISBN: 978–0–415–87891–3 (pbk)
ISBN: 978–0–203–84766–4 (ebk)

Typeset in Bembo
by Keystroke, Station Road, Codsall, Wolverhampton

For Susan

CONTENTS

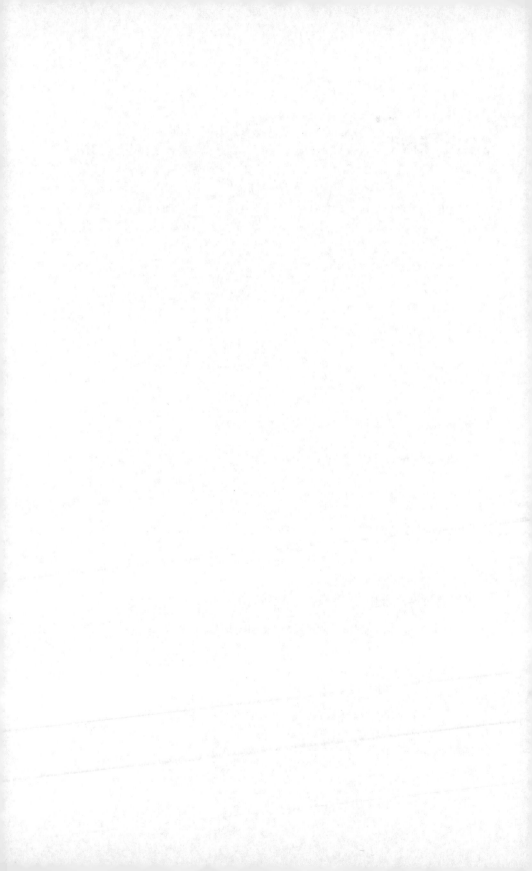

FIGURES

ACKNOWLEDGMENTS

I find that I am at my best when I am working collaboratively. The process of writing this book looked less like me sitting in my office typing alone and looked more like conversations over dinner, cups of coffee, and around conference tables. Many people helped me work through the ideas in this book and, without them, this work would never have been complete. I want to thank the faculty who worked closely with the very early versions of this project: Sue-Ellen Case, Mark Poster, and N. Katherine Hayles. As this project evolved over time, Katherine Hayles offered a generous amount of time and input as I worked through my theory of the "sensory-inscribed" body that is developed in Chapter 1. The overall outline of this book began as a very short talk I gave at Washington State University as part of a Digital Humanities Colloquium put together by Julie Meloni and Chris Ritter. The details began to take shape in my conversations with Dene Grigar and John Barber. Many of my other colleagues at WSU helped me through early stages of this book, especially Doug Gast, Leonard Orr, Patricia Ericsson, Kristin Arola, John Hegglund, Todd Butler, and Victor Villanueva. Much of the work in this book took shape in conversations I had with my graduate students in my seminars "Embodiment and Space in the Digital Age" and "Electronic Literature, Gaming, and Cyberculture." My undergraduates in the Digital Technology and Culture Program helped me study the work of mobile media first hand and their insights into the practices of mobile technologies were invaluable. Before I left Washington State for the University of Maryland, about half of this book was written in Barracuda Coffee Shop with the philosopher Joshua Wretzel sitting next to me, allowing me to constantly test out my approaches to phenomenology and poststructuralism.

After moving to the University of Maryland, I was deeply appreciative of the time and insights offered by Matthew Kirschenbaum, who reviewed several of

the chapters as they developed. I'm thankful also to my colleagues at UMD who offered input at various times on specific aspects of this project: Kari Krauss, Tita Chico, the Critical Theory Colloquium, everyone at the Maryland Institute of Technology in the Humanities (Chapter 2 was first presented as a MITH Digital Dialogue), my graduate students in American Studies, Hasan Elahi, Tara Rodgers, and Katie King. I am especially grateful to my colleagues in the Department of American Studies, who have been supportive of my work and went out of their way to make accommodation for me to take a semester leave to complete this project.

I want to thank the artists and designers who were kind enough to provide me with images for use in this book: William Pike, Paula Levine, Chris Jordan, Jason Travis, the Murmur team, Paul Notzold, Christian Nold, Pranav Mistry, Frank Lantz, Jeremy Hight, Mark Burbidge, the Museum of London, and Blast Theory.

Many others gave generously of their time to offer me wonderful insights and guidance. Adriana de Souza e Silva has gone above and beyond in this regard, and I am truly appreciative. Colin Johnson read through the entire final manuscript and offered fantastic advice. I also want to individually thank those who read through a chapter (or chapters) or allowed me to bounce ideas around with them. I am grateful for their feedback and editing advice: Jordan Frith, Rita Raley, Harmony Bench, Gabriella Giannachi, Lone Koefoed Hansen, Pam Chisum, Tim Hetland, Ben Anderson, Toria Johnson, Chris Salter, Maria X, and Simon Ellis.

I also want to thank my editors at Routledge, Matthew Byrne and Erica Wetter, for their constant belief in this project, their hard work to see it through to the end, and their guidance throughout the process.

Finally, I am deeply grateful for the support given by my family and close friends throughout this project. Susan has been my unwavering supporter in the face of the many challenges that have arisen throughout this book's existence. I'm truly lucky to have someone who believes in me even more than I do.

INTRODUCTION

The Pathways of Locative Media

The term "mobile" has been applied to technologies as early as papyrus, when the written word became transportable across a broad geographic space. Today we typically tend to attribute the word to digital devices such as "mobile" phones, GPS units, tablet computers, and gaming systems. Thus, the notion that mobile technologies are new is indeed shortsighted. Throughout history, when a medium that was once understood as geographically fixed becomes mobile, a cultural shift accompanies this transformation. As writing moved from inscriptions on stone to marks on a piece of paper or papyrus, the world changed. Not only did the human thought process become revolutionized as the process of writing could more closely match the speed of thought, but these thoughts could be spread globally. Thoughts were no longer geographically specific; that is, you didn't have to travel to a particular place to read an inscription. Instead, the inscription came to you.

A similar cultural shift has been taking place as computing technologies are continually moving from their static location at the home or office computer and becoming mobile. As Intel announced back in 2000, "Computing, not computers will characterize the next era of the computer age."[1] This points to a key tenet of our current cultural shift: it is less about the devices and more about an activity. This book analyzes that activity, which is a practice of embodied space in the digital age. Here, I want to focus on mobile interfaces as my primary object of study, developing the ways that these devices work in tandem with bodies and locales in a process of inscribing meaning into our contemporary social and spatial interactions. I think it is important to define "mobile media" broadly to include not only our digital devices but also print texts, subway passes, identification and credit cards, and everyday objects that signify elements of our identity such as keys, notepads, and checkbooks. As Atlanta artist Jason Travis has chronicled in his *Persona*

series of photographs, the items we carry around with us have a unique way of defining our practice of embodied space throughout the day. His series of diptych photographs were taken of over 120 Atlanta residents, in which he asked them to pose for a photograph that would be juxtaposed with a picture of the contents of their backpacks, purses, and messenger bags (Figure 0.1 and Figure 0.2).

The intimate relationships we have with our objects serve to characterize not only our identities, but also the overall nature of our everyday lives as defined by the embodied activities we engage. Sherry Turkle has argued, "We find it familiar to consider objects as useful or aesthetic, as necessities or vain indulgences. We are on less familiar ground when we consider objects as companions to our emotional lives or as provocations to thought . . . We think with the objects we love; we love the objects we think with."[2]

Since the objects we interact with often are given an intimate level of significance in our lives, as seen in Deborah Lupton's description of the various ways we humanize our devices,[3] many discussions of emerging media tend to focus on the device rather than the embodied and spatial actions to which our devices contribute. This book instead seeks to elaborate on the practice of mobile media and the status of embodiment and space for a mobile media age.

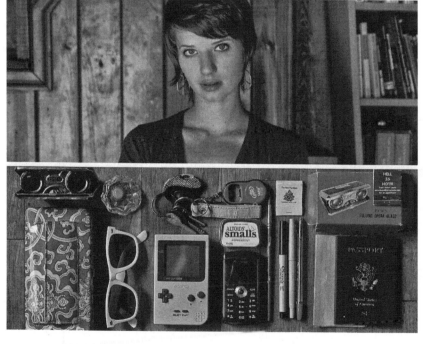

FIGURE 0.1 "Cassie" diptych from the *Persona* series by Jason Travis.

Image © Jason Travis / jasontravisphoto.com

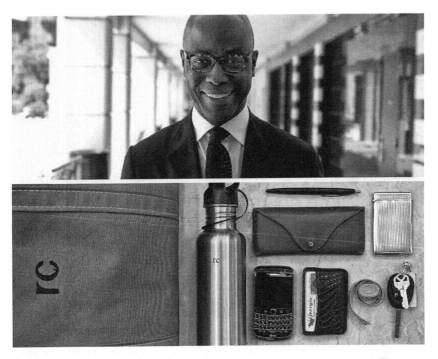

FIGURE 0.2 "Randall" diptych from the *Persona* series by Jason Travis.
Image © Jason Travis / jasontravisphoto.com

Historicizing Mobile Media and the Reconfigurations of Social Space

Defining mobile media broadly allows us to trace the genealogies of mobile technologies and also informs us of the cultural trends and imaginaries that led to certain mobile media. As Jon Agar has pointed out, our current social relationships with and through our mobile phones might actually better resemble the emergence of the pocket watch instead of the emergence of the landline telephone.[4] The pocket watch—a remediation of clock towers and home clocks into a mobile, easily portable (as opposed to simply *transportable*) form—became a symbol of a significant shift in the social experience of local time and space, a shift that is easily mapped onto our experiences with a mobile phone or mobile computing device. The watch has been described as "an instrument of social control," which was seen as "supplanting nature and God with clocks and watches . . . [and] with secular authorities based on efficiency and convenience."[5] This mobile media was supported by the ever-increasing mobility of the nineteenth century, as exemplified in the railroads that spanned the continental United States. Social space was transforming. However, coupled with this transformation was an increasing anxiety over what constituted "the local." For example, travelers on a train had to

continually adjust their watches to account for local time. This meant that for every 12 miles they moved east or west, crossing different longitudes, they had to adjust their watches by one minute. This was a common practice in the mid-1800s until standardized time zones were created in the United States in 1883 and international time zones instituted in 1884. Thus, after 1884, people carrying around a pocket watch were aware that the notion of "local time"—and thus what constituted local space—had changed dramatically. A watch with the "correct" time was set to international standards, based on Greenwich Mean Time in England. This mobile technology connected the individual to a sense of global space and time while changing what it meant to travel and live in local space. For those who lived close to the borders between time zones, traveling to a neighbor's house on the other side of the division between time zones could move time forward or backward by an hour, causing people who are spatially close to one another to live in different notions of "local" time.

This tension between proximity and distance, as it is mirrored in tensions between intimacy and foreignness, has historically been a part of the ways we use our mobile media. I have seen this tension frequently practiced over the last few years. Having recently moved to a region that has a strong public transportation infrastructure (as opposed to my native Southern California), I see this tension played out every time I ride the Washington, DC Metro. As I board a crowded subway, I often see people standing in very close proximity (sometimes even touching, though they are strangers), but they utilize mobile media as a way to distance themselves from having to engage the crowd around them. One of the most ubiquitous mobile media that accomplishes this "distancing-though-proximic" is the mobile listening device (e.g., an iPod or any generic digital music player). Mizuko Ito and others have argued that the personal listening device can serve to help isolate people from social situations, to "cocoon" them from the need to interact with others in a crowded environment. Ito, along with Daisuke Okabe and Ken Anderson, writes, "Cocoons are micro-places built through private, individually controlled infrastructures, temporarily appropriating public space for personal use . . . These cocoons also have specific temporal features, functioning as mechanisms for 'filling' or 'killing' in-between time when people are inhabiting or moving through places within where they are not interested in fully engaging."[6]

For me, this mobile media cocooning points to what initially drew me to the study of mobile media in the first place: the uses of these technologies demonstrates an intimate relationship between the production of space and the bodies inhabiting those spaces. To adequately analyze these emerging technologies, I find it impossible to conceive of mobile media in relationship to a singular notion of space or a singular notion of embodiment in isolation. Instead, space and embodiment are intimately and indelibly linked. This idea remains at the core of how I will define these terms throughout this book and how I situate my theoretical analysis of mobile media as always being embodied, spatial technologies.

The embodied, spatial tension between proximity and distance that I constantly see on the subway starkly contrasts an interesting example in which social space is practiced in almost the exact opposite way. Through the use of personal radios and citizens' band (CB) radios—the technological ancestors of the mobile media player/iPod—people who are geographically distant from one another experience a sense of community and intimacy through the use of these mobile technologies. While at a recent conference, a professor noted to me that while he had never used the mobile social media I was discussing in my presentation—location-aware social networks, which I discuss in detail in Chapter 3—he immediately understood the concept of connecting with others in a spatial way through mobile media. He understood the idea of location-aware social media through his use of the CB while he made a cross-country drive when he was younger. He noted, "I bought the CB especially for the trip. I had heard about them from some friends of mine, but had never used one before I got into the car to make the journey." As soon as he embarked, he began chatting with people, typically beginning by getting the person's name or handle (the CB equivalent of a screen name), his or her location and destination. In this way, the travelers connected on the common themes of the journey, the landscapes, and the other drivers they encountered. The professor remarked to me, "There were long stretches where I was driving alone on these vast, empty prairies. In any other situation, I would have felt extremely isolated from humanity. But by using the CB, I felt like I had companions with me as I drove."

By gesturing to these earlier forms of mobile media, I hope to demonstrate the key concern of this book: the production of social and embodied space through practices with mobile technologies (broadly defined). While the majority of this book looks at location-aware applications, these locative media only serve as contemporary examples of an ongoing relationship between social bodies, technology, and site-specificity. As these examples become obsolete in the future— following the trajectory of the technologies that came before (something I critique in the conclusion of this book)—the core practices of embodied space through mobile media will continue to apply to future instances of this form of technology. In fact, this change is already happening. For my everyday practices of mobile media, it began with the dramatic changes in the ways that I reimagined the uses of my mobile phone.

Locating Pervasive Computing Culture

In the first lines of Howard Rheingold's book on pervasive computing, *Smart Mobs*, he notes an observation he had in Japan that changed the way he thought about mobile technologies: "The first signs of the next shift began to reveal themselves to me on a spring afternoon. That was when I began to notice people on the streets of Tokyo staring at their mobile phones instead of talking to them."[7] This shift from using a mobile device as a voice communication medium toward

usages that focus on data (including internet access, GPS information, and text messaging) heralds an era of what many have termed pervasive computing. The culture of pervasive computing is characterized by the ubiquity of digital technologies woven into the fabric of daily life, typically so integrated that we are often rarely aware of the extent of this integration. Rheingold discusses several ways that this mode of computing manifests itself, such as the ways that pervasive computing often links information and place through digital media. This attachment of information and place can transform urban environments by altering the capabilities that information has over the city. Thus, environments become "smart" by having sensing and responsive abilities. Closely aligned with this idea is the notion that pervasive computing is defined through the creation of objects that become sentient, "not because embedded chips can reason but because they can sense, receive, store, and transmit information."[8] Ultimately, Rheingold argues that there is a collaboration between "virtual" and "material" worlds. Objects affected in one environment affect the other. Eventually, the collaboration between virtual space and what might be called "actual" space becomes so intertwined that it is no longer useful to think of them as distinct categories. Finally, Rheingold notes that pervasive computing culture also includes "wearable computers" that sense environments and also function as communication media.[9]

Though not all pervasive computing is done through mobile media (i.e., much of what we consider as ubiquitous computing is carried out through stationary systems), this model is useful in understanding the impact of contemporary uses of mobile computing. Also, mobile computing is serving to help realize the core tenets of pervasive and ubiquitous computing. This is what Adam Greenfield has termed "everyware." He writes:

> In everyware, the garment, the room and the street become sites of processing and mediation. Household objects from shower stalls to coffee pots are reimagined as places where facts about the world can be gathered, considered, and acted upon. And all of the familiar rituals of daily life—things as fundamental as the way we wake up in the morning, get to work, or shop for our groceries—are remade as an intricate dance of information about ourselves, the state of the external world, and the options available to us at any given moment.[10]

Each of these examples have stemmed from the early theorizations of Mark Weiser, who is often credited with being the forerunning theorist and designer of ubiquitous computing (often termed "ubicomp"). In one of his early papers on the subject, titled "The World is Not a Desktop," Weiser argues:

> What is the metaphor for the computer of the future? The intelligent agent? The television (multimedia)? The 3-D graphics world (virtual reality)? The StarTrek ubiquitous voice computer? The GUI desktop, honed and refined?

The machine that magically grants our wishes? I think the right answer is "none of the above", because I think all of these concepts share a basic flaw: they make the computer visible.[11]

Instead of the excessive visibility of our systems, ubiquitous or pervasive computing often seeks to create an environment in which the technologies remain invisible. Instead of being conscious of our interactions with the interfaces, we simply act intuitively with our environment and it responds accordingly. As Paul Dourish nicely summarizes, "This model of technology stands in stark contrast to most interactive computational technologies whose complexity makes them extremely obtrusive elements of our working environments, to the extent that those environments—working practices, organizational processes and physical settings—need to be redesigned to accommodate computation."[12]

For Dourish, building on Weiser's notions of ubicomp, pervasive computing is focused on "context-aware computing" in which "computers as we currently know them (boxes on desks) could disappear in favor of an environment in which we could be responsive to our needs and actions through ubiquitously-available computational power."[13] This is what Jay David Bolter and Richard Grusin have termed the "interfaceless interface." They write, "What designers often say they want is an 'interfaceless' interface, in which there will be no recognizable electronic tools—not buttons, windows, scroll bars, or even icons as such. Instead, the user will move through the space interacting with the objects 'naturally,' as she does in the physical world."[14]

For Bolter and Grusin, whose work on remediation echoes much of what Weiser theorized, this form of engagement with the computers that surround us (and all media, in fact, even beyond digital technologies) is considered to be "immediate." Immediacy privileges a seamless connection to our media so that they fluidly integrate with our bodies and our surroundings. A pre-digital form of this kind of immediacy is going to the cinema: the audience sits down among perhaps hundreds of other movie-goers, the lights go down and the medium of film transports them beyond the movie theater to the realm of the narrative. The audience is so immediately connected with the medium that they often forget that they are sitting among hundreds of people (and can get so emotionally connected that the story might even lead the audience members to tears). This is the same immediacy afforded by a good book.

Applying this type of connection to digital technologies, the users of pervasive computing technologies should simply be able to wave their hand in an ordinary manner and be interacting with an input device. Common gestures used in daily life result in feedback from the computing system. As Weiser argues, "The most profound technologies are those that disappear. They weave themselves into the fabric of everyday life until they are indistinguishable from it."[15] Designers like Greenfield argue that the user interface of the personal computer is far too antiquated to extend into a pervasive computing environment. For Greenfield,

"everyware" is about the distribution of digital technologies and interfaces through-out the environment, "embedded in objects and contexts far removed from any-thing you could (or would want to) graft a keyboard onto, [thus] the familiar ways of interacting with computers don't make much sense" in pervasive computing culture.[16]

One key example pointed to by the designers and theorists of ubicomp that exemplifies the shift away from the personal computing interface to the pervasive computing interface is wearable computing. From the early manifestations of this form of ubiquitous computing as seen in the clunky versions worn by Steve Mann in the 1980s to more contemporary versions which weave wires and interfaces into clothing to run mobile music devices and phones, the anticipated pervasiveness of this technology has been largely overestimated. Part of the desire for this form of pervasive computing has also been its biggest obstacle: designers and theorists alike are looking for a form of ubicomp that is hands-free (and can thus "disappear"). In order to accomplish this, the everyday objects we use need to be integrated into the network. While we are seeing non-digital objects interact in seamless ways with pervasive technologies, the larger objectives of pervasive computing seek to have the network woven into most of the objects we encounter. While this level of massive cultural transformation is indeed a possibility, it is something that will be a slow growth and overlooks the massive potential for ubicomp that is already integrated into digital cultures: our mobile devices.

Pervasive computing culture has been dawning for well over a decade; however, with the high use of mobile devices on a global level, the theories are finally beginning to take hold. This transition struck me one afternoon in 2007 while teaching an undergraduate course of 35 students. I asked the students who had mobile phones to raise their hands. Not surprisingly, all of them raised their hands. I then asked all the students who had a camera on their phone to raise their hands. Again—this time to my surprise—all of them raised their hands. While this may seem like a minor difference to some, to me it heralded the era of the transition from cell phone to mobile computing device. This was my equivalent of Rheingold noticing the people on the streets of Tokyo looking at their phones rather than talking into them. The mobile phones used by the students at my university were no longer simply voice communication devices; they were being used to document the world around them and interact with the surrounding environment in ways that far exceed the initial design and purpose of the cell phone.

These devices are one of the items many around the world carry with them as they leave home for the day. For me, as with many other mobile phone users, there is a daily ritual that includes grabbing my wallet, keys, and my mobile phone. As many of these phones are becoming GPS- and internet-capable devices, the sheer pervasiveness of these tools is allowing for ubiquitous computing to come to fruition. For example, in late 2009, the Pew Internet Research Center took a survey of the ways those in the United States access the internet. They found that 83% of those surveyed had an internet-capable device (compared to 58% who have

a desktop computer and 46% who have a laptop computer). While this number is quite large, at the time of this writing, only 32% of those with these devices actually use them to access the internet (and only 29% of those with internet-capable mobile devices used them for email).[17] On the global scale, there were 450 million mobile internet users in 2009, expected to hit 1 billion by 2013.[18] This means that over the next couple of years, the main medium people will use to access the internet will be a mobile device.

The implications of this pervasiveness are extensive and demonstrate why current ubicomp theories fall short. While looking for a cultural shift in the way computers are integrated, many designers and theorists have missed the biggest transition that has been taking place for some time: the devices we already utilize on a daily basis are the tools that will herald in the age of pervasive computing. The notion of microprocessors integrated into everyday objects is something that is a distinct possibility; however, such objects would remain accessible to only a fraction of the world population. Even desktop computing and broadband access remain scarce global commodities, with broadband access in Japan costing "6 cents per 100 Kbps, with users typically paying 0.002 percent of their monthly salary for high-speed access. But in Kenya, that same hookup speed costs $86.11 – nearly twice the average monthly income."[19] In contrast to desktop computing and broadband over DSL, cable, or fiber optics—and especially in contrast to everyday objects that integrate computing technologies such as wired clothing—mobile phones with internet access are spreading globally at an amazing pace. Pervasive computing culture, to succeed, needs to be a global phenomenon and not simply limited to those in developed countries with the wealth to afford such devices. Here we see that mobile technologies are intervening in the "digital divide" that separates those with access to digital technologies and those without.[20]

While I am enthusiastic about the current state of pervasive computing—that the tools necessary to implement a culture that interacts with landscapes as interfaces are already among us—I am sympathetic to the concerns of the designers who seek to find a way to make more intuitive and gesture-based interfaces. In a recent conversation I had with William Pike, one of the key researchers in the National Visualization and Analytics Center at the Pacific Northwest National Laboratories (PNNL), he discussed his team's work on a project designing mobile interfaces that can seamlessly move from one device to another, all of which are hands-free. The project, titled Precision Information Environments, was funded by the Department of Homeland Security in an effort to imagine pervasive computing solutions to emergency management and crisis response. The initial vision for the project used a wildfire as an example of ways that mobile devices can be implemented to address the needs of information distribution across a variety of networks. These devices allowed messages to be sent from a central command station to a wrist-mounted interface. As the firefighter wearing the wrist-mounted device entered a vehicle, he or she could make a swiping gesture toward the automobile's windshield and the display would move from the personal device to the interface of the windshield

(see Figure 0.3). This extends the current uses of heads-up displays used by the military in fighter planes. Such designs allow for user interaction that is necessitated by the work at hand. As Pike noted, for firefighters who are out in the field, they do not want to access information about a landscape by walking around holding a phone-like device in front of them. Besides being awkward (and tiring if a firefighter has to hold this phone in front of his or her field of vision for an extended period of time), this mode of pervasive computing distinguishes too much between the physical landscape and the digital information that augments it. Also, adding another tool to the firefighter's kit often translates into exactly that: one tool among many instead of information interacting with the many tools already in use.

The goal of Pike's team at PNNL is to reimagine the ways that the surfaces around us can be utilized as screens. The vehicle used in the Precision Information Environments project is designed with a translucent LED screen that overlays the windshield. Beyond this example, Pike argues that they key will be to find ways to "make use of the hardscape around us to turn existing surfaces into displays."[21] While heads-up displays exist in military usage, Pike seeks to move beyond the enclosed space of the fighter pilot's helmet and find solutions for pervasive computing in outdoor and everyday spaces.

FIGURE 0.3 A firefighter working with Pacific Northwest National Laboratory's "Precision Information Environments" technology, sending map information from his mobile device to the hardscape of the vehicle's windshield.

Photo: Burtner ER, and WA Pike. 2010. "Precision Information Environments Concept Video – Wildfire Scenario." PNNL-SA-72483 Pacific Northwest National Laboratory, Richland, WA.

My objection to Pike at the time—and one which carries into my analysis in this book—is that such ubicomp designs overlook the power of utilizing the mobile technologies that are already integrated into cultures worldwide. Instead, we see ubicomp and tangible computing designers starting every time from the ground up, reinventing the wheel over and over again. While innovation has been the key to designing all of the mobile technologies we have, my main concerns with its current implementation echo the concerns of those like Lev Manovich. Although pervasive/ubiquitous computing has been theorized and attempted since the early- to mid-1990s, Manovich's concern, which was voiced at the 2009 Digital Arts and Culture Conference, is: with all of the technologies we currently have (with their increasingly small size and low cost), "Why doesn't true ubiquitous computing yet exist?" For Pike, there are two major reasons that pervasive computing has not met its full potential: the problem of interface and the problem of commercial disincentive. The first reason—the interface and interactivity problem—remains a major hurdle because there are "no good ways to naturally interact with data" and the ways we currently inscribe onto our devices (such as the pinch/pull zooming when using maps on a haptic interface) are all culturally specific and do not necessarily translate globally. While designers can create standards for interactive gestures with mobile devices, even within a culture people have unique gesturing styles. And, though it may be possible to train a system to learn my specific gestures, these gestures would not necessarily translate to other pervasive computing environments I would encounter. The second reason—the problem of commercial disincentive—is, perhaps, the primary reason that ubiquitous computing has not fully dawned in digital culture. Basically, this idea argues that it is in a company's best interest to keep its environment closed (i.e., a user must interact solely with them in order to receive the benefits of their products and information). Thus, while Pike and his team at PNNL would like to work with existing mobile devices and systems, the problem they have faced thus far has been finding a way to create a "handshake between devices" that will allow devices to work together. Ultimately, corporations do not design handoffs between platforms because their primary business model has been to commodify the access gained through their gateways.

Interventions into these two seemingly insurmountable problems come, in my estimation, in the forms of user interactions with their environments using the mobile media that is already a part of daily routines in digital cultures. While "VR . . . attempts to bring us inside the computer, ubiquitous computing actually brings the computer outside, into our daily, lived experiences," as Adriana de Souza e Silva and Daniel Sutko note, the resulting move of computing outside is looking markedly different than the initial conceptions of pervasive computing.[22] Instead of disappearing into the fabric of our lived experience, ubicomp is something that is consciously interacting with our environments and offering a transformative experience of space. De Souza e Silva and Sutko continue: "The popularity of cell phones and PDAs indicates that portable handheld technologies partly fulfill

Weiser's prediction of ubiquitous computing. They are becoming displays through which we access information about the physical world around us."[23] Finding modes of interaction that reimagine the use and correlation between our mobile devices and the spaces they augment will be the key to successfully creating pervasive computing culture. By functioning as *bricoleurs* who create a patchwork of very different media designed with diverse purposes in mind, users of mobile devices will design the new embodied space of pervasive computing.

Theorizing Embodied Space in Mobile Environments

In a March 2010 article in *Wired* magazine, Scott Brown discusses the immediately obsolete mobile technologies displayed in films. In his sarcastic wit about films in the 1980s, he writes, "I'll miss the shoulder pads, the high-tops, the laissez-faire stereotyping and sexual harassment. But you know what I won't miss? The tech. It doesn't travel. It doesn't charm. It became kitsch the instant it hit the screen."[24] Along these lines, many of the objects of study I will investigate in this book will already be obsolete by the time this book is published and will seem very kitsch to future generations. Though I look at this topic extensively in the Conclusion of this book, my initial response here frames my approach to the examples I use in each chapter. My discussion of current mobile media—from smartphones to laptops, from mobile games to personal listening devices—is only a snapshot of a particular moment; however, my discussions of this moment in mobile media history helps expand on our altering conceptions of embodied space and subsequently the cultural objects we are producing. So, while it might be of interest to some for me to detail the specificities of these emerging mobile technologies (like PNNL's "Precision Information Environments" or the latest social media platform for mobile phones), to do so misses the larger project I am interested in. While drawing on current objects of study, I seek to use these as instances of how mobile technologies—and the ways we interface with the medium and with each other across mobile media—offer insights into the ways that embodiment and space are produced in the digital age. Thus, while those looking for recommendations on interface design might be disappointed in the minimal attention offered to such considerations, I strongly believe that those seeking such knowledge will be offered some insights into the bigger picture that will undoubtedly have a shelf life that far exceeds the current mobile media we use.

To begin this exploration, it is important to note that discussions about space have increased exponentially in the digital age. As computing moves beyond the desktop toward the creation of pervasive computing culture, our focus on spatiality has been intensified. Accordingly, our theorization of embodiment is in need of exploration and refinement. It is my estimation that since mobile technologies are prompting important questions about space and embodiment—from scholars and everyday users alike—the way we conceive of our interactions with these emerging spaces will have everything to do with the ways that the media are

utilized. Many, including myself, are drawn toward theories that emphasize our sensory experience with mobile technologies, turning to the phenomenological approaches of the likes of Edmund Husserl, Martin Heidegger, and Maurice Merleau-Ponty as foundations for exploration. While my understanding of embodiment is indeed founded on much of the work of these phenomenologists, there are still areas lacking in phenomenology that are required for a thorough analysis of how we embody the digital spaces of mobile technologies. What follows in the coming chapters is my development of this theoretical approach.

Navigating *Mobile Interface Theory*

I begin this book by developing a working definition of what embodiment in pervasive computing space means. In Chapter 1, "Embodiment and the Mobile Interface," I create a working definition of embodiment for a mobile media era. Here, I argue for several factors that, when brought together, define embodiment. This mode of embodiment is always co-produced alongside the production of space. Ultimately, by bringing together theories of phenomenology and post-structuralism, I propose a "sensory-inscribed" understanding of the body that is not only conceived out of a sensory engagement across material and digital land-scapes, but also incorporates socio-cultural inscriptions of the body in these emerging spaces. This chapter serves as the theoretical foundation for the chapters that follow, setting up my theory of the "sensory-inscribed" body that will inform my analysis of the various objects of study and practices of mobile media in the subsequent chapters.

Throughout my exploration of what embodiment means for a mobile media age, bodies and spaces are understood as mutually constructed and inseparable. Thus, Chapter 2, "Mapping and Representations of Space," elaborates on how space is produced as a multiplicity of perception and inscription. Drawing from the history of the term "virtual," I look at how the collaboration between virtual spaces and "realized" spaces has always been at the core of how we produce space. This multiplicity is highlighted in an era when our mobile devices produce spaces that are experienced as a collaboration between information, representation, and materiality. Here, I focus on how—by transforming our location into an infor-mation interface—the visualizations of data are dramatically altered as they converge with location-aware embodied space. Part of the way that mobile devices are intervening in the way we relate to space is the way information is structured, displayed, and interacted with. Focusing on examples such as the augmented reality application Streetmuseum, the emotion maps in Christian Nold's *Biomapping*, and the crowdsourced maps created of Haiti after the 2010 earthquake, this study elaborates on the ways that representations of spaces created with mobile tech-nologies reinstill the integral link between embodied action and the production of space. By being able to point your mobile device at a store, monument, or geographic feature nearby and retrieve information on that object, users are able

to engage and contribute to information through an interface that develops a sense of embodied proprioception in pervasive computing space.

Chapter 3, "Locative Interfaces and Social Media," develops my working definition of the "interface" through the example of location-based social media. The essential idea behind locative social media is that by broadcasting my location to my network, I am communicating something about my identity and the fabric of my everyday life. Thinking of the mobile interface as the nexus of the embodied production of these social spaces, locative social media demonstrate the fundamental attributes necessary for social engagement across mobile networks. To experience these interactions as embodied and spatial, the interface must foster reciprocity (both between the device and the user and between the user and other participants) and ideas of "otherness," or alterity. The reciprocity that is essential to the production of these embodied spaces also forces a confrontation of practices of visibility. Thus, I look at issues surrounding participatory surveillance and the core problems in maintaining a distinction between public and private.

Chapter 4, "The Ethics of Immersion in Locative Games," looks at the significant correspondence between play space and everyday life in emerging games that blend the mobile interface with everyday spaces. Immersion in the game, as it blends play and the everyday, brings about several ethical dilemmas around the influence of one sphere on the other. Looking at examples such as the live action role playing game (LARP) *Momentum*, the GPS treasure hunting game geocaching, and the urban game *The Big Urban Game*, I argue for a sense of embodied engagement that allows players to critique the game and the spaces in which the game is played. Through a process of *bricolage* and hypermediacy, players can transform games and their mobile interfaces into sites of social critique.

Chapter 5, "Performances of Asynchronous Time," shifts from the production of locative space to its counterpart: temporality. Specifically, I analyze the draw toward mobile communication that prioritizes asynchronous time over synchronicity. Throughout the chapter, I look at performances—such as Simon Faithfull's *0.00 Navigation*, Susan Kozel's IntuiTweet dance project, and Blast Theory's *Rider Spoke*—that utilize mobile and locative media to engage participants and performers in the tension over ideas of co-presence and mediatized interactions. How do our mediated interactions—especially ones that take place in asynchronous time—foster a sense of embodied connection across space? Comparing these performances to everyday practices like text messaging, I argue that our practices of embodied engagement with mobile devices are challenging the temporal nature of presence and ideas about what constitutes a primary action.

Chapter 6, "Site-Specific Storytelling and Reading Interfaces," focuses on locative storytelling projects that interrogate the ways that reading interfaces address individuals rather than communities. The storytelling projects I discuss offer interventions into this opposition by utilizing the mobile phone as the space of community storytelling, transforming the technology that is perceived as privileging the individual into a technology that captures community narratives in a

way that uniquely takes advantage of its ability for site-specificity, voice recording, textual communication, and portability. By linking the locative storytelling interface to the historical ebb and flow between individual and community interfaces for reading, I situate these stories as site-specific modes of addressing multiple histories. These histories are embodied engagements with the practices of space and the meanings that can be ascribed to a space. I conclude the chapter with an investigation of the relationship between these stories and the embodied nature of information, drawing on the recent debates over the opposition between the database and narrative.

My conclusion, "Movement/Progress/Obsolescence: On the Politics of Mobility," argues that there has been a specific trajectory in our culture when we have invoked ideas of movement: movement equals progress. Progress, however, is intimately tied to ideas and practices of obsolescence. By discussing moments throughout history in which a particular culture derided emerging media as that which produced acceleration, movement, and speed (resulting in a distancing of members of that community), I argue that we have always had perceptions of increased movement and acceleration. This criticism is something that is applied to many forms of emerging media. The consequences of linking this particular kind of movement with ideas of progress is a culture that entangled with overwhelming obsolescence. Instead of maintaining the kinship between movement, progress, and obsolescence, I argue instead for a correlation between movement and dwelling. Through recuperating stillness and dwelling as a type of action and movement (instead of being defined by a lack of movement), we see that ideas of mobility can focus on the particularities of location instead of constant and unending flow.

Each of these chapters hinge on exploring the status of bodies and spaces in emerging mobile media space. Mobile media, from a cell phone to a tablet computer to something as simple as a public transit card, are becoming interfaces that require us to be embodied across several spaces. As we connect with each other, with objects, and with data across material and digital landscapes, these hybrid spaces are transforming the ways we conceive of embodied space. The stakes related to the ways we conceive of embodied space are significant, including the ways we imagine identity, community, and cultural objects we create, including art, games, performance, and narrative.

1

EMBODIMENT AND
THE MOBILE INTERFACE

Growing up in suburban Los Angeles, I always had a unique embodied relationship to space and how space affected relationships. Los Angeles has a unique way of communicating space to its residents. For me, as with many of those living in the area, relationships were always connected through the roads and highways, thus dependent on automobile travel. As a child, my father would pick me up and drive me an hour to his house in Orange County to spend weekends with him. In fact, any social connection was initiated by getting into the car and traveling. Many years later, as I was working on my Ph.D. at UCLA, I began to translate these spatial gaps to the world of online social networking. As online social networking began to flourish in 2003, I began to connect with people globally and find some very fruitful relationships that simply extended the distance paradigm I grew up with even further. Though there was a significant amount of space between my friends and myself, the means to connect was simply an altered form of getting behind the wheel and driving. Through technology, the spatial gap that existed in every relationship I had known was easily traversed. Connecting globally felt natural.

This mode of connection dramatically changed for me once I began working as a professor in the Pacific Northwest of the United States. It was here that I obtained my first "smart" phone and began to realize that connecting globally took a back seat to connecting to those in my immediate vicinity. Though I was still utilizing my home computer to connect to friends and colleagues across vast distances, I found that I was far more eager to take advantage of proximity when connecting. The early applications for my phone that I found most compelling were the ones that helped me locate friends nearby. I was intrigued by the ability to know if friends or colleagues were at the same coffee shop to which I was about to go. By simply loading a smartphone application, I could decide on which venues

I would visit that evening. Entering into pervasive computing culture, spatial proximity became the primary tenet for my digital interactions.

As I began to explore the emerging uses of my mobile phone, I also began to realize a major shift that was taking place culturally: the spatiality of the internet (i.e., the *space* of cyberspace) was moving away from the desktop computer and moving out onto the streets. Computing was becoming pervasive. Though I have always felt and argued that connecting with the computer is an extremely embodied experience, the spatiality of cyberspace—which has been theorized since the early 1980s, when William Gibson invoked the term—is being inhabited in a significantly different way with the advent of mobile technologies. With mobile phones that connect to the internet or GPS receivers that are utilized for a wide array of purposes, locating one's self simultaneously in digital space and in material space has become an everyday action for many people. With this alteration of embodied space, the cultural objects we are producing and interacting with are also being transformed.

Spatial relationships have always determined the way we understand ourselves, our place in the larger context, and the cultural meanings infused into gestures, objects, and sign systems. Spatial proximity and how we locate ourselves in space affects every aspect of the cultural objects we create and interact with. As Nick Kaye writes in the introduction to his book *Site-Specific Art: Performance, Place and Documentation*, "If one accepts the proposition that the meanings of utterances, actions and events are affected by their 'local position', by the *situation* of which they are a part, then a work of art, too, will be defined in relation to its place and position."[1] Throughout this book, I will look at the relationship between the ways we understand embodiment in emerging pervasive computing spaces and how our conceptions of embodied space are informed by works of art including location-based games, performance, and narratives.

My work in this chapter serves as the theoretical foundation that I will build upon in each of the chapters that follows. In order to understand the ways that embodied space is affected by the practices of mobile media, I feel it is essential to develop a solid theoretical framework that informs my study of emerging mobile practices. By spending the entirety of this chapter focusing on my definition of "embodiment," I hope that my theories of a "sensory-inscribed" body help illuminate what it means for us to experience moments like seeing our location mapped on a mobile device, interacting with others via locative social media, playing games that change our perceptions of a city, experiencing site-specific art and performance on a mobile device, and interacting with spatial histories and narratives with mobile technologies. Hopefully, my approach to embodiment will also find resonance with those outside of the field of mobile media, since the theorization of embodied space applies across areas of interest, across disciplines, and across historical eras. Though I find mobile media to be a particularly useful object of study that informs a reading of embodied space, I think the theoretical approach taken here can find significant portability well beyond the scope of this work.

My theoretical approach does not consider embodiment to be separate from the production of the spaces we inhabit. In fact, even the phrase "to inhabit space" is misleading, since it implies a space that bodies enter and fill. Instead, space is constructed simultaneously with our sense of embodiment. The two are indelibly linked, never to be separated. This conception of embodied space harks back to the famous work by Henri Lefebvre, *The Production of Space*, in which he writes, "Each living body *is* space and *has* space: it produces itself in space and it also produces that space."[2] He goes on to argue throughout his work that space cannot be considered a container that is filled; instead, "space is not a thing, but rather a set of relations between things (objects and products)" and that "space is neither a 'subject' nor an 'object' but rather a social reality—that is to say, a set of relations and forms."[3] This idea tends to go against the ways that we speak about space. We often discuss spaces as places we enter, inhabit, move through, and leave. They are there before we arrive and they'll be there after we leave. However, as I will argue throughout this book, space needs to be considered as something that is *produced* through use. It exists as we interact with it—and those interactions dramatically change the essential character of space. Similarly, if relational space cannot be considered a container, neither can the body be something we simply inhabit. Again, the ways that we talk about the body often shape the ways we practice embodiment. As N. Katherine Hayles notes, the term "the body" assumes a universalized body, but there are many types of bodies in digital space and various modes of embodiment. She writes in her article "Flesh and Metal: Reconfiguring the Mindbody in Virtual Environments,"

> "The body" generalizes from a group of samples and in this sense always misses someone's particular body, which necessarily departs in greater or lesser measure from the culturally constructed norm. At the other end of the spectrum lie our experiences of embodiment. While these experiences are also culturally constructed, they are not entirely so, for they emerge from the complex interactions between conscious mind and the physiological structures that are the result of millennia of biological evolution.[4]

Thus, spaces and bodies are co-constitutive as they produce one another, and this production must be theorized with cultural and physiological specificity. We don't all have the same bodies, nor do we have the same experience of embodiment/embodied space.

As we begin to locate what it means to be "embodied," we must simultaneously ask how bodies are enacted in and with space. Many recent theorists of spatiality point toward a distinction between space and place, the former being an unacted, purely theoretical site, and the latter being the "phenomenal particularization of 'being-in-the-world,'" as Edward Casey notes.[5] Place is thus an embodied and practiced space as opposed to the purely abstract notion of "space" as that which is an unpracticed place. Casey goes on to note: "It is a striking fact, on which we

do not often enough reflect, that while we can certainly *conceive* of entirely empty spaces and times—radical vacua in which no bodies (in space) or events (in time) exist—such spatio-temporal voids are themselves placelike insofar as they *could be*, in principle, occupied by bodies and events."[6] While it is not my intention in this book to retrace the debates over the distinctions between space and place, it is important to note that any abstract understanding of space as that which can exist before or without bodies is ultimately a pure theorization that is never actualized. Since bodies produce spaces and spaces produces bodies, unpracticed sites and uninhabited spaces must remain purely theoretical concepts. Since embodiment is always co-created alongside space, it must be noted, embodiment is always site-specific to the particular cultures, histories, and relationships that serve as catalysts to such production. One such historical catalyst is the emergence of mobile computing and the ways it has transformed embodied space in the digital age.

Since mobile technologies have reinvigorated our fascination with location and place, an understanding of this emerging space must include a nuanced perspective of embodiment. Drawing primarily from the phenomenology of Maurice Merleau-Ponty and the ways in which his approach intersects and informs the poststructuralist methodologies of Jacques Derrida, I am arguing for an approach to embodiment that is developed out of these two seemingly disparate fields. Out of a detailed exploration of the ways that phenomenology and poststructuralism intersect, I develop a theory of the "sensory-inscribed" body that becomes a lens for all of our interactions with mobile interfaces. For those familiar with the historical relationship and tension between phenomenology and poststructuralism, to find a way of blending the two might seem to do a grave disservice to the integrity and constitution of each methodology. Pulling pieces out of a particular theory without recognizing the role that each piece plays in the larger formation of the theory could likely cause subsequent theories to topple. However, at this point in history, we have come to a place where such a reworking of these theories has become not only important, but also essential to the ways we conceive of embodied space and identity in a digital world.

Defining Embodiment for a Mobile Era

To begin to locate embodiment in the mobile media era as that which is "sensory-inscribed," I want to reiterate the notion that *embodiment is always a spatial practice*. Trying to imagine a body without space is impossible. Bodies always take up space and, as Lefebvre argued, are spatial in and of themselves. Regardless, throughout the history of technology, we have attempted to distance bodies and spaces as much as possible. This dissection is particularly noticeable in the age of the mobile phone, in which we attempt to dislocate bodies from particular spaces and spaces from particular bodies. As Rich Ling notes, "With mobile communication, we call to individuals, not to locations. With traditional land-line telephony, we called to specific places in the sometimes misbegotten hope that our intended interlocutor

would be somewhere near the phone we were calling . . . Such is not the case with mobile telephony. I call to the individual."[7] When someone makes a call to my cell phone, I could be located anywhere and could be in any embodied state. This free-floating attachment between body and space is possible due to the single-sense modality of mobile phone; everything you know about my situation is gained only by what you *hear*. The ability to implace each other over a phone call to a mobile device becomes an embodied practice, one we can manipulate due to the fluctuating attachment of a body to a particular place across the phone. We do, however, achieve a significant level of implacement when we talk to one another on cell phones, so much so that emerging technologies have attempted to make such embodied connections even more explicit by removing the free-floating relationship between bodies and spaces.

In June 2010, for example, Apple introduced a new feature to its iPhone called "FaceTime." This calling feature allowed people to connect with the built-in camera for video calling. As Steven Levy pointed out just over a month after the release of FaceTime, such a feature recalls AT&T's previous attempt to institute video calling: "Among the wonders shown at the 1964 New York World's Fair was the AT&T Picturephone, a system that allowed two people in video-telephone booths to make phone calls while peering at each other through TV screens."[8] Levy goes on to note that video calling was even conceptualized in early science publications in the 1870s. In 1927, as noted by Ken Ling-Pei Kung, Bell Labs experimented with video calling by connecting Herbert Hoover with then President of AT&T, Walter Gifford, in New York using a television signal in conjunction with the phone. Gifford "foresaw the use of television as an adjunct to telephone calls for face-to-face telecommunications in the future."[9] Commercial versions were available after the New York World's Fair and, though there were numerous attempts in the subsequent decades to revive the technology, video calling never became an everyday practice. The reason that the Picturephone "bombed so spectacularly," as Kenneth Lipartito wrote, has been the speculation of many scholars and designers.[10] Explanations ranging from price, technological limitations, and the most resounding reason of "invasion of privacy," all circle around the question of this technology's demise.

Lipartito asks an important question that gets to the heart of why we are so intrigued with the Picturephone and why it has surfaced in contemporary mobile phones through features like FaceTime. He writes, "To get at these issues, we have to start with a new questions. We should ask not 'Why did it fail?' but rather, 'Why was it invented?'"[11] Since their inception, many communications media tend to prioritize a singular embodied sense at the sacrifice of others. Examples including the telephone and music recordings have historically been a single-sense medium, limiting our connection with another person to sound. One reason these "cool" media (to draw on Marshall McLuhan's term for a medium that requires us to fill in the sensory blanks of a medium that offers limited information) become so successful is because they require us to practice embodied space. Here, our

embodied subjectivity, which is inherently intersubjective, is enacted. One reason that technologies like the Picturephone and FaceTime have been created is out of a misunderstanding of the relationship between bodies and spaces. Such technological approaches assume these categories exist a priori and thus the more sensory information we are given about our connection with someone, the more intimate our communication will be. Ultimately, these technologies attempt to reduce the practice of embodiment because, from this perspective, bodies aren't practiced but only experienced. Instead, when we engage the process of enacting embodiment across media interfaces, we understand the inherent link between our practice of embodiment and the spaces bodies create.

A compelling example of this mode of embodied practice is Allucquére Roseanne Stone's sociological study of phone sex workers. In her writings about her experience, she noticed that the entire project of phone sex was reliant on the fact that embodiment is something that is practiced rather than something that is a given. The important claim Stone makes in her observation, one that resounds strongly with my theories of embodiment, is: "[W]hat was being sent back and forth over the wires wasn't just information, it was *bodies*."[12] She details this embodied practice:

> The sex workers took an extremely complex, highly detailed set of behaviors, translated them into a single sense modality, then further boiled them down to a series of highly compressed tokens. They then squirted those tokens down a voice-grade phone line. At the other end of the line the recipient of all this effort added boiling water, so to speak, and reconstituted the tokens into a fully detailed set of images and interactions in multiple sensory modes.[13]

Phone sex and its later instantiations such as "sexting" serve as strong examples of the ways we construct embodied space even when we are not near one another. Here, we again turn to the theories of Lefebvre, who argued for the production of space as simultaneously a production of embodiment. To put Lefebvre's argument another way, embodiment is always a spatial practice and, conversely, space is always an embodied practice. To argue that embodiment is a spatial *practice*, I mean that bodies and spaces exist through their use, through movement, through person-to-person and person-to-object relationships.

These examples point to another defining component of embodiment in the age of mobile computing: once enacted, *embodiment does not always need to be located in physical space*. As people connect across networks on a global level, what many are experiencing as they practice the space of the network is embodiment. This has been one point of contention among users and non-users of information and communication technology (ICT): if you can't reach out and touch someone, how can you truly have a meaningful relationship with that person? As I will more thoroughly develop in Chapter 3, as people develop significant relationships that

have their origins (or their entire existence) in and through digital media, what we are seeing is the evidence that embodiment is not dependent on physical space. Instead, we create space as we create our bodies across digital media. As Paul Dourish writes, "Certainly, embodiment retains this notion of immanent 'presence,' and of the fact that something occurs in the world; but it need not rest on a purely physical foundation."[14]

Here, I'd like to take a brief aside to make one important and relevant distinction that will be further developed in the next chapter. One of the implications of arguing for embodiment as that which is not reliant on physical space is that it exposes the dichotomy "real/virtual" as a false opposition. For, if it were an accurate opposition, then that which is virtual would also be considered "not real." Quite the contrary is true. That which we encounter as virtual—from chatting with a loved one via text or over video conferencing to playing a multiplayer online game—is often so "real" that it alters the very ways we identify ourselves, the ways we use language, and the ways we conceive of everyday space. While I don't find the "real/virtual" opposition useful or accurate, its use is actually developed out of a misconception of the virtual. In the next chapter, I will go into greater detail about the relationship between virtuality and the terms it is often coupled with or opposed to; however, it is worth noting here that our embodied relationship to the virtual must be linked to the phenomenologies of multiplicity. That is to say, an experience of the virtual is always an experience of the virtual in conjunction with another concept such as the "actual." The term "virtual" comes from the Latin *virtus*, which is typically translated as "virtue" or being "effective in respect of inherent natural qualities or powers."[15] This was the common use of the word "virtual" in English until the late 1400s, when it began to stand in for ideas of force and power. The virtual as a force or power is always conjoined with ideas of actualization or realization. As John Rajchman writes, "The virtual lies in those forces or potentials whose origins and outcomes cannot be specified independently of the open and necessarily incomplete series of their actualizations. Such is their multiplicity (or complexity) that it can never be reduced to a set of discrete elements or to the different parts of a closed or organic whole."[16] Thus, the virtual is not the opposite of the real; instead it is a component of experiencing the real. The virtual serves as a way to understand the real and as a form of actualization that serves to layer and multiply an experience of that which is already realized. In terms of our embodied engagement with mobile media, which simultaneously takes place in our everyday spaces (which have been "realized") and in the ways this space is augmented by virtuality infused from our interfaces, the terms cannot be used in isolation from one another. The realized or actualized is always implicated by the virtual (broadly defined) and such an implication is produced through embodied practices.

What takes place across the "virtual" space of mobile computing is almost always founded on social interaction in the material sphere (i.e., to learn how to practice embodiment in virtual space we must initially experience embodied

practice in material space). However, since the two realms are so intertwined, the embodied practice of space on mobile networks strongly reinforces our sense of embodiment in the material sphere. In other words, our sense of embodied self can be developed and thrive from interactions that take place across geographically distant places. When it comes to intimate interpersonal connections, face-to-face is now implicated and informed by the virtual.

Over the past decade, several studies have been done to test our abilities to perform actions simultaneously in our immediate material space and across the space of the mobile phone. Specifically, social and cognitive scientists have been interested in the effects of driving while talking on a mobile phone. While recent legislation across the United States and many other countries has banned the use of a phone while driving unless the driver is utilizing a hands-free headset, studies published as early as 1999 show that simply talking on the phone while driving can significantly increase the possibility of an accident. Most studies of the use of hands-free devices while driving find that there is amplification in the cognitive load from talking on the phone that causes an increase in distraction and even a degradation of hand-eye coordination with the road.[17] Tying these results in with my analysis of embodiment in digital space, it becomes obvious that we are indeed all too ready to practice embodiment across media spaces, so much so that we are often more embodied in a virtual space (such as the space on the other side of the phone connection) than we are in material space. Thus, significant practices of embodied space can and do take place in spaces that have no foundational connection to any shared material space.

While it is essential that our experience of embodiment is a spatial practice, the ways we practice embodiment and space are very culturally specific. Ultimately, *embodiment can never exist outside of culture.* Culture frames all of our embodied and spatial interactions. Elizabeth Grosz argues profoundly in her book, *Volatile Bodies,* that bodies are always a product of the culture that produces them. She writes, "The body must be regarded as a site of social, political, cultural, and geographic inscriptions, production or constitution. The body is not opposed to culture, a resistant throwback to a natural past; it is itself a cultural, *the* cultural product."[18] I find Paul Dourish's definitions of embodiment to offer an interesting contrast to Grosz's conceptions. "Embodiment," as Dourish writes, "is the property of our engagement with the world that allows us to make it meaningful." He goes on to augment his definition by stating, "Embodied interaction is the creation, manipulation, and sharing of meaning through engaged interaction with artifacts."[19] Such a proposition, while accurate, does not articulate the relationship between the production of embodied space and the production of culture. While Dourish's second definition of embodiment seems to point toward a symbiotic relationship between culture and embodiment (much in the way that Lefebvre argued for a symbiotic relationship between space and embodiment), such a definition is not wholly developed, since bodies are never able to step outside of culture. While embodied actors do indeed create culture, they are inextricably created by culture.

The very essence of Heidegger's "being-in-the-world" is produced out of the cultural nuances that serve as the spatio-temporal context of embodied being: from the words we use to describe what it means to inhabit a body to the associations we have with certain colors to the very ways we move our bodies through space, all of these foundational characteristics are entirely developed out of the culture that contextualizes us. To be clear, "culture" is not a transcendental signified, that single idea that is the end of the line of reasoning for the signifier of the body. Culture, instead, is multifaceted, never "grounded" in meaning, and made up of innumerable pieces that accumulate across time and space.

One question that will arise is: How do we describe culture if we are unable to get outside of it? Here, I turn to Jacques Derrida's usage of the *mise-en-abîme*, which draws on the heraldry usage of the term as the representation of a shield depicting the very shield itself. Heraldry points to the design of certain shields, which had a coat of arms emblazoned on the whole of the shield. These shields would have a smaller copy of the shield and coat of arms design at the shield's center. This was a type of representation of the item within the item. To draw on this metaphor and the ways Derrida uses it, we cannot escape culture (or, for Derrida, escape the text) but we are able to analyze it by describing the thing within the thing. Thus, while culture can and does exist in part outside of embodiment (since it serves as an organizing structure for embodiment), it is also constructed and maintained by embodied actors who are able to analyze it as a *mise-en-abîme*. Put another way, though embodiment is not pre-personal or something that exists a priori to our engagement with it, culture is in fact something that is pre-personal and even structures our conceptions of the personal.

This is an important distinction to make with regards to our embodied, cultural relationships to the mobile interface. In contrast to this stance is the notion that technology is not culturally situated but is instead the force driving culture. Recent headlines in popular technology magazines echo such sentiments, ranging from "How the Tablet Will Change the World" and "Be Prepared for the Smartphone Takeover" to "Mobile Phones and Internet Essential in Building Democracies." It seems in much of the advertising of emerging technologies culture is along for the ride as various digital media show us the possibilities. This cultural imaginary, termed "technological determinism," offers not only a limited view of the role of technology in culture, but inaccurately frames a picture of humanity being pulled forward into a particular technological destiny. Instead of our embodied spaces being shaped by technology, there is interplay between the ways we shape our technologies and how they, in turn, shape us. Hayles explores this relationship in depth when she asks, "Should the body be subjected to the machine, or the machine to the body? The stakes are nothing less than whether the embodied human becomes the center for humanistic inquiry within which digital media can be understood, or whether media provide the context and ground for configuring and disciplining the body."[20] Hayles' position resonates with my understanding of the relationship between embodiment, technology, and culture when she writes

that a third perspective must be brought into the picture (beyond the centering of either culture or technology), one that focuses on the "dynamics entwining body and machine together."[21] Arguing that Friedrich Kitler's dictum, "Media determine our situation," offers an incomplete picture of the interrelationship between culture and technology, Hayles points out that our situation is instead "encapsulated within the horizon codetermined by media conditions and cultural formations."[22] She continues: "If media alone are not enough to determine our situation, neither is embodiment . . . Embodiment will not become obsolete because it is essential to human being, but it can and does transform in relation to environmental selective pressures, particularly through interactions with technology."[23] Thus, our bodies, our spaces, and our technologies are all formed within culture and subsequently work within the bounds of culture to transform it. Culture is reworked from the inside by embodied interactors designing and repurposing technology. Within this situation, technology often serves as a catalyst for the massive cultural and embodied transformations that come to define an era.

In contrast to Kitler's perspective, Mark Hansen has argued for a human-centered understanding of the role technology plays in the transformations of culture. He argues for a "bio-philosophical basis for the priority of the human framing function over any possible technical frame, and thus shows that it has always already been at work, buried as it were beneath the glitter associated with the technical."[24] This bio-philosophical approach to embodiment in the mobile computing age stems from the phenomenological work done by Merleau-Ponty. One of the key theorists of phenomenology, Merleau-Ponty's foundational ideas about embodiment shows that *embodiment is conceived out of the sensory*. He writes, "All knowledge takes its place within the horizons opened up by perception."[25] Once embodiment enters the picture, we are already discussing theories of perception. Any theory of embodiment, for Merleau-Ponty, is ultimately a theory of the sensory. Our knowledge of the world and our place within the world depends on the feedback from our senses. Though our senses can trick us at times and be unreliable mediators to the world, even our knowledge of this type of trickery is gained through the sensory connection between our bodies and the world that surrounds us. As Merleau-Ponty argues, "For if it is true that I am conscious of my body *via* the world . . . it is true for the same reason that my body is the pivot of the world . . . I am conscious of the world through the medium of my body."[26] He goes on to say:

> Perception is not a science of the world, it is not even an act, a deliberate taking up of a position; it is the background from which all acts stand out, and is presupposed by them. The world is not an object such that I have in my possession the law of its making; it is the natural setting of, and field for, all my thoughts and all my explicit perceptions. Truth does not "inhabit the inner man," or more accurately, there is no inner man, man is in the world, and only in the world does he know himself.[27]

Merleau-Ponty's sentiments here echo the foundational thoughts that served as the catalyst for the directions phenomenology would take. The early phenomenological work of Edmund Husserl broke from the mind/body dualism that characterized Descartes' theory of being ("I think therefore I am") and instead sought to argue for an understanding of being that put away the interior/exterior binary of the mind/body split. Instead, our thought processes are never divorced from our bodies. The very act of knowing we are beings in the world is an embodied act of perception. Heidegger extended this to argue for *Dasein*, or a theory of "being-in-the-world" that is "the more radical question of what gives or produces being *as an effect*," as John van Buren notes.[28]

Our senses, which inform us of the world and our place as beings in the world, are inherently cultural (as previously stated) and are also interpersonal. While some senses might be heightened for some due to physical or cultural contexts (whether it be an increase in the faculty of hearing due a lack of sight or because the auditory is one of the dominant senses in the culture), these senses always find their full expression of existence in interaction. Our senses connect us as beings in the world through interaction with objects, such as a toddler's knowledge of the limits of the body by experiencing where his or her shoulder ends and the edge of the table begins. For Jacques Lacan, in his famous work on the mirror stage, a child learns the limitations and borders of the body by seeing him or herself move and interact in the mirror. The arm moves and it is reflected in the object of the mirror. This sensory interaction teaches the child that the object floating around in front of the eyes is actually a part of the self—the hand. For Lacan, the mirror stage of development has a vital component: the child isn't the only one in the mirror. Standing with the child is the child's mother. Thus, an essential component of our senses teaching us about our place in the world is to know that my body is distinct from your body while simultaneously understanding that the sensations I feel must be mirrored in your body as well. Merleau-Ponty's chapter "The Child's Relations with Others" explains this phenomenon:

> Only one recourse is left for classical psychology—that of supposing that, as a spectator of the gestures and utterances of the other's body before me, I consider the totality of signs thus given, the totality of facial expressions this body presents to me, as the occasion for a kind of decoding. Behind the body whose gestures and characteristic utterances I witness, I project, so to speak, what I myself feel of my own body. No matter whether it is a question of an actual association of ideas or, instead, a judgment whereby I interpret the appearances, I transfer to the other the intimate experience I have of my own body.[29]

My experience of my body is reliant on the sensory interaction between the limits of my body, the space that contextualizes it, and the interaction with your body. As Casey argues, my "here" is entirely dependent on the fact that it is distinct

from your "here." My embodied understanding that I inhabit this locale as my "here" has a continual reciprocity with the fact that I am aware of a "there" that others inhabit which will never be identical to my "here." Though "here" and "there" are never the same, the ever-present relationship between the two spaces is what constitutes the intersubjective self as "being-in-the-world."

This intersubjective formation of embodiment, especially across digital networks, is flourishing in the age of mobile computing. From the foundations of the mobile phone as a communications device to the current rise of location-based social networks, our mobile devices have been encoded with interpersonal connections as their founding principle. With the introduction of location-aware and site-specific social media, our interactions with online social networks that are now locative have transformed the relationship between embodied identity and social space. As will be discussed in more detail in Chapter 3, location-based social networks offer a form of intersubjective embodiment that gives participants a sense of social proprioception: a sense of embodied integrity that is aware of the self's place as that which is always already situated in relationship to the location of others.[30] I know where I am (and *how* I am) because I am always relating my space to the spaces you inhabit. The self's identity extends beyond the immediate context and encompasses a much broader socio-spatial sphere.

While those things that we are aware of and perceive are vital to our sense of being-in-the-world, our senses also work at blocking out much of the sensory input that we are bombarded with. Thus, *embodiment depends on the cognitive unconscious.* Imagine for a moment that your senses did not place objects or people in the foreground and leave some in the background; or, imagine that while you were having a conversation with someone, that every other conversation in the room and every sound in the room became as equally important. This level of sensory overload would not only make communication and interpersonal relationships impossible; it would dislocate the self from the place. Our sense of being-in-the-world is quite dependent on much of the world *not* being noticed. We function as embodied beings because we do not notice everything or sense everything.

Building off of the long history of the relationship between consciousness and the unconscious, John F. Kihlstrom noted in his 1987 essay "The Cognitive Unconscious" that the metaphor of the "modern high-speed computer" served to inform our contemporary understanding of the complex relationship between cognitive awareness and the cognitive unconscious.[31] As James S. Uleman describes, "In early models, the unconscious referred to preattentive perceptual processes and latent memory traces, so that complex higher mental processes depended on awareness for their operation . . . In later models, complex processing did not require awareness of the information that was transformed, so much more complex unconscious cognitive processing occurs."[32] The implications, as further developed by Kihlstrom's research, are that our sense of self and knowledge of the world as gained through sensory perception do not take place entirely in the realm of

cognitive awareness. Instead, much of what we know of the world and our place within it takes place at the level of the unconscious (not to be confused here with the psychoanalytic use of the term). Kihlstrom expands on his research:

> One thing is now clear: consciousness is not to be identified with any particular perceptual-cognitive functions such as discriminative response to stimulation, perception, memory, or the higher mental processes involved in judgment or problem solving. All of these functions can take place outside of phenomenal awareness. Rather, consciousness is an experiential quality that may accompany any of these functions. The fact of conscious awareness may have particular consequences for psychological function—it seems necessary for voluntary control, for example, as well as for communicating one's mental states to others. But it is not necessary for complex psychological functioning.[33]

The makeup of the body is an important example. A question: Are you currently thinking about your toes? Or your ears? It is unlikely unless something about your toes or your ears is causing them to be noticed, such as an injury or extremely cold temperatures. Our body parts recede from perception so that we can exist as a whole body rather than a culmination of disparate sensory pieces. Such is the interplay between cognitive awareness and the cognitive unconscious. We notice the world and places within it through what we perceive, those things which are obvious to us through our senses. However, just as important are those things we do not notice—at the level of the cognitive unconscious.

The conception of ourselves as embodied beings is also seen in the relationship between cognitive awareness and cognitive unconscious use of technology. Heidegger writes about our uses of tools, or "equipment" which is "ready-to-hand" by becoming an extension of my hand. The tool at the moment of use is not characterized by the way it appears or how it feels; instead, a good tool (for many designers) is one that disappears when used. It is so intuitive that it is characterized by its purpose and use rather than its physical makeup. As he writes, "The peculiarity of what is proximally ready-to-hand is that, in its readiness-to-hand, it must, as it were, withdraw in order to be ready-to-hand quite authentically."[34] Using any digital interface will have users grasp the concept of ready-to-hand quite quickly, especially if the interface is one that is unusual for a user (getting my parents to use a newer videogame controller would be a good example). Conversations on a mobile phone also serve as a good example: once connected to someone, the interface of the phone typically recedes and you are moved into the space of conversation. If, however, there becomes an extended period of silence, the sense perceptions immediately pull focus from the other person to the device (the "equipment"). You will move the phone away from your ear to look at the screen, determining if you are still connected, if your reception is strong, or if your battery has died. This, for Heidegger, moves the

equipment from ready-to-hand to present-at-hand. It is the move from the cognitive unconscious to the realm of cognitive awareness. Thus, embodiment is a constant interplay between the two realms.

Though we may not perceive these elements of the world and our place in it, these elements that recede into the background are sometimes the most telling characteristics of a lived space. The behind-the-scenes, the off-stage, and the hidden-from-view often serve as the foundations for the perceptive world. And often when the cognitive unconscious elements move from the background to the foreground, there is a cultural paradigm shift that accompanies the new understanding of the sensory world. This movement is what can be considered (from our phenomenological point of view) the foundations of cultural revolution. In brief, which will be expanded more thoroughly in my discussion of the ethics of immersion in Chapter 4, a phenomenological reading of Louis Althusser and Antonio Gramsci's notions of hegemony reveals that our embodied sensory engagement with the world (both at the level of the cognitive unconscious and at the level of cognitive awareness) has much to do with the ways that power is exerted. Althusser argues in his article "Ideology and Ideological State Apparatuses,"

> The tenacious obviousnesses (ideological obviousnesses of an empiricist type) of the point of view of production alone, or even of that of mere productive practice (itself abstract in relation to the process of production) are so integrated into our everyday "consciousness" that it is extremely hard, not to say almost impossible, to raise oneself to the *point of view of reproduction.*[35]

Thus, as we shall see later in the book, the ethics at play between the sensory and the meta-sensory is a highly wrought battleground of control and subjection. Perhaps the "interfaceless interface" of pervasive computing carries with it the threat of exercising hegemony by receding to the background and avoiding critique.

While our sense of embodiment as formed through perception (via cognitive awareness and the cognitive unconscious) is culturally situated, it has been argued that much of what takes place at the perceptive level is not in the realm of the cultural but in the realm of the biological. Any theory of embodiment must therefore account for the fact that *embodiment is conceived out of biological factors.* Here, I return to Hayles' quote from the beginning of the chapter, when she argues that our experiences of embodiment are not entirely cultural, but "emerge from the complex interactions between conscious mind and the physiological structures that are the result of millennia of biological evolution."[36] Thus, while the concept is far outside the purview of my expertise and the scope of this book, I do want to briefly note that many of the ways we encounter our bodies have to do with the biological makeup of our bodies. From hereditary traits to the ways our immune

systems fight disease, much of what serves as our embodied engagement with the world has to do with the impact that biological factors have on our bodies. While much of this can correspond with our sensory engagement with the body, such as having asthma or arthritis, much of what happens in our bodies happens at the cognitive unconscious realm. While my position on this predominantly sides with Merleau-Ponty when he argues that biological factors are secondary elaborations of our place in the world, the materiality of our bodies far exceeds the realm of the perceptible and nonetheless has important impacts on the ways we conceive of embodiment.

While embodiment is conceived out of an interrelationship between cognitive awareness and the cognitive unconscious, our embodied engagement with the world in a mobile media age is simultaneously conceived out of our relationship to the ways the world is inscribed. Thus, *embodiment is always conceived in relationship to modes of inscription.* Here, I seek to bridge a gap between phenomenology and poststructuralism, pointing toward a theory that understands being-in-the-world as simultaneously about our sense perception and about ways we encounter the world as a reading process. Here, poststructuralism intervenes, namely in Derrida's understanding of our engagement with the world. He famously argues that "there is nothing outside of the text," or, in other words, the world as we know it and engage it is simply ever-changing sign systems that we interpret. This process of interpretation is ongoing, never settled or "grounded," and thus always defers meaning. He continues, "What we have tried to show by following the guiding line of the 'dangerous supplement,' is that in what one calls the real life of these existences 'of flesh and bone' . . . there has never been anything but writing; there have never been anything but supplements, substitutive significations which could only come forth in a chain of differential references."[37] Thus, our embodied engagement with the world is a constant process of reading the world. Derrida, it must be noted, argued against any binary opposition between embodied presence and absence (filtered through representational forms), thus noting that what we consider to be "full embodiment" as face-to-face conversation and dialog is actually closer to a process of reading that is ongoing. Our embodied engagements with each other are always about meaning being deferred as we interpret words, gestures, clothing, race, gender, sexuality, and the cultural signifiers that are inscribed onto the body. Our sense perceptions here work in tandem with the ways that we read the world around us. And, for Derrida, this process of reading the various signs inscribed onto bodies is one that resists coming to full meaning and thus full, embodied presence is always being deferred.

Throughout this book, I will look at ways that embodiment is produced in relationship to the sensory and with modes of inscription. The latter will illuminate ways that we are read as embodied subjects with and through mobile technology. We simultaneously read the cultural inscriptions written on others (again, with and through mobile technologies). Bridging this notion with the necessary idea that our embodied integrity as subjects comes through a sensory engagement with

the world, I seek to show, through examples of mobile interfaces, the significant moments of complementarity and overlap between phenomenology and post-structuralism. When brought to bear on an analysis of embodiment in a mobile media age, these ideas offer a theory of the body that is far more nuanced and thorough than each of the theories individually. My theory of embodiment that is conceived out of this complementarity is called the "sensory-inscribed" body.

Embodying the Sensory-Inscribed

My theory of embodiment blends the theories discussed above toward an under-standing of bodies as simultaneously conceived through site-specific sensory engagement and a reading of bodies as always culturally inscribed. This theory of embodiment develops a particularly useful notion in phenomenology: proprio-ception. As a brief definition of proprioception, Mark Hansen writes that a proprioceptive experience of the body is that which "designates the body's nonvisual, tactile experience of itself, a form directed toward the bodily projection of affection (affectivity)."[38] Hansen develops this idea further when he quotes Brian Massumi: "Proprioception folds tactility into the body, enveloping the skin's contact with the external world in a dimension of medium depth: between exodermis and viscera . . . Proprioception effects a double translation of the subject and the object into the body, at a medium depth where the body is only body."[39] Proprioception is not reliant on the purely visual; instead, it combines all senses into embodied movement that clearly negotiates where the limits of the body are and how the body is located in the space it inhabits. Two examples of proprio-ception will elucidate this. Firstly, mentally locate the nearest mode of trans-portation, be it your car or a bus or train. Where is that mode of transportation in relationship to your current location (assuming you aren't currently reading on the subway, that is)? How do you know its location if you are unable to actually see it? We are able to position ourselves in lived space and are able to know where we are in relationship to the people and objects around us (such as a car) through proprioception. We thus can locate ourselves in relational space at all times. If you walk to your car in a parking lot and suddenly realize that you have no idea where you parked, your proprioceptive relationship with your vehicle is lost. A second example develops the specifics about how proprioception functions. Merleau-Ponty famously discusses how the limits of our proprioceptive body do not necessarily end at the limits of the skin. Instead, we often extend ourselves out into the world in proprioceptive ways that extend our being-in-the-world well beyond the physical limits of the body. He writes:

> A woman may, without any calculation, keep a safe distance between the feather in her hat and the things which might break it off. She feels where the feather is just as we feel where our hand is. If I am in the habit of driving a car, I enter a narrow opening and see that I can "get through" without

comparing the width of the opening with that of the wings, just as I go through a doorway without checking the width of the doorway against that of my body.[40]

Our perceptive understanding of our place in the world and how we specifically inhabit the spaces we move through is accomplished through proprioception. With proprioception, the senses work in conjunction—as they always have since no sense works in isolation from the other senses—to give us a sense of embodied place and situatedness. This sense of being "here" in the world extends well beyond the limits of the skin toward a relational being-in-the-world. In doing so, the spaces we inhabit fluctuate from our immediate surroundings to the distance between us and a destination or between us and another person. Again, this points to how our proprioceptive being-in-the-world can function across virtual spaces, including imagined spaces, such as being distant from a loved one yet connected to their space through an imagined proprioceptive engagement with their locale (as it is attached to my own).

This mode of proprioception is an incomplete version of embodiment since much of what we understand as being an embodied subject in the world relies on the ways we read or interpret the various sign systems around us. Our bodies, as culturally inscribed, are constantly read. Simultaneously, we are inscribing our bodies and the bodies of those around us. We "signify" identities through the cultural inscriptions of masculinity or femininity, the signifiers of our cultures, or sexualities, our religions, among other aspects of our embodied identity that we read in others and encode on our bodies for others to read. Oftentimes this encoding/decoding dynamic is thrust upon us through what Althusser terms "interpellation." The interpellated identity is one that is inscribed by someone else, as that person or entity "hails" you as a particular body. An anecdote by Frantz Fanon of a white child "hailing" him as a black man, and subsequently as a *dangerous* black man is a profound example of this type of embodied inscription:

"Look! A Negro!" It was a passing sting. I attempted a smile.

"Look! A Negro!" Absolutely. I was beginning to enjoy myself.

"Look! A Negro!" The circle was gradually getting smaller. I was really enjoying myself.

"*Maman*, look, a Negro; I'm scared!" Scared! Scared! Now they were beginning to be scared of me. I wanted to kill myself laughing, but laughter had become out of the question.[41]

Fanon goes on to say,

My body was returned to me spread-eagled, disjointed, redone, draped in mourning on this white winter's day. The Negro is an animal, the Negro is

bad, the Negro is wicked, the Negro is ugly; look, a Negro; the Negro is trembling, the Negro is trembling because he's cold, the small boy is trembling because he's afraid of the Negro, the Negro is trembling with cold, the cold that chills the bones, the lovely boy is trembling because he thinks the Negro is trembling with rage, the little white boy runs to his mother's arms: "*Maman*, the Negro is going to eat me."[42]

This entire process of reading the various inscriptions on the body is precisely the inscribed mode of embodiment that comes as a hermeneutic reading of bodies in cultural space.

A "sensory-inscribed" body, however, blends these two modes of embodiment. We are embodied through our perceptive being-in-the-world and simultaneously through our reading of the world and our place as an inscribed body in the world. This mode of phenomenological hermeneutics echoes Hayles' materiality of embodiment in "an age of virtuality," when she argues for a dynamic interaction between "the body as a cultural construct" and our various experiences of embodiment that are understood as "a dance between inscribing and incorporating practices."[43] Thus being simultaneously a perceptive, experiential mode of being-in-the-world and a process of "inscription and incorporation," the sensory-inscribed body serves as a bridge between the body as sensory and body as sign system. Neither precedes or dominates the other; instead, they work in conjunction to produce the embodied space of pervasive computing culture.

An example of the sensory-inscribed body in mobile phone culture will illuminate the interplay between the sensory mode of embodiment and the sign-system mode of embodiment as they simultaneously function to embody us in the world. A colleague of mine at the university had a very strict policy of "no cell phones in the classroom." However, during one of her lectures, a student's phone rang. She paused while the student fished for his phone in his bag, waiting for him to turn it off. Instead, the student looked at the screen to see who was calling and then answered the phone. Without getting up, he began speaking to the person on the other end of the line, who (it soon became obvious) was a relative facing a moment of crisis. In this scene, the sensory-inscribed body is at play on several levels. Firstly, the student's sensory mode of embodiment is located in two places at once. He was in the classroom and also in the place where his relative was in a moment of crisis. His being-in-the-world was simultaneously here and there as he connected with those students and professor in his immediate surroundings and with the loved one over the phone. His embodied space is both material and virtual. He apparently sensed the urgency in the voice of the loved one, able to perceive the gravity of the situation. Thus, simply through aural means, he could place himself in the "here" of his loved one, embodying their crisis. While his sense engagement with the world situated him across places—the classroom and the location of his loved one—he likely filled in the sensory gaps in the perceptive moment. Relying solely on a single-sense technology, a person in his situation

makes assumptions about what may be going on at a loved one's location, their gestures and other non-verbal expressions that are imperceptible. Beyond this mode of embodied engagement, this student was soon keenly aware of the ways the encounter was being read. Receiving disapproving (and utterly shocked) looks from the professor and the other students in the classroom, the student soon realized the major cultural faux pas he was committing by using a mobile phone in this setting. As he got up to continue the conversation outside, and in order to counter the negative inscriptions of his actions as he read them, he embodied expressions of urgency, demonstrating the unique nature of the call to those in the classroom. As he opened the door to the classroom in order to leave, he offered advice to his relative and, with the door open, he paused and looked at the screen. The line had gone silent. "Hello?" he repeated, but the call was over. Did he offer poor advice? Had the reception vanished? The silence itself entered into the sign system of the moment. He turned around, looking apologetically at the room, and returned to his seat.

Negotiating these various modes of embodiment is to understand the sensory-inscribed. Neither the sense perceptions of the moment nor the reading of the various signs of the moment would offer a full picture of what it means to be embodied in the situation. Thus, by seeking a theory of the body that bridges the phenomenological modes of body and the cultural inscriptions of the body, we see a fuller view of what it means to function as a being-in-the-world. The sensory-inscribed body envelops all of our experiences of the body.

Beyond the simple example of using a mobile phone in a classroom, this conception of embodiment is essential to the ways we interact with and interpret emerging cultural forms. From art to narrative to the games we play, the sensory-inscribed body offers a fruitful lens with which to view the emerging landscape of the mobile interface. While it has been my goal in this chapter to fully develop a working definition of embodiment for the era of mobile media, this notion is incomplete without coupling it with an investigation into the spatial characteristics of pervasive computing culture. In the next chapter, I will seek to connect my definition of embodiment with an exploration of mobile media spaces.

2

MAPPING AND REPRESENTATIONS OF SPACE

How we represent space has everything to do with how we embody that space. Our concepts of culture, identity, and agency all spring from our understanding of bodies' relationships to the spaces they exist in and move through. Such understandings are conceived out of the various ways space is represented and visualized. The previous chapter focused specifically on my definition of embodiment for mobile media culture. Here, I want to focus on embodiment's counterpart: spatiality. Since embodiment and space are indelibly linked together, it is important to develop a strong understanding of our usage of the term "mobile media space." Such an understanding is undoubtedly linked to the various ways space is represented on mobile devices, representations that a community comes to rely on to interact with pervasive computing space. In order to define the various ways space is produced in our mobile media era, I will draw on several examples that demonstrate the various ways we embody and practice space. These examples are primarily rooted in ideas of mapping: from mapping geographic regions to mapping ideas and concepts in word clouds, from mapping information and visualizations onto landscapes through augmented reality applications to mapping disaster zones through site-specific text messages. Mapping, as a means of representing and practicing space (and the cultural capital that is so intimately connected to this concept), serves as a key example in the exploration of what "space" means in our embodied practices of mobile technologies.

The Space of Virtuality

On a recent trip to Boston, after being dropped off at my hotel by a taxi, I placed my luggage in my room and stepped outside to find a restaurant. I loaded a map on my phone, hit the button that would request my location, and noticed the blue

dot that located me at an intersection. I looked at the nearby street corner signs, which did not match the place that the map located me. I knew the map was representing my location incorrectly. I also knew the name of the nearest intersection. But, I had no idea where I was! Though I had barely taken a few steps outside of the hotel, I was already lost. With no one nearby to help clarify the discrepancy, I tried a few techniques to get the map to show my correct location, so I could find out which restaurants were within walking distance. I did a search for my hotel and discovered that the map was placing me about a half-mile from my current location. What struck me most about this situation was the feeling of displacement I had until the map lined up with my physical location. I had an odd anxiety about being lost but couldn't quite figure out why. It dawned on me that as I typically move through a new place, I use my mobile device to inform me of the context of my location. The "virtual" world of the mobile interface deeply affects the way I move through my everyday life. I savor the context-aware information my mobile device provides me and, when the representation of my environment on my device does not match up with the material space around me, I feel that one of my lenses to the world has been broken.

Increasingly, our experiences of virtual space are dissolving into the practices of our everyday lives. In fact, by tracing the history of the term "virtuality," we immediately see that the intimate relationship between the virtual and the "actual" has always been historically assumed. For Elizabeth Grosz, this dissolve takes place at the level of the perceptual, noting that the most striking transformation heralded in by digital technologies is the "change in our perceptions of materiality, space, and information, which is bound directly or indirectly to affect how we understand architecture, habitation, and the built environment."[1] Though Grosz continues to utilize the dichotomy between "virtual" and "real" space (as exemplified in her book's title: *Architecture from the Outside: Essays on Virtual and Real Space*), her ultimate goal is quite aligned with my approach to pervasive computing space (as actualized through mobile technologies). By interrogating whether or not the "computer screen [can] act as the clear-cut barrier separating cyberspace from real space," my chapter parallels Grosz's argument that "virtual objects are now capable of generating the same perceptual effects as 'real' objects."[2] Ultimately, an updated approach is needed for our conceptions of how virtual and material spaces interact. Here, we must complicate "our notions of real, of body, and of the physical or historical city . . . [and] what they seem to oppose."[3]

While pervasive computing space often prompts a comparison between the "real" and the "virtual," such dichotomies do little to inform our embodied experience of this kind of space, especially in an age when the perceptive interaction with the digital environment offers a significant embodied experience. We might even ask, what distinguishes the "real" space when a virtual interaction offers a very "real" experience. Instead, by understanding the space of the digital and the space of the material to have constant interplay and permeability between one another, distinguishing the space of the virtual from the space of the real does not

inform a nuanced understanding of pervasive computing space, mobile media space, or space broadly conceived.

As I touched on briefly in the previous chapter, the term "virtual" is drawn from the Latin word *virtus*, which has had many meanings over the years including "virtue," "force," "power," and then, in 1959, it began to be used in computing terms as that which is "[n]ot physically existing as such but made by software to appear to do so from the point of view of the program or the user."[4] This use of the virtual as that which is not physical but emulates the physical (such as "virtual memory" or "virtual machine") gestures back to the 1600s, when people used it to refer to metaphysical ideas related to Christianity, especially in distinguishing between the physical practices of faith—such as taking communion or getting baptized—and the metaphysical/"virtual" components of faith—such as the inward belief and connection to God. Connecting the virtual to the spiritual illuminates the historic idea that virtuality is non-physical and largely about potential or a process of becoming. However, this definition of the virtual had never been opposed to that which is real. For people of faith, sometimes that which is "virtual" and metaphysical is even *more real* than the physical world in which they live.

This definition is only one approach to the virtual. Accompanying this approach to the virtual is the idea of the virtual as simulation. The extended history of using the virtual to stand in for ideas of simulation is traced by Adriana de Souza e Silva and Daniel Sutko and is what they term the "technological virtual." They write, "Because the Internet was mostly accessed through fixed interfaces (e.g., personal computers) that were physically attached to a home or office space, physical spaces were perceived as independent from digital spaces. Accordingly, digital worlds, such as chat rooms and multiuser environments, were considered 'virtual' because they allowed people to meet in nonphysical, simulated spaces."[5] The emergence of the relationship between virtuality and simulation is linked to a shift in computing from a "culture of calculations to a culture of simulations." De Souza e Silva and Sutko note, "In the culture of simulations, everything is taken at interface value."[6] The simulation as a screen representation that stood in for physical spaces has since caused a significant amount of cultural anxiety due to the potentials present in these forms of representation (from fears of children committing acts of violence after playing a violent videogame to people being so distracted by their devices that they no longer pay adequate attention to the physical space around them). De Souza e Silva and Sutko rightly trace this anxiety back to Plato's anxiety over art as a representational form that would draw us away from the "real" world. This fear has extended into contemporary discussions of digital interfaces as spaces that threaten to become more important—and will thus eventually subsume—"actual" space. As Umberto Eco has argued, once there is a 1:1 relationship between the representation and the thing it represents (such as a map that is the exact size of the space it represents), the former will destroy the latter. They are unable to coexist.[7]

These theories of virtuality and simulation fail us in important ways: they do not take into account the sensory-inscribed experience of virtuality as a multiplicity

and tend to ignore the materiality of the virtual. The virtual has been experienced throughout history as not a privileging or erasing of one space over another. The virtual is instead an experience of multiplicity. It is an experience of layering, and the constant interplay that bonds the virtual and the actual together is the pleasure of virtuality. As John Rajchman writes, citing Proust: "The virtual is 'real without being actual, ideal without being abstract.'"[8] This constant interplay—without a full dissolution of one space into another—is the key to the success of virtuality. Rajchman continues: "The actual is then what manifests and effectuates the virtual, but the actual never *completely* shows or activates all that the virtual implies. Something always remains."[9]

Playwright Tony Kushner, author of *Angels in America*, relates this kind of experience of multiplicity to the reasons that representational forms (from plays to maps) are effective and powerful. He says,

> At the end of Hamlet, you think, "What was Shakespeare thinking? You have somebody die at the end of a swordfight?" Well, if you've ever done stage fencing you know, at the end of the fencing when he falls dead he's just been running around the stage with Laertes waving his sword, so he's going to lie on the stage and he's going to be [breathing heavy]. It's always—every Hamlet—there's the body, bellows breathing. And yet, in a good production of Hamlet, when Horatio says, "Goodnight sweet prince; and flights of angels . . ." it kills you. Of course, Shakespeare knew exactly what he was doing. He wanted you to see that body breathing and to have this double experience. That's how you understand, if you can develop that in yourself: if you can learn to read the world, if you learn to understand that fundamentalism and literalism are anemical to human progress (and, I think in a certain sense, to human happiness and to decency and justice and liberty and all sorts of good things). If you are a literal reader of texts, you're never going to understand anything. If you don't have the ability to interpret, you're missing the whole point of being alive, the whole point of being alive with a brain. And you'll be—that's what Shakespeare says—you'll be the fool of time, the fool of history, the fool of the world instead of being someone who can understand.[10]

The doubleness that Kushner argues for is essentially the multiplicity that is the experience of virtuality. It is experienced as a multiplicity that "can never be reduced to a set of discrete elements or to the different parts of a closed or organic whole. (This is what Bergson called 'qualitative' rather than 'quantitative' multiplicity.)"[11] Thus, as we experience the virtual through our mobile interfaces, it is vital to note that virtual space always implies a counterpart, such as Gilles Deleuze's coupling of the virtual with the actual. For Deleuze, these are not oppositional terms; instead, they serve as counterparts indelibly linked to one another. In this view, the virtual would never fully dissolve into the actual because

it is already an integral part of the ways we have always experienced the actual. From our interfaces to our imaginations, the virtual and the "realized" have historically been tandem and complementary elements of our experiences of everyday life.

Yet, the virtual and the real continue to be discussed as opposites. One reason we are so drawn to discussing space in such bifurcated terms is largely due to a significant shift in our experience of space with the advent of mobile computing, especially with internet-capable devices. The move from personal computing to pervasive computing, a shift characterized by the move from immobility to mobility, has allowed for online space to interact with material space in unprecedented ways. Smartphones allow us to go online from any place with an internet connection, a fact that is quite amazing after connecting online for years while attached to non-mobile places. By having a device (one we carry with us wherever we go) that is able to interface with the world in a way that transforms our everyday experience of space into an experience of multiplicity, the production of virtual space is with us on seemingly unprecedented levels. This experience of virtuality, it must be noted, extends Deleuze's (and later the work of N. Katherine Hayles) idea that the virtual is a "process of becoming."[12] Instead, the virtual better represents "being-as-becoming." Mobile technologies' impact on the production of space demonstrates how the virtual is always understood as a state of being that is intertwined with a state of becoming. This being-as-becoming is a present-tense experience of embodied space informed by past and future potentials. Essential to this experience of virtual space is the way that the practice of materiality is informed by various modes of representation. Examples from mobile and locative media will demonstrate how the production of embodied space is enacted.

Augmented Reality and Embodied Implacement

One key feature of locative media is the ways in which data can be organized and accessed with site specificity. This site specificity affords users a new window into the meaning of complex data and ideas. The transformation of complex information into manageable visual layouts is the ultimate goal of practitioners of "information visualization." Information visualization is important to the ways that locative media utilize the convergence of material and virtual spaces. One key technology that allows for this organization and display of spatial data is augmented reality (AR). This technology, in essence, superimposes data onto an object (or person) through a mobile device. Whether the interface is eyewear, a vehicle's windshield (as seen in the PNNL project discussed in this book's Introduction), or simply holding a smartphone up to a building to gather information about the site, the meanings of places are augmented by data overlays. This can be utilized for commercial purposes (as is largely the case now with mobile phone AR applications, which are still in their infancy), as seen in the Layar application for the iPhone. Layar activates the phone's camera and, by holding it up to the

surrounding space, users are able to gather information about the stores, activities, real estate, and other site-specific points of interest in the immediate vicinity. These forms of visualization, according to artist Tom Corby, are able to "capitalize on humans' natural ability to spot patterns and relationships in visual fields (cognition). This enables an intuitive identification of structures, which would not be available if presented in purely numeric form."[13]

AR on mobile devices is also being utilized in the arts and the preservation of histories. In 2010, the Museum of London released an iPhone application called Streetmuseum, in which users go to a variety of places around the city that correspond to one of the many historical photographs and paintings in the museum's collection. Users are able to utilize the phone to overlay the historical photographs onto the material landscape. Based on location and the direction you are facing, you are able to juxtapose images from the past with current surroundings. Additionally, users can access information about the image and the historical context. For example, a user can go to the gates of Buckingham Palace and bring up a photo taken in 1914 of the arrest of Emmeline Pankhurst (Figure 2.1). Holding the phone up toward the gates will position the photograph on top of the live image of the space captured through the phone's camera. Tapping on the image offers a caption for the photograph, this one saying, "Emmeline Pankhurst arrested outside Buckingham Palace. Carried past reporters to be taken to Holloway prison, Emmeline shouted 'Arrested at the gates of the Palace. Tell the King'. The arresting officer died two weeks later of heart failure." Pankhurst, one of the leaders of the British suffragette movement, who was arrested on several occasions during protests for the right of women to vote, is here juxtaposed with our present-day context. Similarly, if a user of the Streetmuseum application stands at 23 Queen Victoria Street, the application will bring up an image of the Salvation Army International Headquarters tumbling to the ground soon after the night raid on May 10, 1941, "the most severe attack London had sustained throughout the Blitz," as described by the caption in the application (Figure 2.2).

While the Streetmuseum application has been well received, AR in general at the time of this writing has often been deemed gimmickry. However, AR applications like Streetmusuem demonstrate the ways that mobile technologies are able to imbue space with meaning, thus transforming a space by giving it a sense of place. Additionally, beyond the ability to implace people, mobile technologies are able to offer users new ways of visualizing information.

The transformation of space into place is linked to what Edward Casey calls "implacement." Related to Heidegger's *Dasein* (roughly understood as "being-in-the-world"), implacement locates our situated nature and our sense of proprioception with others and with objects in a space. Implacement serves as the counterpoint to displacement, which "represents the loss of particular places in which their lives were formerly at home." This loss of place is "tantamount to losing one's existence" for many.[14] Embodied implacement gives us the sense of direction in a particular place—direction not only in movement but also in

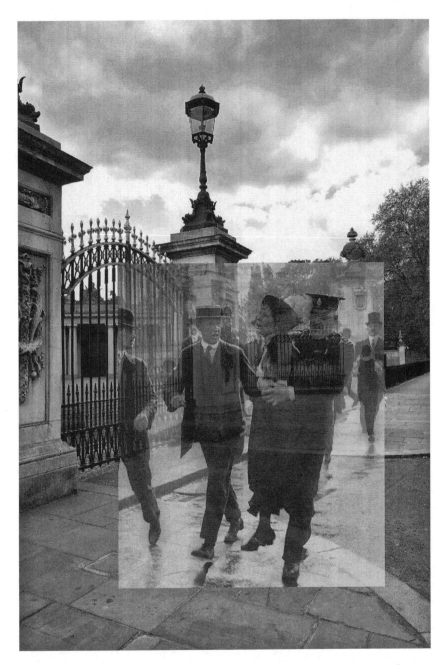

FIGURE 2.1 A screen capture from the iPhone application Streetmuseum, overlaying an image of the arrest of Emmeline Pankhurst at Buckingham Palace in 1914 onto a present-day backdrop.

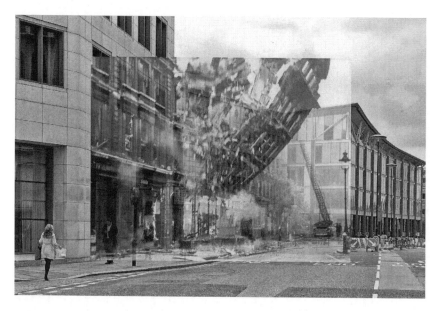

FIGURE 2.2 The Streetmuseum application showing imagery of the Salvation Army International Headquarters crashing to the ground after a night raid during the Blitz.

© 2010, The Museum of London.

purpose. Implacement gives us a sense of embodied integrity in a particular locale and also answers the questions "Which way am I going?" and "What am I doing here?" Implacement offers context for embodied being-in-the-world: "What is my history with this place?" For emerging generations, such questions no longer prioritize between material space and digital space since these spaces simultaneously inform our experience of implacement. Our lived conception of space, especially the online realm, is very much a situated experience always contextually informed.

When we use technologies as a way of developing implacement, the media specificity and materiality of the technology must be a central concern in our analysis. Here, it is important to note that *embodied content* is non-transferable across media and across situations; instead, as we are implaced, we give context to the information we interact with. This information characterizes our environment and our embodied engagement with that space. In other words, accessing information on Wikipedia while at your desk is quite a different experience from accessing the exact same information from a site-specific interaction with a mobile device. One example that remains memorable for me was reading a bit of history about the Oxford martyrs before one of my trips to the UK. I had read some background about Thomas Cranmer, the Archbishop of Canterbury, his work to push through Henry VIII's divorce, and his eventual renunciation of the Pope leading to being burned at the stake. I took a tour of the University Church where Cranmer gave his last sermon and loaded up some of this history on my phone's GeoPedia

application. This app detected my location and I was able to read a bit about what happened during Cranmer's last sermon. The article mentioned that a portion of a pillar had been cut out to create a ledge for a stage on which Cranmer stood. With my phone in hand, I hunted for the cut pillar and located it. Standing where Cranmer stood, I read again about his sermon in which he took back his signed confession that recanted his "heresies" against the Catholic Church. At this spot, he renounced the Pope and said that his hand would be the first to burn for signing the confession that recanted his Protestant beliefs. He was pulled from the pulpit and dragged to Broad Street, where he was burned. While I had read about these events prior to my trip, standing at this spot and making the walk to Broad Street while reading the details on my mobile interface transformed the content. Though the content was identical to what I had encountered at home in the United States, the medium it was delivered through and the site-specificity of the application I was using made the meaning of what I was reading completely different. Both my situation and the medium that informed that situation altered the ultimate meaning of the content. The power of site-specificity to engage us with information in an embodied way has led to a growing interest in finding ways to transform the landscapes around us into information interfaces.

Landscapes as Information Interfaces

In recent years, there has been a major transition in digital culture toward a focus on the importance of location. From location-aware technologies to a renewed interest in the role of proximity in online social interactions, site-specificity has gained a new foothold in the cultural and scholarly imaginary. Landscapes, it can be said, have become information interfaces much like the graphical user interface of a computer screen. The landscape around us can serve as a type of interface where data of all types can reside, from the quotidian rankings of various restaurants to the mobile mapping of crisis zones after a major natural disaster. This notion has recently been literalized in the creation of the N Building in Tokyo. The façade of the 24-story building is a large Quick Response (QR) code, which allows mobile devices to scan the side of the building and gain detailed information about what's going on inside in real time. The QR codes on the building, which can contain larger and more varied characters than a standard UPC barcode, are able to connect to URLs and AR information. When users scan the façade of the N Building, they are able to connect with people's Twitter feeds that are geotagged within the building. Also, stores within the building offer real time information over an AR interface. Here, the notion of a hardscape that is an interface for information is literalized.

Our locale—which should be distinguished from "location" much in the same way that place can be distinguished from space as that which is practiced and specifically contextualized—has always served as a type of information interface long before the advent of digital technologies. Information is communicated about

a space in a variety of ways, most of which are not digital. From street signs to graffiti and from statues to billboards, cities have used the urban landscape as a site of information. Our embodied interaction with a locale offers insights to the meaning of the place and our situatedness there. However, a locale's context is limitedly known and much may remain unknown to us during our interactions with that place. As Derrida has argued,

> But are the conditions of a context ever absolutely determinable? . . . Stating it in the most summary manner possible, I shall try to demonstrate why a context is never absolutely determinable, or rather, why its determination can never be entirely certain or saturated. This structural non-saturation would . . . mark the theoretical inadequacy *of the current concept of context.*[15]

For example, people can often spend most of their lives in a particular place without knowing certain significant facts about that location. Even the events that are known are understood in a limited way. Context, it must also be understood, is ongoing and never settled.

Many site-specific and location-aware technologies are addressing both the desire for further context and the engagement with ongoing contexts so that we may transform locations into locales. Therefore, while AR interfaces may not do anything revolutionary in regards to historicizing a place (people could, for example, simply take the 1914 photograph of Emmeline Pankhurst and hold it up to the gates of Buckingham Palace instead of using a smartphone to do it for them), the major shift here is the implication of the user in the act of defining the site. By utilizing technologies that draw on a person's location through GPS, a user is understood as being situated in relationship to technology and thus experiences the world as a collaboration between digital and material interfaces.[16] While this notion harkens back to many discussions held over the last 15 years about "what's *new* about new media," my brief reply, especially in connection to mobile interfaces, is that our embodied relationship to these interfaces uniquely structures our experience (and thus conception) of the world around us. Therefore, while holding a photograph of Pankhurst up to Buckingham Palace is one experience of that place, using the exact same photograph in the exact same place but on a digital interface like an iPhone will be an altogether different embodied experience. The same is true of reading a print newspaper and the exact same content but on a mobile device. To reiterate, the embodied experience of content is non-transferable across media. Instead, by investigating the media specificity of our engagement with cultural objects, we can see that interfaces shape our embodied engagement with space and the ways we practice space as a lived place. This extends Lev Manovich's distinction between media and "new" media: "All existing media are translated into numerical data accessible for the computer. The result: graphics, moving images, sounds, shapes, spaces, and texts become computable, that is, simply sets of computer data. In short, media become new media."[17] Thus, the transformation of our cultural

objects into binary data, such as a photograph of a significant event in front of Buckingham Palace, also transforms our embodied engagement with these objects. Here, the "sensory-inscribed" mode of embodiment developed in the previous chapter again becomes significant. Our experience of place through mobile technologies is at once a phenomenological engagement with this particular medium and a mode of reading the significance of that mode of engagement. Our bodies sense the world as a collaboration between material and digital spaces while simultaneously interacting with the cultural inscriptions written into the experience, such as the privacy implications of disclosing your location to businesses and other users.

Maps and Mobile Media Space

The correspondence between the material world and digital media indeed has many predecessors. An extensively practiced form of this mode of engagement is navigating a place using a map. From print media representations of place, to words scrawled on a scrap piece of paper noting landmarks, to GPS navigation systems, our traversal of space has long been understood as the correspondence between the material world and the ways we represent that world. We rely on maps to offer us an external visualization of our internal sense of proprioception. Maps give us a sense of where we are in relationship to the places around us. As Paul Jahshan notes in his book *Cybermapping and the Writing of Myth*, while cyberspace is a place people inhabit, we must still contend with bearings and thus "the problem of mapping is unavoidable."[18] Such a problem becomes unavoidable because our ability to traverse space in a meaningful way is inherently tied to the mode of representation that constructs that space. The mobile map in its many instantiations is thus a key example of how representations of space in mobile technologies inform conceptions of—and interactions with—pervasive computing space.

Mobile maps, however, are very culturally situated and various maps of the same location offer us a very different sense of implacement. A famous example of this type of relationship between representation of space and conception of space is seen in the difference between Mercator's 1569 map of the globe and the Gall-Peters Projection Map published in 1973. In the Mercator projection, used for nautical navigation, continents like Africa appear smaller in landmass than those closer to the poles, like Greenland. The Gall-Peters map sought to address this discrepancy by making a map that better visualized the landmass of each of the continents. The Gall-Peters map sought to amend the ideologies that were inherent in the representation of global space in the Mercator map. Mercator's map projection came to be a visualization of Western supremacy by emphasizing the size and location of Europe. An everyday example for the mobile age is seen in the distinction between the overhead/aerial view of a map and the street view offered in maps such as Google and Bing. The point of view offered by these maps engages the user along a spectrum from "disembodied voyeur" to "situated

subject." Taken one step further, location-aware devices that can pinpoint a user's location on a map and trace his or her movements through space offer a unique representation of being in a space. By distinguishing between the ideologies behind the disembodied voyeurism of the satellite view and the situated nature of the street view, both maps offer a very particular ideological stake in the status of bodies in the digital age.

The interface of each of these maps is indeed mobile—they are each designed to be portable and to function while moving through space. While print maps may have not confused the distinction between material space and its representation, the mobile interface offers us a distinctly fluid relationship between space and representations of space. In other words, we are living in a time in which the two realms of the realized and the realizing (or the actual and the virtual) do not signify themselves as exclusive spaces; instead, the interaction between these spaces continues to become mutually constructive. The reason for this transition is that the media specificity of mobile devices embodies us in a very particular way in space. The very practice of embodied space is becoming entirely reliant on the seamless interaction between our devices and our landscapes. The representation of space is not outside of the lived experience of that space. It is instead entirely incorporated into the production of embodied space. We have thus moved beyond the theorization of our mobile devices as a type of prosthetic to our bodies—an extension of ourselves out into the material world—but instead have to conceive of our devices as absolutely integral to the very foundations of embodied space in the digital age. As Jean Baudrillard noted, "The territory no longer precedes the map, nor does it survive it."[19]

Yet, our interactions with maps often avoid the critique that we typically give other forms of representation. This is especially true with mobile maps since, as representations, they so closely mirror the material landscape we are navigating in real time. As Raymond B. Craib argues, drawing from Baudrillard's quote above, "Jean Baudrillard's choice of the map as an example is highly appropriate—no other image has enjoyed such prestige of neutrality and objectivity . . . The most oppressive and dangerous of all cultural artifacts may be the ones so naturalized and presumably commonsensical as to avoid critique."[20] Thus, we tend to interact with our mobile maps without interrogating their mode of representation and the consequences. Users of maps employ them because they are reliable and only when they fail us does their interrogation come to the fore.

Another key distinction between pre-digital maps and current mobile maps is the ways in which users are able to contribute to and alter maps. User-generated content is one of the defining features of Web 2.0, and maps have also incorporated user data, imagery, and information to create new notions of spatial mapping. This is especially seen in many locative art projects that investigate this relationship between space and cartography. As Drew Hemment notes, "Digital mapping is at the core of many locative projects," in which artists explore modes of representing embodied movements through cartography. He specifically draws on examples

like Esther Polak's *Amsterdam Realtime*, in which "participants roamed the streets of Amsterdam equipped with networked GPS devices, and traces of their movements were relayed to a projection screen in an exhibition space."[21] The project demonstrates collaborative cartography that is deeply connected to users' bodies and their movements through everyday space. Here, mobile devices show the lived space of the city through the bodies navigating through space. Such a map can serve to represent the lived and embodied nature of that space. Another key example of this mode of mobile cartography is Christian Nold's *Biomapping* project. *Biomapping* offers a perfect example of the representation of space working in collaboration with mobile technologies and information visualization. The project, which began in 2004 and has thus far taken place in four cities including San Francisco, Paris, Greenwich, and Stockport, equips participants with a mobile device similar to the technology used on a polygraph machine that tracks their galvanic skin response (GSR), logs their GPS coordinates, and allows them to annotate their locations as they navigate the city on foot. As they walk, their stress is visualized on a map, with each person represented by a different color wall that traces their movement and shows the spikes when they experience heightened physical encounters (Figure 2.3). In his article on the uses of information visualization in the arts, Tom Corby nicely summarizes the procedures behind *Biomapping*:

> As part of the University of Westminster exhibition, self-selecting student volunteers were introduced to the project in a workshop situation. Each was fitted with a device and sent out on an hour-long walk of the university and

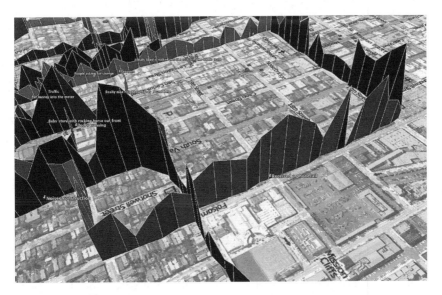

FIGURE 2.3 Christian Nold's San Francisco *Biomapping* project, showing the visualization of people's emotions as they walk through the city.

its immediate environs, which includes a hospital and a densely built-up urban environment. While this was happening each student's changing location and level of arousal were sampled every 4 seconds by the device and the data downloaded to a memory chip. This information was then fed into Google Earth and visualized as three-dimensional forms to produce, what Nold calls, an "emotion map" of the area.[22]

As they moved (and even after the fact upon reviewing their map) participants were able to tag certain locations they note as high stress or high stimulation areas. In San Francisco, for example, a participant tagged an area with, "Noticed an ambulance and decided to follow," which is then followed by the tag, "Could see the guy on the stretcher." As Chris Perkins writes about the project, "There is a relationship between GSR response and emotional arousal: anger, being startled, fear and sexual feelings can all produce similar responses. Using this system it is possible to construct individual tracks and display the ridges and troughs of emotion on a map. Results can be merged into composite maps reflecting wider social responses."[23] Corby develops the consequences of user-generated mapping and annotations in *Biomapping*:

> These conversations allowed a number of interesting outputs to accrue. For example, consensual interpretive processes allow participants a deeper purchase on ownership of their data. By taking analysis and information-gathering out of the hands of experts, persons normally considered as "subjects" of study are enabled to construct understanding of results in any way they see fit. Thus, the work provides an alternative to institutionally directed visualization practices that is rooted in what Nold has described as social or "bottom-up" data gathering.[24]

In *Biomapping*, the stark contrast between the aerial map and the visualizations of the participants' emotions demonstrates the equally harsh juxtaposition between the indexicality of the map (especially one that utilizes satellite or aerial photographs) and the notion that maps are ultimately lived and changing representations. Returning to Craib's argument that maps are so commonsensical that they avoid critique, the notion that a photograph, particularly a map that utilizes a photograph, could be wrong is easily dismissed by many. Here, satellite imagery, since it is removed from a human agent that takes the photograph, is often deemed as an accurate representation of a place at a particular moment in time. As I have argued elsewhere, though photographs have undergone scrutiny in the digital age, and their reliability as indices of reality is continually questioned (since photographs can be so easily manipulated with digital technologies), the satellite map has not undergone equal scrutiny.[25] Instead, maps are seen as static representations of reality. One key reason for this is that the technologies used to capture map images like these are disembodied technologies, such as the satellite which does its work

silently in our orbit without being manned or without a hand snapping the shutter closed. Because of the satellite's automation, there is no human subject implicated in the act of taking the photograph. The disembodiment associated with this mode of representation makes it seem more reliable, since human error or manipulation isn't woven into the process of creation. This false imaginary associated with satellite mapping is undone in Nold's *Biomapping*. What we are given in conjunction with the satellite map is a visualization of human movement throughout the mapped space, thus demonstrating that the space itself is constructed by human movement, not by disembodied technologies.

Our sensory-inscribed experiences of geographic space are always informed by the ways we represent that space. Here, *Biomapping* gives a representation of what it means to be a pedestrian in a crowded urban environment. We can immediately associate the city with the process of being embodied by the space. The map in Nold's project represents a lived locale, the practice of space that transforms it into lived place. These representations go far in dismantling the separation of the sensory body in space and the cultural inscriptions of that space. The map and the body are unified in a sensory-inscribed experience of the urban space.

The fact that *Biomapping* utilizes mobile technologies as its primary interface is significant in transforming the site of the map into a sensory-inscribed mode of implacement. The collaboration between the mobile device and GPS satellites positions the human body within space, yet it is the experience of that space coupled with a reading of the location that imparts meaning to the space. To elaborate, the act of walking through San Francisco offers one mode of sensory-inscribed engagement; to walk through the city with a mobile device provides further levels of implacement and signification. That is, while using a mobile device to trace my exact movements through a city and chart my emotional state, I experience my body in the city as being inscribed by the technologies that locate me. With these technologies, users are able to precisely know their location in space and time through GPS satellites. Simultaneously, users have to contend with the fact that they are being surveilled constantly, not only by the satellites but also by the people monitoring their emotional state through the GSR device and by passersby who inscribe the user's interactions with the mobile devices with certain significance (usually trying to "read" what you're doing and why you're there). This mode of sensory-inscribed engagement is very pronounced when people engage in location-based games, which I discuss in detail in the next chapter.

Another striking art project that works to redefine the uses of maps and representations of space is Paula Levine's *San Francisco ↔ Baghdad,* which is part of her series *Shadows from Another Place* (see Figure 2.4). This project overlays a map of the city of Baghdad onto a map of San Francisco and, at each place where a bombing occurred in Baghdad, Levine maps corresponding points onto coordinates in San Francisco. Once these corresponding nodes have been created, Levine places a geocache container at each location. Her goal, one that resonates throughout her work as a whole, is to make the foreign something that is familiar. She

writes, "Collapsing 'foreign' and 'domestic', these maps bridge local and global, and allow walkers/viewers to experience spatial and narrative contiguity between separate and distant locations."[26] This interplay between maps is drawn from the work in psychogeography by the Situationist International (SI), especially in the work of Guy Debord. Debord would encourage a wandering throughout the city (or, *dérive*), in which a wanderer would use a map from one city as the guide for another. The disjunction between the two would "contribute to clarifying certain wanderings that express not subordination to randomness but total *insubordination* to habitual influences."[27] Debord continues: "A friend recently told me that he had just wandered through the Harz region of Germany while blindly following the directions of a map of London. This sort of game is obviously only a feeble beginning in comparison to the complete creation of architecture and urbanism that will someday be within the power of everyone."[28] This reimagining of the relationship between wandering the city and the representation of the city space allowed for new embodied relationships to form between the wanderer and the urban landscape. As Mary Flanagan notes, "One of the significant intentions behind psychogeography, as Debord described it, was to be *mindful* of space in the method's open-ended, deliberately vague mission of encouraging people to explore their environment, usually the streets of the city."[29] This mindfulness serves as a resistance for the inscriptions written into urban planning and design. Instead of following predetermined paths, which create predetermined relationships as prescribed bodies in space, the work of psychogeography seeks to find strategies to reimagine our relationship to urban space.

Levine's *San Francisco ↔ Baghdad* project, while offering a new mindfulness of the city, simultaneously subverts the militaristic foundations of GPS. By using a tool created by the United States military to critique the military, Levine's work allows participants to reimagine the uses of mobile and locative technologies and the ways we understand our representations of place. By mapping the city of Baghdad onto San Francisco using a mobile device, people engage the tension between embodied space and the tools used to signify place. Engaging this project also forces users to participate in an embodied way with the historical conflict between maps and empire. Here, subverting the map by using the very technologies designed by the power structures that typically draw the map, the grounded nature of the map as a static signifier comes into question. As Matthew Edney has argued in *Mapping an Empire*, "Imperialism and mapmaking intersect in the most basic manner. Both are fundamentally concerned with territory and knowledge." He continues by noting that the "maps came to define the empire itself, to give it territorial integrity and its basic existence. The empire exists because it can be mapped, the meaning of empire is inscribed into each map."[30] In Levine's project, the map critiques the imperial agendas of the war in Iraq instead of reinforcing the power structures behind the map.

As seen in projects like *San Francisco ↔ Baghdad*, *Biomapping*, and *Amsterdam Realtime*, there are obvious correlations between representations of space and

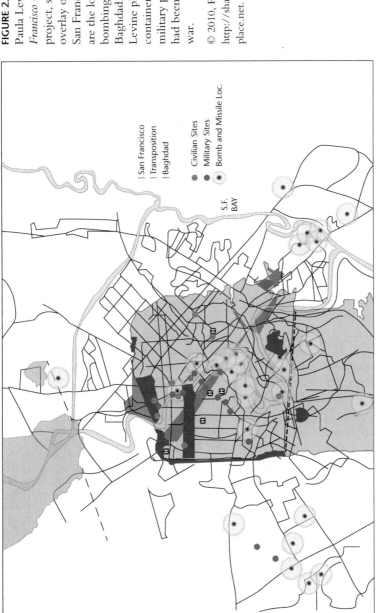

FIGURE 2.4 The map of Paula Levine's *San Francisco ↔ Baghdad* project, showing the overlay of Baghdad onto San Francisco. The dots are the locations of bombing sites in Baghdad. At these sites, Levine placed a geocache container with a list of military personnel who had been killed in the war.

© 2010, Paula Levine, http://shadowsfromanother-place.net.

power structures. Maps are not simply representations of ontological reality; instead, they signify space in a very particular way that is designed to be read to fit with the current cultural hegemony. With mobile technologies, the ways that space is represented is a practice of lived space. The movement through space and the collaboration between material environment and representations of that environment inform an embodied meaning of space.

What these projects also demonstrate is that our experience of space is inherently tied to intersubjective modes of embodiment. Space is not only an individually lived experience but is always produced as a social experience. The sensory-inscribed body is developed out of a reciprocity that embodies the self as spatially related to others and also as inscribed as a particular body by others (as the self also inscribes the spaces and bodies around him or her). In fact, many of these spatial visualizations only find their true nexus when used by a community for a collective revisioning of lived space. Thus, there is a need for mobile mapping projects to move beyond the individual-centered design and begin to imagine the space of the mobile interface as a site for collaboration. Liqiu Meng, for instance, argues that "In mobile usage context, however, a geocentric map can hardly remain usable due to the following reasons: What a large target group needs is often much more than what is necessary for an individual user."[31] To streamline the design and usability of a mobile map, it seems, it must be tailored for the individual. Again, such an approach prioritizes the mobile interface as designed for an individual and not as a community space. While this is understandable given the size and common usages of the mobile interface, such a statement overlooks the important ways that mobile devices and mobile maps can engage a community and become a space of dialog.

For example, when a massive earthquake hit the island country of Haiti in January of 2010, most emergency response organizations were unable to navigate through the destroyed landscape, since many of the roads in the area had not been adequately mapped by major mapping distributors like Google. The cartographers using the crowdsourced mapping tool Open Street Map responded to the need for emergency organizations to have maps that were not only accurate of the area (many roads, for example, were either not mapped, mapped incorrectly, or were no longer there) but could also be tailored to this situation. At that time, there were nearly 200,000 cartographers contributing to the Open Street Map project, many of whom worked directly with the Haiti earthquake crisis.[32] The use of mobile phones for the mapping process after the earthquake allowed for rapid crowdsourcing of various information. For example, people would send Ushahidi, a volunteer organization that responds to global crises through digital technologies, a text message about emergencies and the status of roads. Ushahidi volunteers would then translate that information into visualizations on the Open Street Map of Haiti. One thing that is remarkable about this crowdsourced mapping project is how the stream of information involved people across vast geographical distances in a visualization of Haiti. The typical trajectory of one of the emergency SMS

messages looked something like this: an SMS message is sent to Ushahidi's emergency number, 4636, that says, "I am with someone who was hit in the head. They pass out from time to time. Where can I find a neurologist? He's in Delmas 44, by the church Altagrace, which is across from the Texaco and the market Monsieur Henri."[33] This message, however, was sent in Creole to the Ushahidi volunteers in Boston (none of whom spoke the language). Thus, Ushahidi mobilized many volunteers from the Haitian diaspora to translate the text message from Creole to English, to help categorize and rank the emergency, and to help locate the emergency on the map based on their knowledge of their homeland. The translated text would be sent back to Ushahidi, who would then send it on to the appropriate response groups such as the Red Cross or the Coast Guard.

As crowdsourced maps continue to emerge using mobile devices, it becomes evident that the mobile interface can become a collaborative space. Here, users can work together to create mobile representations that inform the lived space they traverse. In doing so, the digital space of the mobile device corresponds and permeates material space in meaningful ways. Likewise, as those identified as part of the Haitian diaspora, through interacting with these emergency maps, they are able to identify with a community that is geographically distant from them. They re-embody their former homeland, and by remembering the spatial relationships between landmarks, they can help create a visualization of the area that will help those on the ground in Haiti bring emergency relief to those in need. Here, we see that the phenomenologies of the imagination serve to embody our relationship to a place we consider home, no matter how distant, as well as link our body to the body of the community.

Producing Information Landscapes

Our representations of place using mobile media demonstrate the ways that mobile interfaces are transforming the information landscape around us. Our interactions with the landscape as an information interface is still in its infancy; however, some technologies are pointing the way to what future instantiations of mobile technologies could look like. Recently, I had my graduate seminar make a collaborative map showing all of the surveillance cameras on our campus at the University of Maryland. They formed four groups and split the campus into quadrants. Most of the students in the class had never created or altered a map before, so I hoped that the processes of cartography would provide them with a different embodied relationship with a space they perceive as commonplace. As the students began compiling their images with location data and camera type, I was (somewhat foolishly) shocked at the number of cameras on our campus. Pulling back to take in all of the pinpoints layered on top of the digital campus map offered a very different visualization of the space of our university. The assignment was designed to allow students visualize the space they move through on a daily basis in a different way and thus transform their very sense of embodiment in that space.

The production of this map by this group of students provided a clear example of the sensory-inscribed body: by inscribing the space as a space of inscription (through surveillance), their sensory perceptions collaborated with the various modes of inscription that are involved in the production of embodied space.

The students' responses were varying and fascinating. One student's reaction was similar to the many frustrations people feel about the age of participatory surveillance we are living in (a topic that I will cover in the next chapter). She said, "Though we are mapping these cameras, they don't necessarily represent the current threats to privacy with so much data surveillance, personal information on Facebook, and everyone having a camera in their pocket on their cell phone. It worries me because I feel helpless trying to identify where the power structure is located these days." Another student noted how odd it felt to take a picture of another camera, especially how that act was "read." This moment for her was very much a sensory-inscribed moment of watching the self being watched and documenting that process. This sensory-inscribed experience was heightened when she and another student decided to go into the bank on campus and take pictures of all of the surveillance cameras inside. This led to another student coming to the realization about what the cameras were being used for in the first place:

> While the cameras are being placed under the guise of protecting people on campus, they aren't there to protect us. They are there to protect the University's assets and infrastructure. When we decided to see what the cameras were actually looking at, we noticed that they were focused on areas of the campus with a large number of computers or highly sensitive research equipment.

For the student, this realization transformed his conception of the campus as a surveilled space: it wasn't necessarily the disciplinary structure that Foucault described as a means to create citizen subjects, but instead becomes about protection of assets. The embodied relationship to this space emerges, therefore, as always in relationship to commodities. Bodies are not of worth in the lens of these cameras; instead, bodies can only be potential threats to the assets of the university.

These moments exemplify the transformations that can take place through interactions of sensory-inscribed bodies with mapping technologies. Whether it be discovering the purposes of surveillance cameras by mapping them, connecting a historical image and moment to our current experience of that location, or the community mapping of a city (such as the emotion maps of San Francisco or the crisis maps of Haiti), the ways we experience these spaces has everything to do with the representations we interact with of those spaces. Developing information landscapes—especially spaces we can collaborate in and contribute to—demonstrates that context is never grounded, but is instead lived, ongoing, and enacted. The role of these context-rich environments in transforming landscapes

into information interfaces also demonstrates the role these visualizations play in our experience of community space as sensory-inscribed. This phenomenology and cultural inscription of community space is elaborated in the next chapter, in which I investigate the role of the sensory-inscribed body in location-based social media.

3

LOCATIVE INTERFACES AND SOCIAL MEDIA

The contemporary era of computing is social. However, the social practices in the digital world don't always translate well into face-to-face encounters. As Pattie Maes notes, when you first meet a new person in a face-to-face interaction, "You don't shake somebody's hand and then say, 'Can you hold on for a moment while I take out my phone and Google you?' "[1] Maes, who is a professor in MIT's Media Arts and Science Program, has sought to develop technologies that are both social and context-aware to address the gap between how we interact with each other in digital spaces and how we interact in everyday, face-to-face encounters. Her solution, which was developed with several graduate students led by Pranav Mistry, is called SixthSense. SixthSense is a gesture-based mobile technology that is worn around the neck and looks like a pendant. It is comprised of a camera and a battery-powered projection unit. It interacts with the environment and with other people through prescribed gestures such as holding your fingers in front of you in a square, which instructs the device to take a picture. These pictures can then be projected onto any surface and interacted with. The device also responds to each user individually. For example, when a user picks up a book at the store and looks at the cover, SixthSense recognizes the cover from an image database and then draws on user reviews of the book to then project an overall rating that is customized to each user's tastes and preferences. Addressing Maes' concern that we wouldn't pull out our smartphone to Google someone in front of them, SixthSense is also able to detect the person you are interacting with and project a word cloud onto them that gives their name and a variety of words that characterize them (Figure 3.1). These can be words that the person decides ahead of time or can even be their latest updates on a social networking site. Similar to the landscapes that are transformed into information interfaces as discussed in the previous chapter, here, the human body becomes inscribed (quite literally) as a surface and becomes an

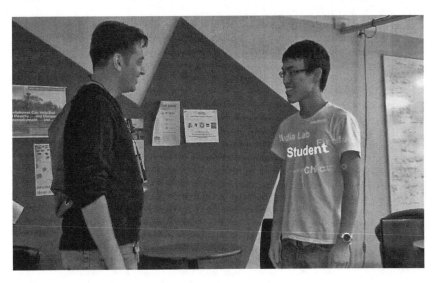

FIGURE 3.1 SixthSense technology worn by Pranav Mistry (left) detects the person he is speaking with and projects a word cloud onto the person of various terms they would use to characterize themselves.

Image © Pranav Mistry, MIT Media Lab.

information interface. This form of embodied inscription shows clearly the ways that the material world, including our bodies, can become (and, arguably, always were) information interfaces, revealing data that more fully informs the phenomenological engagement with the material world.

This particular use of the SixthSense technology demonstrates the current trajectories of social media. People are continually making themselves visible within networks that function as inscribed and inscribing social spaces. One critical characteristic of this visibility is the disclosure of location to a person's social network. While the SixthSense technology is context aware, one of the main elements of this mode of context-awareness is a participant's site-specificity and all the ways that a particular location can signify. In essence, emerging forms of social media are utilizing a person's location as the primary descriptor of that participant. By informing their social network of their location as they move about their everyday lives, users of locative social media are relying on the fact that location says something about their identity. I began using locative social media as soon as I purchased my first smartphone, and, after building a network of my friends and colleagues, I practiced the disclosure of location as a means of communicating the fabric of my everyday life (and as a means to broadcast the unique moments that were extra-ordinary). Tracing my use of locative social media in 2010, I noticed that for several weeks my "check in" pattern with locative social media only revealed a few places: my university, the grocery store, and a couple of restaurants.

(Unlike several of my students, I never disclosed the location of my home.) Then, in August of that year, I made a cross-country drive across the United States, broadcasting my location to my network as I traveled. This served as a means of mapping and chronicling the journey, but it also importantly served as a means to interact with my network of friends and colleagues during an important trip in which location served as the defining characteristic of my social interactions.

As location becomes a core area of focus due to the emerging practices of mobile media, and as we begin exploring the production of embodied space on mobile networks, it is essential to identify the social quality of space that characterizes our interactions. The social quality of space is inherently intersubjective, and while communications media imply some form of social interaction, the site-specificity of these connections using mobile technologies force us to reexamine the nature and status of proximity and intimacy. The reason mobile technologies force this reexamination is that online social networks have been fostering a sense of place and intimacy for several decades; yet, with the advent of location-based social networks, have we become more intimate? Does the inscription of site-specificity onto an online social interaction give it a quality that was previously lacking in the immensely popular social networks that began in the early 2000s?

The sensory-inscribed body that I have established in the previous chapters is, at the core, a socially inscribed body. Our social relationships serve to not only give us a sense of spatial and sensory understanding of our role within a given space, but also ultimately implicate us in a feedback loop of socio-cultural inscriptions (e.g., insider or outsider, friend or enemy, citizen or terrorist, to name a few). As I argued in the previous chapters, embodied connections can and do take place across digital networks that aren't reliant on any shared geographic space. So, the question remains: Do locative social media offer us a new form of intersubjectivity by reasserting the importance of spatial proximity? Do my connections using these location-aware media offer a distinct social quality than the connections made on non-mobile social networks? Throughout this chapter, my analysis of locative social media will illuminate an essential interplay of embodied practices within digital social networks: reciprocity and otherness. The production of social space as exemplified in locative social media, is founded on the sensory-inscription of reciprocity between individuals acknowledging each other in the network as well as reciprocity between participants and interfaces (especially haptic and gestural interfaces). Simultaneously, these forms of reciprocity force an interrogation into the status of the other and practices of alterity—a core concern for the effective theorization of phenomenology. Subsequently, by detailing the defining characteristics of the interface, I point to how this nexus of social relations serves to produce the embodied spaces through which we connect. The issues developed around the location-aware interface bring up the final point that I explore in this chapter: practices of visibility and participatory surveillance. Ultimately, the embodied space of locative social media prompts an interrogation into the practices of surveillance and the status of the public/private opposition.

The Rise of Social Computing

In 2011, at the time of this writing, the top 10 most visited websites globally included four social media sites: Facebook, YouTube, Blogger, and Twitter. The other six sites in this list included companies that each had some form of social media incorporated into their business model (such as Yahoo's Flickr photo sharing site). Social networking websites have drawn top traffic globally since the early 2000s, with the launch of sites like Friendster in 2002 and MySpace in 2003. Since the inception of online social networks, there has been a trend to migrate from one social network to the next, as seen in the massive transition from MySpace to Facebook in 2006, when Facebook opened up registration to people outside the previously delineated networks (such as colleges and high schools). Subsequently, the membership and site visits to MySpace began to dwindle significantly, with a drop from 73% of online social networkers utilizing MySpace in April 2008 to only 23% in April 2009.[2] This trend was apparent as soon as Facebook began opening its gates. A 2006 *Washington Post* article discussing online social networks quoted a high school student from the United States, whose thoughts on MySpace were: "I think it's definitely going down—a lot of my friends have deleted their MySpaces and are more into Facebook now."[3] The *Post* article goes on to note that "Within several months' time, a site can garner tens of millions of users who, just as quickly, might flock to the next place, making it hard for corporate America to make lasting investments in whatever's hot now."[4] While the study of online social networks has been, to some, simply the study of pop culture trends, an analysis of the process of migration from one social network to another, with the recent movement to location-based social media, offers an important understanding of how digital communities practice forms of reciprocity and discovery through intersubjective relationships with otherness. When reciprocity is lacking (either from others or from the interface), there is an indeterminacy of embodied space and, until reciprocal relationships are restored, the production of digital, social space wanes.

One of the first forms of digital social networking was the computerized Bulletin Board System (BBS). An early version was called Community Memory, which was started in 1972 and was placed around laundromats, record stores, and public locations in San Francisco, California. The computer terminals allowed anyone to log in and place a bulletin posting on the system. While initially conceived as a way to connect the various people and places in the community to social organizations and the trading and selling of items (the way a traditional bulletin board might work), it soon became a tool for the community to create art, literature, and social commentary.[5]

Later on in the 1970s, text-based videogames (such as *Zork* in 1977) inspired the creation of the first "Multi User Dungeons" (MUDs). In 1978, Roy Trubshaw designed the first MUD, which was "originally little more than a series of interconnected locations where you could move and chat."[6] These became the precursor to today's text-based chat rooms and soon developed into MOOs (MUD,

Object Oriented). The MOO, through the development of object-oriented programming, allowed users to co-construct their social space within the network. These spaces were fundamentally social and embodied. One of the more famous discussions of the intense embodiment experienced by users in a MOO is chronicled by Julian Dibbell in his article "A Rape in Cyberspace," about an incident taking place in LambdaMOO.[7]

These social networks developed into Usenet sites, forums, and eventually online sites like Craigslist and Classmates (both launched in 1996). Blogging sites, like LiveJournal, launched in 1999 and encouraged users to create groups and interact with each other's content. That same year, social online gaming took off with the launch of *EverQuest* (which built on the Massively Multiplayer Online Role Playing Game genre, or MMORPG, started with *Ultima Online* in 1997). MMORPGs have continued to gain immense popularity, with *World of Warcraft* currently having over 12 million monthly subscribers. Taking a similar tack as MMORPGs to the design of 3D virtual worlds for social interaction, Second Life was created in 2003 to provide virtual spaces for people to interact through avatars. While there are roughly 18 million registered accounts, in a given month, around 800,000 repeat users log in. Unlike the "affinity spaces" that are focused around a communal activity (such as the raids carried out in *World of Warcraft*), Second Life is considered to be a virtual world that is characterized by social interaction, building, and commerce.[8] Emerging around the same time as Second Life, and in contrast to the spatial architecture of these virtual worlds, were the major online social networks that are typically associated with the term, including Friendster (2002), MySpace (2003), and Facebook (2004). Subsequently, a number of other types of social media have emerged, including music listening networks like Last.fm, photography social networks like Flickr, and video networks like YouTube.

To reiterate: the contemporary era of computing is social. While many of the sites discussed here may seem to address current online trends (and once those trends become outdated and are replaced, the social network becomes obsolete), the intrinsic nature of these sites is the creation of a sense of shared space through embodied practices. Thus, in order to embody a space, one must feel a sense of reciprocity within that space. And while most of these sites engage users in reciprocal relationships across vast geographic distances, the emerging form of social media is shifting that paradigm to instead focus on social proximity. Early examples of location-based social networks range from Dodgeball (2000), Loopt (2006), Gowalla (2007), Foursquare (2009), and MyTown (2009). Each of these social media prompt users to check in to locations they visit throughout the day, sharing this information with their network. Users also typically receive incentives for checking in, including points, badges, mayorships of locations they check into more than anyone else, and, in the case of MyTown, users get virtual cash to purchase locations in-game (Monopoly style) and charge rent on them. Participation in these locative social networks is currently small, with a 2010 Pew Internet Study showing only 4% of mobile users engaging with locative social media[9] and a *New York Times*

article noting that only 11% of mobile users participate in these networks.[10] While location-based social networks are only beginning to take hold, it is becoming an increasingly popular form of social networking. The sense of place that users have historically created in online social networks is here infused with the site-specificity of the locations that a user frequents. The sense of space that is produced in social media, and its intrinsic connection to embodied movement, here becomes physical. Locative social media are instead developed out of site-specificity. By engaging the body at the axis of material and digital space, the process of engaging the network as a spatial site becomes a defining characteristic of the social interactions on the network.

The emergence of location-based social networks illuminates some important notions about this mode of social media that distinguishes it from previous online instantiations. In terms of sensory-inscribed bodies, locative social media, by emphasizing site-specificity, reiterate that alterity and otherness are keys to our sense of implacement. In other words, while intersubjectivity is essential to the production of embodied space across the network, it also clearly serves to show that, while we can both exist in proximity, the self and the other are always distinct. Though they are constitutive of each other in the same way that bodies and spaces are co-produced, those places are never identical. To balance this notion, we must also take into account that the acknowledgment of one another in these spaces is a fundamental component of embodiment. Thus, we must be acknowledged by others and by objects (such as the interface, the network, and the GPS satellites) to fully embody the space. Entering into a constitutive relationship with others and objects can also pose a threat to the subject, since many of these networks seek to commodify the user's position and movement across space. This commodification threatens to turn the user into another object within the network, finding value only in the accumulation of a user's movements, locations, and habits (a topic I cover in greater detail at the end of this chapter in my discussion of the public/private opposition). Increasingly, as we engage each other through mobile media interfaces, the interface itself becomes a site for interactions with objects—including advertisements that are site- and interest-specific. In this convergence between users and the individually tailored ads on the interface, the sensory-inscribed interactions must account for the various spatial, social, and exchange relationships that take form in this meaningful site of social exchange.

Theorizing the Interface

The interface that serves as the nexus of these complex interactions is foundational for the production of embodied space in locative media. Yet, we often use the interface without asking ourselves: What is an interface? What are the defining features of this site of social interaction? Thus, before I continue my analysis of the intersubjective relationships developed through locative social media, it is vital to expand on my theory of the interface. We use the term "interface" very broadly

across a range of media and experiences. As I have used the term throughout the book thus far, it has invoked ideas of a medium through which we connect to each other or to data of some kind. Yet, this needs a great deal of refinement. My definitions of the interface sides closely with Johanna Drucker's idea that the interface "is the mediating environment that makes the experience, a 'critical zone that constitutes a user experience'."[11] These critical zones of user experience often get described in metaphorical terms: windows, doorways, gateways, and thresholds. Yet, there are potential flaws to the implementation of these metaphors when theorizing the interface. As Alexander R. Galloway questions:

> The doorway/window/threshold definition is so prevalent today that interfaces are often taken to be synonymous with media themselves. But what would it mean to say that "interface" and "media" are two names for the same thing? The answer is found in the *layer model*, wherein media are essentially nothing but formal containers housing other pieces of media . . . Like the layers of an onion, one format encircles another, and it is media all the way down.[12]

Following Galloway's argument, do interfaces lead us to connections with each other or do they simply recycle the process of connection as we repeatedly connect with other forms of media? In my estimation, if interfaces are to be defined and experienced as spatial, then they imply an embodied production of space. We do produce significant embodiment with the objects we interact with such as media. The argument that Galloway is making instead suggests that our connections to media are simply interactions with containers that have no core. In this view, interfaces are possibly frames that simply serve to frame other frames. The primary flaw with this perspective is that it assumes that a medium and its content are discrete elements that are separable from one another. Instead, contact with a medium is contact with content of some form (and not simply a connection to a medium-as-content).

However, the idea of interface cannot be reduced to its medium or to its content. It is both and it is neither: if an interface can be defined as a set of relations that serve as the nexus of the embodied production of social space, then the medium (here, a mobile device or a locative application) plays only one part in the larger schema of the interface. Similarly, the content (broadcasting my location to my friends and colleagues) only plays a part. These are indelibly connected to each other and to the larger schema of social relations that define the practices of the mobile interface.

Jef Raskin provides a compelling example of this embodied, social schema of the interface in his book *The Humane Interface*. He points to the interface of a car, which includes the steering system, speed and fuel gauges, mirrors, the accelerator and brake, among a host of other elements. It also includes the windshield and the external media that alter the uses of the car's interface. For example, as a driver

approaches an intersection, the body of the driver is connected to the car's interface on several levels: the responsiveness of the gas and brakes, how the potholes in the street affect steering and the speed the driver will use, and how the light changing to red will inform the timing of pressing on the brakes and how hard. Raskin asks us to then imagine if the placement of the accelerator and brake were reversed. Perhaps we would be able to drive fine for a couple of blocks (more than likely, he says, we would not even make it out of our driveway), but soon our habits would kick in and we would revert back to our muscle memory of where the gas and brakes are as we have practiced (to the point where interacting with the interface has become a part of our cognitive unconscious). Raskin writes, "As soon as your locus of attention is pulled away from the novel arrangement—for example, if a child runs into the street—your habitual reaction will make you stomp on the wrong pedal . . . I emphasize that you cannot undo a habit by any single act of willpower; only a time-consuming training process can undo a habit."[13] Raskin uses this example to point to two important facts about the interface: 1) it is less an object than it is a set of relations and 2) the relations that define the interface are habituated. To put it another way, the interface is produced through a sensory-inscribed body. The interface is deeply connected to our experiences of embodiment and how embodied practices get inscribed through cultural forces and habits.

The interface extends beyond this model to also include object-to-object interfaces, thus extending beyond the idea of the human–computer interface. Interfaces can be understood as "significant surfaces" according to Vilém Flusser, "meaning a two-dimensional plane with meaning embedded in it or delivered through it."[14] Along this plane, two objects can interface with one another to exchange data. This model most closely relates to the original usage of the word "interface" in English when it was coined in the 1880s. In 1882, James Thompson Bottomley wrote in his book, *Hydrostatics*, about the various states of liquidity and viscosity, noting, "A perfect fluid may be defined as a body, the contiguous parts of which exert pressure upon each other perpendicular to the interface which separates them at the interface." He goes on to define the interface as "a face of separation, plane or curved, between two contiguous portions of the same sub-stance."[15] This use of the term highlights the relationship between forms of matter. Thus, in the first usage of the word in English, materiality was a key component, a fact that I find particularly useful when thinking about "interfacing" in the digital age. As objects interface with one another to exchange data, this mode of inter-facing has, at its core, materiality encoded into the transfer.

The scientific usage of the word that began in the 1880s—the interface as an object—continued in the mid-twentieth century. In the 1960s, the term began to be used as a verb—*to interface*. Brought into popular usage by the likes of Marshall McLuhan, the term connoted computer interactions. The term was then remapped back onto other social and technological instances as a metaphor through which these interactions could be read (such as understanding face-to-face interactions as

"interfacing"). The interface as an object also began to be remapped as a metaphor to understand "old" media like eyeglasses or in related fields like industrial design.[16]

Since the 1960s, common usage of the term "interface" has drawn on this historical relationship with computing. However, it must be noted for my study of the interface: the mobile device is not an interface. Instead, the device serves as a part of the interface that is constituted as the larger set of social relations. The mobile device, on its own, cannot be considered an interface. The ways we use the device (i.e., the embodied practices of social space) as well as the ways the technologies of the device interact with other devices (by receiving calls, exchanging data, pulling electricity from a power source, among other things the device can do without human oversight) transform it into an interface. The interface serves as the nexus of these practices. To quote again from Drucker:

> What is an interface? If we think of interface as a *thing*, an entity, a fixed or determined structure that supports certain activities, it tends to reify in the same way a book does in traditional description. But we know that a codex book is not a *thing* but a structured set of codes that support or provoke an interpretation that is itself performative.[17]

Drawing from previous studies done on defining the interface by Brenda Laurel and Norman Long, she notes that the interface is a site of "power and control" and "a critical point of action between life worlds."[18] Thus, to summarize my definition of the interface: the interface is a set of cultural relations that serve as the nexus of the embodied production of social space. While this understanding of the interface is broad, it is necessarily so. Such an approach touches on the key attributes of the interface: it is a nexus between spaces (and thus is fundamentally spatial) and it is founded on the idea of social embodiment.

Reciprocity and the Ethical Other

There is one spatial metaphor of the interface that I have yet to touch on: the relationship between the depth and the surface of a mirror. The mirror-as-interface metaphor offers some interesting insights into the production of embodied space with the other (and the self's body-as-other). In his essay "Eye and Mind," Merleau-Ponty compares our relationship to the world with a mirror, which "converts things into spectacle, spectacle into things, myself into another, and another into myself."[19] This phrase can be mapped onto our experience with the mobile interface (again, broadly conceived): it converts things into spectacles and spectacles into things. Most interestingly, however, is the way our interactions with locative social media convert "myself into another, and another into myself." The reciprocity between people as they acknowledge each other across social networks is integral for the creation of embodied space in locative media. Without reciprocity, our embodied relationship to the world around us either remains in flux

or is only materialized through objects. We would, therefore, only enter the world, not as a social subject, but instead as a body "in itself."[20]

Reciprocity can and does take place between embodied subjects and technological objects. The haptic interfaces of our touch screen mobile devices offer an important example of this embodied reciprocity. Designers of these interfaces know that for effective interactivity with a touch screen device, the time between gesture and computer response needs to appear seamless. This feedback between my body and the mobile interface is the reciprocity needed to engage this interface as a spatial construction of which I am part. This rapid response hides the complexity of the system in exchange for adaptive feedback. As Ben Shneiderman has argued,

> I believe that users want comprehensible systems in which they understand the features and can readily take action to complete their tasks. The interfaces should be predictable, so that users know what to expect when they press Return, and controllable so that they can realize their intentions, monitor their progress, and recover from errors. These cognitive attributes lead to a sense of mastery over the system and pride in accomplishment. Then users can feel responsible for their actions. Such responsibility is necessary in life-critical applications such as air traffic control, and highly valued in common office or educational systems.[21]

If successful, this haptic reciprocity engages the users in a feedback loop that produces sensory-inscribed embodiment. When it fails (i.e., when I press the button and there is no response), this again points toward a kind of reciprocity: negative or asymmetrical reciprocity. My touch confirms that I have made contact with the device; however, the device refuses to acknowledge my touch. This is still reciprocity. It is just a type of negative reciprocity, perhaps best understood as asymmetrical in nature. However, haptic interfaces allow this asymmetrical reciprocity to be read quite easily. Other interfaces do not afford such clear-cut feedback (both positive and negative). An example I point to in the next chapter is the relationship between the user and GPS satellites: as a user is aware of the process of attaining a signal between the mobile device and GPS satellites, he or she is seeking acknowledgment of location from the technological objects. Until that connection is made, embodied reciprocity remains in flux and unknown.

However, while this form of acknowledgment and reciprocity does seek to offer a form of embodiment by delineating the limits of the self, it confronts the questionable relationship between the embodied subject and an "ethical other" within the world. As a basic example, hitting my arm against a doorway lets me know that I have pushed the limits of my body into a place that it cannot pass. Thus, my body ends here and the doorway starts there and the two shall not blend. However, if I were to hit my arm against another human being, the limits of the self are likewise delineated, but now the reciprocity it affords puts the limits of my

body into an ethical relationship to another body. It can be argued, however, that the ways we engage with objects still places us in a relationship with the ethical other (such as those who question if we should be relying so heavily on technologies initially designed by military structures). These questions confront the core dilemmas that surround the production of the embodied, social subject across locative media.

Proximity and Alterity

Merleau-Ponty has argued that "I borrow myself from other; I create others from my own thoughts."[22] This interplay between the self and the other highlights the constant exchange between notions of proximity/distance and solipsism/alterity that are raised by confronting notions of the "ethical other." As Jack Reynolds astutely notes about Merleau-Ponty's attempt to theorize these exchanges:

> This formulation might seem somewhat misleading, in that it almost reads like a reinvention of an antiquated idealism—which is exactly what phenomenology is sometimes claimed to be. However, this statement also pertains in inverse fashion, and this ensures that others must borrow themselves from me, create me with their thoughts, and it is this interactive and transformative element of alterity that remains an enduring focus of Merleau-Ponty's philosophy.[23]

In terms of notions of proximity and distance, we can chart a similar tension that exists between solipsism and alterity: nearness is that which is local, familiar, intimate and is contrasted with the distant as that which is foreign, strange, and remote. Once we tie these two notions together in the same way that the self must be intertwined with the other, we see that often that which is near is quite strange and removed from our frame of reference and that which is geographically distant is near to our affections and more familiar than anything in our immediate vicinity.

Forms of online social media exemplified this idea by demonstrating that social connections across vast geographical distances can be intimate.[24] Such connections, through the process of reciprocity, create meaningful spaces for social interaction. The inclusion of site-specificity into these social networks reasserts geographic nearness to the notion of proxemic intimacy. This mode of proxemic intimacy, it must be noted, was not necessarily lost with previous online social networks. As some sociological studies have discovered, social interactions that take place online often privilege relationships that have a lower social distance. A 2008 study of interactions in virtual worlds by Marina Fiedler, Ernan Haruvyb, and Sherry Xin Lic studied participants' partner choices for reward games that combined economic incentives with geographic distance. Their findings showed that participants are "more likely to select socially closer responders despite the lower rate of investment returns."[25] These studies build off of the proxemics work of Edward T. Hall, most

notably in his book *The Hidden Dimension*, in which he distinguishes between "intimate distance," "personal distance," "social distance," and "public distance." Hall attributed precise distances to each of these across the broad swath of cultures in the United States; the close phase for personal distance is labeled as being between one and a half to two and a half feet. The notions of these spatial gaps have typically been studied in physical environments. Though Hall's understanding of social distance was not necessarily designed with mediated interactions in mind, his definitions have been utilized in sociological studies of online connections, such as the reward game mentioned above. His definition of social space as a "hidden band that *contains* the group" is one in which a person will "feel anxious when he exceeds its limits."[26] Though Hall attempted to account for cultural specificity in his study, from a phenomenological perspective it is apparent that the borders between these spaces are highly individualized, not only between cultures but also from personal interaction to interaction. Intimate space between partners is an action, not simply a physical distance. Thus, it can be argued that Hall's notions of these various intersubjective spaces assumes the spaces exist before the embodied individuals enact them in a meaningful way. Instead, as is seen in the social networks people create, spaces and embodiment *are actions* out of which we derive meaning.

Since a sense of intimacy has been produced in online social media, the move to locative social media transforms the metaphor of closeness into a geographical actualization. The results of this emerging prioritization on geographic proximity include a sense of common space that is traversed. For example, the locative social network Loopt turned on "proximity alerts" in mid-2010. As mobile devices began designing their operating systems to allow for multiple applications to run simultaneously, Loopt expanded the way it notified users of the proximity of those in their network. By continually running in the background, this locative social network automatically updates your position while you move and sends an alert when someone in your network is nearby. The consequences of this reiteration of proximity do not support the broad generalization some make, including Judee Burgoon et al., who argue, "Physical closeness fosters psychological closeness and mutuality—a sense of connection, similarity, solidarity, openness, and understanding."[27] Instead, the sense of a common space that is mutually traversed highlights the process through which digital spaces are created. They are enacted by relational bodies in motion. This process of motion, which is one of the key characteristics of locative social networks and mobile devices as a whole, offers many insights into ways such networks achieve a sense of place. Though the characteristic of movement will be the primary focus of the Conclusion of this book, it is worthwhile at this point to gesture toward the ways these spaces are enacted.

In addition to proxemics and movement, an additional way that locative social networks are enacted (rather than simply experienced) is through reciprocity. These social networks engage reciprocity in a variety of ways, including simple actions like accepting a request for friendship, leaving a message for someone,

having someone delete you as a friend, or even having site-specific advertisements reference your location. Through these forms of acknowledgment—positive or negative reciprocity—you exist in the network. A parallel example, one that has a growing body of literature around it, is the exchange of text messages. In the study done by Nicola Döring and Sandra Pöschl, they note the ways that SMS messages are interpreted based on the timing of reciprocity. They note, "Extended response times can be perceived as creating an uneasy silence, while short response times might nonverbally communicate thoughtfulness, eagerness, or closeness."[28] However, it must be noted, that not all unanswered messages can serve as negative or asymmetrical reciprocity. Instead, such non-responses can work to leave the user's sense of embodiment in the space of the social network unstable and tenuous. Recently, I sent a text message to a new colleague whom I was meeting for dinner in Washington, DC. Before we met, he gave me his mobile phone number, to which I sent a text message before I left to meet him saying, "Are jeans and a t-shirt appropriate for the place we're going, or is it more formal?" I never got a response. The lack of reciprocity in this situation was not read as a slight but instead left the digital space between us in flux. I wasn't sure if I took down his cell phone number correctly, if there was some technological glitch that prevented my message from being received, or if he was simply riding the Metro subway, which, at the time, had no reception for mobile devices. (I later discovered that my colleague never sends or responds to text messages!) Our interaction across a medium that is a growing tool for embodied connection was never fully established and the embodied space between us on this network was not produced. Reciprocity is required to create the embodied space for further meaningful actions to take place. If my colleague and I had already established a history of reciprocity using SMS messages, then his lack of response (rather than delayed response) could be interpreted as a type of asymmetrical reciprocity rather than a signal of no reciprocity. While meaning is inserted into both situations, only the latter can serve as an example of an embodying mode of interaction. Experiencing no reciprocity (positive or negative) demonstrates that embodied space and notions of social distance are enacted rather than simply experienced.

Participatory Surveillance and Reciprocity

One significant form of reciprocity that has garnered the attention of many scholars, artists, and everyday users alike, is the act of making ourselves visible to the network. By letting ourselves be watched by those we connect with, we are involving ourselves in the network as participants rather than simply voyeurs. By checking in throughout the day, which 26% of users of locative social media do every hour,[29] they are making their locations visible to each other in real time. This mode of viewing while simultaneously being viewed is termed "participatory surveillance." This term, coined by Mark Poster and further developed by Anders Albrechtslund, has been analyzed in the ways it makes users complicit in the

loss of personal privacy and also in the ways it can be empowering for users. As Albrechtslund argues,

> A hierarchical conception of surveillance represents a power relation which is in favor of the person doing the surveillance. The person under surveillance is reduced to a powerless, passive subject under the control of the "gaze." When we look at online social networking and the idea of mutuality, it appears that this practice is not about destructing subjectivity or lifeworld. Rather, this surveillance practice can be part of the *building* of subjectivity and of making sense in the lifeworld.[30]

He goes on to argue that this process of building subjectivity in relationship to participatory surveillance is empowering. He writes, "This changes the role of the user from passive to active, since surveillance in this context offers opportunities to take action, seek information and communicate. Online social networking therefore illustrates that surveillance—as a mutual, empowering and subjectivity building practice—is fundamentally social."[31]

Yet, many are skeptical of the level of empowerment provided by participatory surveillance. Let me return to the example I used at the beginning of this chapter: the SixthSense technology and the word cloud that was projected on the human body. This particular use of this technology has come under scrutiny because it is not entirely clear how the word cloud projected onto the person is generated. Is it their latest updates? Words they have chosen that best represent their identity? Or, was the word cloud generated by an external system or structure of authority? For example, could the SixthSense detect you as you walk through an airport and project a word cloud onto you that informs the authorities that you are a "terrorist" or "person of interest" that should be on the "no fly list"? The question of this kind of visibility is, "Who has the power to inscribe?" Even if the person was in control of the information that was displayed to others, the problems that face this mode of interaction center on issues of visibility in surveillance contexts and in access to the technology which allows these interactions to take place. For instance, if you look again at Figure 3.1 of the SixthSense technology, one remarkable thing about the image is that the person on which the word cloud is projected does not have the SixthSense device, thereby limiting his interactions with the context-rich environment. Since the person without the SixthSense device has, presumably, allowed others to gain insights about him by establishing keywords that he wants others to associate with him, we might ask why he would enter this type of environment willing to be inscribed this way. Simultaneously, the person with the SixthSense device, here Pranav Mistry, does not have a word cloud projected onto him. Thus, there is an inscribing process at play in this demonstration of the technology that is not reciprocal. Instead, it clearly shows the issues of power at play in the process of inscribing and representing with mobile and pervasive technologies. In this era of locative surveillance,

the role that participation plays in the creation of social space should not be underestimated.

There thus emerges an unresolved tension between participation/embodiment/subjectivity on the one hand, and non-participation/disembodiment/objectivity on the other. To be active in this emerging environment, one seemingly must participate by simultaneously being a watcher and allowing others to watch. Reciprocity is vital. However, if one chooses to resist this form of embodied activity that forces the self to be surveilled, the sense of disembodiment that accompanies this decision can be read as either an opportunity for voyeurism (and thus a potential position of power through the ability to gaze but not be gazed upon) or read as a loss of agency (lacking a participatory body, you become "no body" in this sphere). Seemingly, to have no body is to become a non-person, a "no-body" in the emerging social spheres that depend on participatory surveillance.

This later reading of participation—as "participate or lose all agency"—might seem to go against much of the resistance that has emerged around surveillance, from the immensely public outcries against Facebook's many changes to its privacy policy to mapping projects that allow you to travel along routes of least surveillance through cities like Manhattan. However, as surveillance artist Hasan Elahi has argued, by fully exposing his life in his work—in which he allows his every move to be tracked, accompanied by images of every location, meal, and restroom he uses—this deluge of data becomes meaningless due to its sheer volume. As Elahi has said, "The reason information has value is because no one else has access to it. The secrecy applied to the information is what makes it valuable. So, by me disclosing this to everybody, [it becomes worthless] . . . If 300 million people did this, we would potentially need to hire another 300 million people just to keep track with the data flood."[32] This can also be coupled with a participatory activity that disseminates misinformation. This act of participation embodies the user as an active body engaging the mechanics of participatory surveillance, yet frustrates the system by inserting false information such as a mis-mapping of the user's location. Therefore, ideas about what it means to participate and offer reciprocity within these surveillance systems can take on various forms for diverse reasons.

While the notion of reciprocal surveillance is indeed derivative of the empowering actions discussed by Lili Berko in her article "Surveying the Surveilled"—in which turning everyday recording devices against those who normally perform the gazing levels the hierarchy of surveillance—such discussions nonetheless continually inscribe significance into the binary of public and private.[33] Culturally we continue to give relevance to the clear distinction between public and private. We still have a sense of when our privacy is violated and we know when information is private as opposed to public. I am not, for example, going to publish my credit card numbers in this book. As I mentioned at the beginning of this chapter, I never disclose the location of my house on locative social networks. While we are quick to identify clear examples of public and private, we fail to acknowledge

that these terms are so intensely flexible and intertwined that they ultimately cannot function as clear-cut opposites. Essentially, the extension of these values into the realm of locative social media demonstrates the ways that this divide reiterates a liberal humanist understanding of the self as essentially a Cartesian subject. As users move out into material space and announce their location to the network (in what is deemed "public space"), there is a notion that they are offering private information. Such an understanding of what constitutes private stems back to the notion that the interior self is what is private as exemplified by the inner thoughts of the self. This understanding of the private self later extended into notions of the home as a private, interior space. The privacy of the interior self extends beyond the home as the self moves about in public spaces since the private self is, essentially, interior. Yet, as Merleau-Ponty argued, there is no "interior self" since this idea of the self is founded on Cartesian dualism. As phenomenology argues for reciprocity between interior and exterior as mutually constructive, the same holds true for notions of public and private. Similar to Elizabeth Grosz's use of the möbius strip as a metaphor of the body, in which exterior and interior become one and the same, locative social media demonstrate that the space between public and private collapses under the scrutiny of sensory-inscribed spaces. While we will undoubtedly continue to use these terms, in so doing we must acknowledge that the opposition between public and private is less and less useful to accurately describe our experiences with embodied spaces.

While many users of location-based social networks simply disregard the concept of personal privacy altogether, they do so for several reasons. As Albrechtslund notes, these reasons can extend from shortcomings in the design of the network, a lack of awareness with regard to the network's privacy settings, or (as he argues is more likely) "By exhibiting their lives, people claim 'copyright' to their own lives, as they engage in the self–construction of identity."[34] Extending Albrechtslund's argument to my analysis of reciprocity, the act of participatory surveillance engages the user in the process of acknowledgment. As mentioned, both negative reciprocity (e.g., hierarchical surveillance that functions as a mode of interpellation) and positive reciprocity (e.g., meeting with a friend or colleague after being notified that you are both in the same vicinity) work to embody users in hybrid space.

If notions of public and private maintain in these spaces, it is an act that seeks to reiterate the connection between the private self and a sense of true presence (i.e., by disclosing private information, you are revealing a self that is closer to the true subject rather than a distant/absent self). While I spend the majority of Chapter 5 looking indepth at the issues of presence and absence in locative media, it is worth noting here that the continued debate around privacy in digital spaces is often a tool that is utilized to maintain the metaphysical and Cartesian notions of the self as an interior being. As modes of surveillance continue to move into digital forms (from location-aware technologies to database surveillance), the debates between public/private and presence/absence are being mapped onto

the newer distinctions between patterns/randomness. In database surveillance, as users contribute massive amounts of information, their presence is dispersed only to find meaning as it culminates into patterns. However, as is seen in the problematic endeavor of distinguishing between binary systems, attempting to separate pattern from randomness ultimately demonstrates their inherent interconnectedness. As N. Katherine Hayles argues,

> If information is pattern, then noninformation should be the absence of pattern, that is, randomness. This commonsense explanation ran into unexpected complications when certain developments within information theory implied that information could be equated with randomness as well as with pattern . . . Within such a system, pattern and randomness are bound together in a complex dialectic that makes them not so much opposites as complements or supplements to one another. Each helps to define the other; each contributes to the flow of information through the system.[35]

The interconnectedness of pattern/randomness, public/private, and presence/absence makes the process of delineating them as distinct spaces impossible; however, tracking the cultural imaginaries around each of the terms offers insights into the ways that we inscribe each category with distinct meaning. For example, as presence is closely tied with pattern in digital spaces, and while most might agree that the act of checking in and letting my network know that I am at a local grocery store might be insignificant information on its own, many are concerned that the culmination of all of this data is ultimately read in a particular way. Thus, while patterns might emerge that show that my everyday life centers around my university, such information can ultimately signify very different things for my colleagues than it would for advertisers. We subsequently seek to reinstill notions of privacy into our networks and create spaces in which reciprocity will be achieved with those who will read us as we "write ourselves into being" rather than being interpellated as a particular type of subject (such as a consumer).

Homophily and Transcendence

The process of "writing the self into being" in these locative social networks—to use danah boyd's term[36]—is often done through seeking reciprocal relationships with people who tend to reiterate our worldview. As boyd suggests in her article "White Flight in Networked Publics?" the emerging demographic of the most used social networks has much to do with our "homophily," or the "practice of connecting with like-minded individuals."[37] A feature added to the locative social network Loopt extends this homophily to location-based networks: in October of 2009, the company launched "LooptMix." As Adriana de Souza e Silva and Jordan Frith note, "LooptMix changes Loopt from a friend/permission-based

network into an open network. If users enable LooptMix, they can see all the other LooptMix users in their immediate physical space, not just their friends." This feature serves to support homophily because "Users can even change their settings to target specific types of strangers. For example, a single male can change his filter settings so that only single females appear on his map, or surfers can set up LooptMix so that only people who list surfing as an interest appear on their map."[38] These attempts at exclusions of difference gesture toward the problems of theorizing difference through philosophies like phenomenology, which tend to always return back to the self as the point of departure. Emmanuel Lévinas' concern with the phenomenology of Merleau-Ponty was, as Reynolds puts it, "that by insisting on the importance of horizons and contexts, either phenomenology precludes the possibility of something being absolutely other, or, if it considers the other, it does so only in terms of a more derivative otherness that the subject is already prepared for."[39] Thus, features like LooptMix demonstrate a desire to engage with an other that fits within the self's pre-established frame of otherness. Reynolds continues: "According to him, phenomenology hence ensures that the other can be considered only on the condition of surrendering his or her difference."[40] This objection has been raised throughout the work of Merleau-Ponty, perhaps most memorably in the discussion that followed his talk at the Société francaise de philosophie in November of 1946. Published as a prospectus of his work in *The Primacy of Perception*, the discussion began with Emile Bréhier questioning the very foundations of phenomenological intersubjectivity:

> When you speak of the perception of the other, this other does not even exist, according to you, except in relation to us and in his relations with us. This is not the other as I perceive him immediately; it certainly is not an ethical other; it is not this person who suffices to himself. It is someone I posit outside myself at the same time I posit objects.[41]

Michael Yeo rephrases the question: "How is it possible to experience the other as other—as really transcendent—given that I cannot but experience her in relation to my own immanent frame of reference?"[42]

However, if the other only exists in relation to my frame of reference, the migration from one social network to another, and from online social media to locative social media—in which we often simply reconnect with those who were a part of the previous social network—seems unusual. Here, social media would only reiterate what I am already aware of, since any form of difference is flattened by my frame of reference. Why would people find these new networks novel, interesting, and stimulating? Reynolds argues that Merleau-Ponty's notion of alterity can actually renew our appreciation with the difference of others rather than eliminate it altogether. Through our sensory-inscribed relationship to the other, we are offered surprise: "Not only can interactions with the other involve us in a renewed appreciation of their alterity (i.e., the ways in which they elude

us), but the other is equally importantly that which allows us to surprise ourselves, and move beyond the various horizons and expectations that govern our daily lives."[43] He goes on to note that when we engage others in dialog, we not only access the ability to learn about that which extends beyond our horizon and frame of reference but also even discover and "be astounded by our own thoughts."[44]

The idea of *perspective* thus becomes an important trope for our understandings of alterity. Perspective assumes a point of view but simultaneously admits that this point of view is always already limited. Changing perspectives is an embodied notion of moving your place to see things anew. This process of movement is exactly what users experience when they migrate from one social network to another. Though they may simply be encountering the same people again, since the space is different, the perspective they have on one another can be very different. This transformative process of changing perspectives through move-ment is linked to users of social media feeling that they are discovering those around them for the very first time. This process of rediscovery, as it is linked to movement, instills the digital space with significance and a new sense of place. Ultimately, what we are seeing in the transition from online social networks to locative social networks is people's rediscovery of their relationships to others—a rediscovery that is essentially linked to gaining a new perspective on places.

Locative social media put the movement that enacts the digital space into physical practice. The user's movement throughout material space actualizes the discovery of new perspectives. Not only do locative social media allow for a renewed perspective of the other, but—as has been argued throughout this study—it offers a renewed perspective on space, since bodies and spaces are indelibly linked. Connecting with familiar spaces in a new way through locative social media offers the potential for physical space to be transformed into a hybrid space. De Souza e Silva defines these spaces as that which is "created by the constant move ment of users who carry portable devices continuously connected to the Internet and to other users." She continues: "The possibility of an 'always-on' connection when one moves through a city transforms our experience of space by enfolding remote contexts inside the present context."[45] This transformed space that enfolds socio-spatial contexts is, at its core, defined by mobility. While mobility is essential to the construction of space, the interfaces that we connect through are equally dependent on practices of reciprocity and otherness.

Locative social media are often described as "participatory media" that are built out of our interactions with one another. These interactions are, however, quite complex. They involve reciprocity on many levels: the reciprocity of the interface, the reciprocity of surrounding infrastructures, the reciprocity of other participants, and so on. Within these moments of feedback, there are multiple forms of reci-procity: positive/symmetrical reciprocity and negative/asymmetrical reciprocity. Inscribed into each of these forms are our choices about how we engage practices of visibility, how we define public and private, and how these practices engage us with "the ethical other." Here, the sensory-inscribed body is produced at the nexus

of the interface, practices of reciprocity, visibility, and the placement of the self in relationship to the other. Ultimately, by using locative social media, location *does* become meaningful for the construction of self-identity, yet this construction takes place on all of these fronts simply by using your mobile device to broadcast: "I am here."

4

THE ETHICS OF IMMERSION IN LOCATIVE GAMES

In the fall of 2006, players in Stockholm immersed themselves into the world of *Momentum*, a "live action role playing" game (LARP) that required players to embody roles of various historic characters. Moving seamlessly between their everyday lives and the world of the game by using the city as the game space, players used specially designed mobile devices to navigate to sites within the city where they were able to communicate with the dead and perform rituals that would invoke the powers of the other side. The motto of the game, as in most LARPs, is that players were to "play it as if it is real." As players progressed in this game world, the administrators of the game were less hands-on in guiding them to these significant locations, letting the players figure out which items in the environment were clues and which were not. This led to significant interplay between the realm of the game and the realm of everyday life. As Jaakko Stenros and Markus Montola write about the game:

> The players could never tell who was playing and who was not . . . Sometimes outsiders were presented in a way suggesting that they might be players, and sometimes such outsiders had actually been instructed to act in some way when encountered by players. As the players did not know where the ordinary ended and the game began, the protection offered by the magic circle waned.[1]

The permeability of the "magic circle" in which games reside—Johan Huizinga's famous metaphor for the division between the realm of play and the realm of everyday life—is one of the key attributes to these "pervasive" games that utilize mobile technologies in an attempt to reimagine the relationship between game space and everyday life. By taking advantage of the permeability of the magic

circle in the digital age, these games seek a heightened level of immersion in game space as it utilizes the material landscape as its setting. This embodied space—which is sensory-inscribed as a dynamic and simultaneous interplay between several spaces—produces ethical challenges for gamers and designers as these worlds collaborate to offer a distinct sense of the embodied production of immersive gaming space.

The players of *Momentum* confronted one such challenge. One mission the players had to pass, the "Gullmarsplan" mission, took place in a city square where the players had to meet a non-player character (NPC), placed by the game designers, who was dressed as a homeless person. This NPC would give them an essential component for game play: a tablet computer that was used in other missions. The players, however, misread the time they were meant to meet the NPC and, as time lingered, the NPC left the city square. While waiting at the park bench for the players, the NPC signified his location with several chalk markings related to the game, which were left behind on the ground and bench. As the players arrived, they set up three GPS receivers around the entrances to the square. These receivers communicated with their Bluetooth-enabled mobile phones and were typically used to help players identify meaningful locations and people within the game. Wandering the square for 40 minutes and even trailing strangers with the in-game mobile devices to see if they were NPCs, the players happened upon the bench where the real NPC had been sitting early that evening. However, at this moment, the bench was instead occupied by an inebriated homeless woman. Noting the designers' previous attention to costuming detail and seeing the in-game markings around the woman, the players began to interact with her as an in-game character. They performed rituals around her, asked her for clues, and eventually went through her belongings looking for the tablet computer they were after. Their attempts to gain information from the woman lasted for nearly two hours until several players finally left and several others tried to get help for the woman, who passed out while walking away from the players.

One player described his interactions with the woman as his historical in-game character:

> I, as my ghost Rottweiler, who has some strange morals, went through her bag of stuff, found that she wasn't carrying any information for us. And she was in very bad shape, drawling and passing out from time to time, unreachable and rather repulsive. Rottweiler went through her bag once more, and took some of her money [four Swedish crowns] just because he felt he needed it. After that we performed some kind of ritual around her and chanted for a while, but she never woke up to talk to us.[2]

The immersive game interface—which, drawing from my definition of "interface" in the previous chapter, served as the nexus of collaboration between technologies, landscapes, and characters—afforded in-game identities like Rottweiler

to disregard the everyday context of the situation and instead fold this context into an in-game experience. Even in his description of the event, the player refers to the actions as being carried out by his in-game character: "Rottweiler went through her bag once more, and took some of her money just because he felt he needed it."

In this chapter, locative games exemplify the production of a sensory-inscribed body that is produced through the mobile interface, an interface in which play spaces and everyday spaces converge. Through the heightened experience of immersion afforded by these games, players experience a specific form of embodiment: a proprioception that is developed out of feedback from the technology and social inscriptions written by players and bystanders alike. Within this sensory-inscribed interaction with locative game spaces, players are confronted with the ethics of the collaboration between these spaces. Ultimately, I argue that games are a form of *bricolage*, a type of creative misuse, and through this misuse, players can create a space of critical distance where the process of play can become actions of social critique.

Immersion and Immediacy

The spaces created by our interactions with mobile technologies offer a phenomenologically significant experience of hybrid space that is simultaneously composed out of digital and material objects (or, in reference to my earlier discussion of virtuality, a collaboration between the virtual and the realized). In this example, the game space is simultaneously play and everyday life. This practice of embodied space offers an experience of spatiality as an immersive world that is created as more than what is immediately available to the senses. Instead, the space is layered with other worlds, and the full sensory-inscribed experience of these spaces depends on successfully navigating the permeable delineations between them. The design of these games, however, often presents ethically challenging scenarios; and, the media-specificity of games that utilize mobile technologies creates environments that often only address a privileged audience. As Mary Flanagan notes, bystanders such as the homeless woman in *Momentum* are "unwillingly commodified by the players." She notes, "In major cities throughout the world, the homeless, prostitutes, and domestic workers possess the streets in a way that speaks to economic and social *disempowerment*. Their 'drift' is not one of exploration or privilege, but a search for a place to sleep or for labor . . . Few location-based art projects are nuanced enough to address these kinds of issues."[3] Many of these ethical problems, however, go unnoticed by players who are immersed in the hybrid space of the game.

Thus, the immersive quality of these hybrid spaces, which are experienced as "enfolding remote contexts inside the present context," as Adriana de Souza e Silva notes, pose a challenge for ethical interactions within these spaces.[4] The challenge comes out of an inability to phenomenologically move from the immersive effects

of Heidegger's "ready-to-hand" to the non-immersive experience of being "present-at-hand." These notions are similarly mapped onto Jay David Bolter and Richard Grusin's discussion of the distinction between "immediacy" and "hyper-mediacy" in our relationship to interfaces. Immediacy, which is akin to Heidegger's ready-to-hand, is an interface that disappears, since it "is supposed to make this computer interface 'natural' rather than arbitrary." It is the "'interfaceless' interface, in which there will be no recognizable electronic tools—no buttons, windows, scroll bars, or even icons as such. Instead the user will move through the space interacting with the objects 'naturally,' as she does in the physical world."[5] Many of the locative games discussed in this chapter seek for a gaming experience that is immersive, and thus "immediate," drawing on the idea of the material world being an "interfaceless interface." As we look at the ethics of designing and playing "immediate" locative games, I will contrast this mode of play with "hypermediate" game play. The logic of immediacy in Bolter and Grusin is in direct contrast to their notion of "hypermediacy," which "expresses itself as multiplicity" and "makes us aware of the medium or media and (in sometimes subtle and sometimes obvious ways) reminds us of our desire for immediacy."[6] They go on to describe the distinction between these two logics:

> If the logic of immediacy leads one either to erase or to render automatic the act of representation, the logic of hypermediacy acknowledges multiple acts of representation and makes them visible. Where immediacy suggests a unified visual space, contemporary hypermediacy offers a heterogeneous space, in which representation is conceived of not as a window on to the world, but rather as "windowed" itself—with windows that open on to other representations or other media. The logic of hypermediacy multiplies the signs of mediation and in this way tries to reproduce the rich sensorium of human experience.[7]

These two logics are particularly applicable to locative games because these games take advantage of the player's immediate setting as the backdrop for the game, thus offering the potential for a highly immersive experience. Thus, what was represented in a traditional gaming world is here simply part of the user's experience of everyday space. The collaboration between the mobile interface and the material landscape offers a "unified visual space." Hypermediacy, as we will see, resists this mode of immersion, typically to offer the player a mode of critique that immediacy does not offer.

Gaming's Impact on Actions in Everyday Life

As soon as videogames began to outsell the movie box offices in the United States in 2001 and globally in 2002, games sealed their fate as the dominant medium worldwide.[8] With such exponential growth in this industry came an equal amount

of criticism, both scholarly and in the popular presses. Criticisms that "watching or playing violent media can increase aggression and violence," as psychologist Craig Anderson has argued, proliferate throughout both clinical case studies and in the headlines of magazines and newspapers.[9] As I have argued elsewhere, these arguments about violence in videogames are simply a symptom of a much larger problem, one that directly informs a study of locative games: since the magic circle that has traditionally delineated the game world from the material world is essentially porous, how do we distinguish between practices in game life and practices in everyday life?[10] Thus, the in-game ethics of players seem to simply be a mirror into their non-game/everyday ethics. Such concerns, which get unfortunately mapped onto the endless conversations about violence and the effects of media, have some historical roots that are worth exploring. Most notably, the foundation of videogames is intimately tied to the simulations created by the military to train soldiers for wartime activities. As Simon Penny writes, "Training simulation and interactive entertainment were born joined at the hip."[11] He continues:

> We are drawn to the conclusion that what separates the first person shooter [videogame] from the high-end battle simulator is the location of one in an adolescent bedroom and the other in a military base. And having accepted that simulators are effective environments for training, we must accept that so too are the desktop shooter games. The question is: what exactly is the user being trained to do?[12]

As these games continued to develop more mimetic tools for game play and utilized the material spaces as game boards, critics have argued that the games are simply training platforms for violent behavior. This was seen in the release of violent games for the Nintendo Wii, including *Manhunt 2* and *The Godfather: Backhand Edition*. Videogame critic and reviewer Scott Steinberg argued that, when playing games that involve the body in significant ways, "the experience is even more intense when it's played on Nintendo's Wii, which gets players to act out the violence." He continues, "The Wii has motion-sensing controls, and therefore to stab you're gonna mimic a stabbing motion, to swing a sledgehammer or a shovel you would do the same. Unfortunately it's probably not something you would want to have your kids get much practice on."[13]

Here, the immersive experience of the game interface, as traced back to its roots in military training, shows that our sense of embodiment can indeed be formed out of a collaboration between digital and material spheres. As Flanagan reiterates,

> In addition to its role in entertainment culture, play has long been used as a tool for practice, education, and therapy. From war games, in which troops sharpen their skills before battle, to games involving learning about science, to games that help one tease out reactions to phobic scenarios, these

"uses" of play are thought to lead to a kind of rehearsal, a practice, a type of empowerment. When taken to the streets, this empowerment can be transformed into a reengagement with the city and thus reclamation of that space. But if this is a goal, it must be integrated into the mechanic and the setting of the game system developed. Taking play onto the pavement, in this light, cannot be seen as a de facto act of empowerment in and of itself.[14]

Though the outcomes of the collaboration between everyday space and game space (taking games "onto the pavement") can be—and are often are—overstated, much of this book has pointed to the significant sense of embodiment that arises out of meaningful interactions between digital spaces and our everyday lives.

Beyond noting the changing conceptions of embodiment in the digital age, it is also important to note that there are substantial ethical problems that are bound up with the design of immediate and immersive interfaces. The concern over such interfaces is not at all new with digital media. Such concerns can be traced back at least to Greek theater, which coined the notion of the "obscene" as that which was *"ob skene"* or "off stage." In the Greek dramatic tradition, any actions in the play that were considered morally deviant were carried out off stage, typically with another character coming on stage to retell the events. This tradition carried on for centuries in the theater and eventually into other forms of popular media, including the Motion Picture Production Code, which began in 1930 and regulated what was "appropriate" to be shown in film in the United States.

Hypermediacy and the Alienation Effect

My critiques of these spaces of immersion, and how they can be mapped onto locative games, tend to align more with the work of theater critic and playwright Bertolt Brecht than they do with the overstated outcries against the violence caused by immersive media. As I will argue at the end of this chapter, Brecht designed and advocated theatrical environments that resisted immersion in order to afford the audience a space for critique. A similar space of critique must be made for the emerging pervasive gaming environments of locative games. For Brecht, the immersive effects of media can potentially remove viewers from the activity of critique, and his arguments for a type of "hypermediate" interface for media— what he terms the "Alienation Effect"—can be especially useful for locative game play and design. Brecht, whose critiques were addressing an era of realism in the theater that prioritized immersive experiences, noted that by being immersed in media, we tend to simply identify with protagonists and be transported along with the narrative. This mode of immersion leads people to respond to media by saying, "Yes, I have felt like that too—Just like me—It's only natural—It'll never change —The sufferings of this man appal me because they are inescapable." Brecht's mode of "hypermediacy" through the Alienation Effect conversely leads the audience and actors alike to say, "I'd never have thought it—That's not the way

—That's extraordinary, hardly believable—It's got to stop—The sufferings of this man appal me, because they are unnecessary."[15] Ultimately, modes of hyper-mediacy can, for Brecht, lead to political revolution by motivating the audience to take to the streets and demand change.

The tension between modes of immediacy and hypermediacy are exemplified across many genres of locative games. As seen with the above example in *Momentum*, the interplay between pervasive game space and everyday space provides a unique object of study for the sensory-inscribed body and modes of immersion. These pervasive games—which come with a variety of labels such as "urban game," "ubiquitous game," "hybrid game," or "flash mob game"—require players to continually interact with modes of sensory-inscription in order to successfully balance the spaces of play and the everyday. Often, when immediacy becomes the dominant mode of game play, players are not cognitively aware of the process of sensory-inscription and thus are unaware of how their body is inscribed across the spaces of play and the everyday. This was seen when a player of the GPS treasure hunt game, geocaching, prompted a bomb scare while he was playing. In February 2008, the geocacher was witnessed on a CCTV camera placing a game container near the Aoeta Center in downtown Auckland. Those who saw the player placing the geocache container believed that it was an explosive device. The bomb squad was called in and sections of the city were closed down as they investigated the suspicious container. Here, the player's interaction in a space as simultaneously a play space and an everyday space created a situation in which he was not aware of the ways his game play was being read by non-gamers. By playing in only one realm and ignoring the inscriptions from the other, his actions were mis-inscribed.

This mode of immersion in the magic circle of the game is one that has applied to play for as long as it has existed. As Huizinga notes,

> The exception and special position of play is most tellingly illustrated by the fact that it loves to surround itself with an air of secrecy. Even in early childhood the charm of play is enhanced by making a "secret" out of it. This is for *us*, not for the "others." What the "others" do "outside" is no concern of ours at the moment.[16]

He continues, "Summing up the formal characteristics of play we might call it a free activity standing quite consciously outside 'ordinary' life . . . but at the same time absorbing the player intensely and utterly."[17] Traversing the sensory-inscribed modes of embodiment of a player who is engaged in a game that is played in and among non-players (who, in geocaching, are called "muggles") is integral to the success of analyzing the ways that these emerging play spaces are interacting with the spaces of "ordinary" life, as Huizinga terms it.

Geocaching and Hybrid Space

To fully explore immersive locative games and the traversal of game space and everyday space, I choose here to elaborate on the sensory-inscribed engagement with these elements in the game geocaching. Geocaching, which is essentially a high-tech treasure hunt using a GPS receiver (GPSr), began shortly after May 1, 2000, when the United States government removed the restriction to civilian access to the highly accurate signals from GPS satellites. Soon after the "Selective Availability" was removed, people began testing the accuracy of their GPSrs, including Dave Ulmer, who placed a container in the Portland, Oregon area and logged its coordinates onto a Usenet site. The container was found by users of the site, who logged their visits both in the container's logbook and online. Thus began the GPS treasure hunt game called "geocaching." This locative game serves as a strong example of the sensory-inscribed body in pervasive gaming space: from the correspondence between the GPSr and the material landscape to the confirmation of "presence" at the site of the cache gained through a physical signature in the logbook coupled with an online retelling of the find, geocaching blends two distinct genres of locative gaming. It utilizes both augmented landscape gaming (in which data overlays the city) and trace-based gaming (in which the trails or tracks created by the user's movement are utilized as part of the objectives of the game). Movement across the augmented landscape—and the proprioception of the self in relationship to that augmented landscape and technology that creates the mixed reality space—is how gamers are able to successfully locate geocaches and log their visits. This proprioception also convenes with the cultural inscriptions users must engage to hide in plain sight through performing a sense of alternate purposes. Users embody false purposes in order to keep their agenda hidden from passersby, thus keeping the cache container hidden from non-gamers. Geocaching serves as a key example of the sensory-inscribed body in locative gaming, since users who enter the augmented landscape of GPS data also enter a realm that requires a different mode of embodiment, one that depends on a sensory-inscribed convening of bodies, technology, and material space. In this hybrid space, embodiment is reliant on the correspondence of all these elements and is utterly dependent on the acknowledgment of presence by technology and the social structures that establish and maintain the space.

Geocaching has grown in popularity as a locative game since its inception in 2000. As of early 2011, there are over four million registered players, growing at a rate of 2,500 a day during 2009–2010. There are currently over 1.2 million geocaches hidden around the world (including Antarctica) and some regions are so densely populated with caches that players can find one every 0.1 mile (the minimum distance caches can be placed apart from one another). Players can either upload a cache's information (including GPS coordinates, hints, and container type) to their GPSr or simply load the details of nearby caches on their mobile phone through the geocaching application. Once within reach of the cache, it is often up

to the player to discern where the cache might be hidden, since the player's location might be inaccurate due to poor satellite connection or by a difference in the GPSrs of the hider and the seekers. As mentioned, players often must pretend to be occupied with some other purpose as to not draw suspicion to their activities or give the location of the container away to non-players.

Once players find the cache, they sign their player name into the logbook along with the date of the find (see Figure 4.1). This physical signature is a requirement of the game. In order for the find to count toward the players' overall finds, they must prove their presence at the cache with a physical signature. The players can also leave items such as Travel Bugs that move from cache to cache and accumulate distance along with accounts of the item's travels by the gamers who pass the Travel Bug along. There are also usually trinkets left by gamers who can trade one item for another. The last step of the players' experience with a cache is to log the visit online at Geocaching.com. Here, players describe the events of the hunt (often discussing the roles they had to play to not be spotted by non-gamers), the condition of the cache, and the objects left or traded. This multi-step process makes geocaching a game that utilizes the correlation between the material landscape and digital space and depends on the collaboration between these spaces for a sense of embodiment.

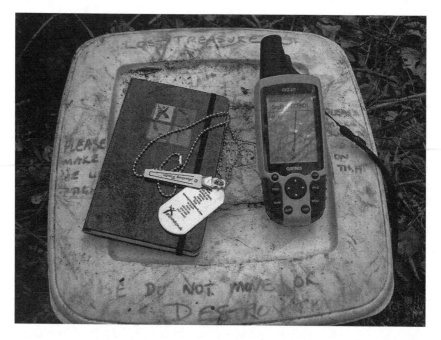

FIGURE 4.1 Geocache container, logbook, Travel Bug item with dog tag, and GPS receiver.

Image © Mark Burbidge, 2006.

Site-specificity is a key aspect of locative gaming's appeal, since it typically takes advantage of the user's real time correspondence to the development of space-time-movement. Flanagan goes as far to argue that "With only a few exceptions, one can conclude that the phenomenon of play is local: that is, while the phenomenon of play is universal, the experience of play is intrinsically tied to location and culture."[18] Due to locative gaming's reliance on precise coordinates, the use of space is often misunderstood as simply a site enacted upon by an agent. A central concept for my study of locative space, as developed from the work of Lefebvre, is to expose the misconception that space is a container that is entered and manipulated rather than that which is co-produced alongside embodiment.[19] Space seems to be preexisting and thus is able to be transformed by the gamer who hides the container. This carries over into many discussions of the relationship between the screen space of the mobile device and the player's experience of the everyday space he or she navigates. Christian Licoppe and Yoriko Inada make such a claim when they write, "Tele-presence, augmented reality or virtual reality extend this problem to the juxtaposition of the lived experience of the body 'here and now' with a disembodied experience 'over there'. Living harmoniously in an augmented world means being able to smoothly integrate the embodied lived experience of the body and the mediated perception of oneself and of the environment."[20] While locative gamers do point toward the constant interplay between these spaces, such statements assume the presence of a preexisting space that is then inhabited or experienced in a disembodied way (e.g., across a network or on the interface of the mobile device). Conversely, this chapter points toward the production of locative gaming space in conjunction with bodies that create the space for playful purposes. These spaces, whether digital, material, or a hybrid space, never function as a disembodied zone. Instead, space itself requires a convening with bodies (and here, with technologies) for its production.

In an analysis of hybrid space, the embodied status of the gamers can often become dichotomized between those who focus on the ways the body is transformed by the technology (harkening back to Friedrich Kittler's notion that "media determine our situation")[21] or the ways that technology is perpetually imbued with meaning through modes of embodiment (such as Mark Hansen's argument that only embodied "meaning can enframe information").[22] This tension over the role of technological determinism, which I gestured to in Chapter 1, is taken up by N. Katherine Hayles when she writes, "Embodiment will not become obsolete because it is essential to human being, but it can and does transform in relation to environmental selective pressures, particularly through interactions with technology."[23] Extending Hayles' argument, I seek a balance between looking at the ways locative technologies such as GPSrs and smartphones have created a new space for play and the arts and also seek to develop the integral role that embodiment plays in the success of these games. The space is neither fully delineated by the technology of the game, nor is it limited to the perceptions of the players. Instead, through the development of sensory-inscription, player's embodiment

is developed simultaneously between the zones of perception and invisibility, between resistance and hegemony, between technology and the body.

The Interface of Everyday Life

The space of geocaching is a combination of user movement that corresponds to mapping space on the GPSr interface and the digital information that augments this space. This augmented space is understood by Lev Manovich as "laying new information over a physical space" in which "power lies in the interactions between the two spaces."[24] Movement through the space and the embodied production of the space is determined by the playful purposes of the game. As Hansen argues, discussing the relationship between movement and the creation of space:

> How and why, exactly, can GPS technology re-organize space into another space, into spacing itself? It can do this because it facilitates a virtualization of planes of information, which is equally to say, a passage between time and space, a mutual contamination of time by spacing and of space by duration or delay . . . Put another way, the GPS network restores the originary condition of space, its originary composite with duration, the name of which is movement.[25]

The movement is able to create and define the space. Thus, as geocachers move through a space to retrieve a cache, their movements and purposes transform the space as the space of play.

The first geocache I discovered was an odd one for geocaching and was in a format they no longer allow: it was indoors, where GPSrs are ineffective. Hidden among the books of the Portland Public Library in Portland, Oregon, I finally stumbled upon the cache after wandering and repeatedly saying to my colleague, Doug Gast, "I have no idea what we're looking for!" Part of the play element involved Doug and I looking up a particular phrase in the library's database. This led us to a call number at which the container was shelved among the books. As I wandered among the shelves of the library, my movement and purposes were not aligned with the structure and design of the building. My movements through the building instead transformed the structure into a game space. Theorists, such as Caroline Bassett, often point to Michel de Certeau's spatial tactics to understand this transformation of everyday space. Bassett writes,

> In the 1970s, in *The Practice of Everyday Life*, Michel De Certeau contrasted the embedded perspective produced by walking in the city at ground level with the strategic viewpoint from on high, a view usually enabled by technology. For De Certeau walking was a spatializing, narrativizing practice. Those who felt their way through the streets, tracing out their own

trajectories, produced a second, ghostly mapping of the city; one that confounded the official city of the planners and architects – at least for a time.[26]

Such a "ghostly mapping of the city" connects to Guy Debord's notion of *dérive* and the transformation of the city by the wanderer who isn't led by any purpose other than spatial flows. As Marc Tuters and Kazys Varnelis write in their article "Beyond Locative Media," "In adopting the mapping-while-wandering tactics of the dérive, tracing-based locative media suggest that we can re-embody ourselves in the world, thereby escaping the prevailing sense that our experience of place is disappearing in late capitalist society."[27] The production of locative gaming space relies on this transformation as a key component for the constitution of embodied space. Therefore, the study of locative games must be aware of how such spaces can be reorganized and resignified by the process of movement, especially the movement associated with play.

Locative media have made the process of navigating everyday space that is informed by digital media a seamless, day-to-day activity for many mobile technology users. This is the new interface of everyday life. While Manovich argues that the power of augmented space is found in the interaction between material space and the digital information that overlays it, the process of inhabiting multiple spaces simultaneously has moved into the sphere of the quotidian and often goes unnoticed. And, while the multiplicity that serves as the foundational characteristic of the virtual (as discussed in Chapter 2) may go unnoticed, the phenomenology that attaches this multiplicity to our experience of space still produces a sensory-inscription through the cognitive unconscious. In cities throughout the world where inhabitants are active mobile phone users, navigating the landscape is a simultaneous process of sensorial movement through streets and buildings (attended to by either cognitive awareness or the cognitive unconscious) and an embodied connection to how those places are augmented by digital information on mobile devices. Thus, what constitutes the "interface of everyday life" is the process of navigating the correspondence or disjunction between the physical landscape and the digital augmentation of that landscape. GPS devices in automobiles were some of the first examples of this new form of navigation that depended on the correspondence of material interface (the windshield) and digital interface (the GPS device). The relationship between these interfaces has become so seamless that it has completely altered the way we embody the landscapes we inhabit.

GPS and Proprioception

Since space and embodiment are so intimately tied together, it is important to interrogate the ways that locative games develop a sense of player embodiment. From the outset, it is key for players to gain proprioception through the GPSr. Knowing where you are in space and how far away from the cache you are serve as the first correspondence between body and hybrid space. In order to get a clear

sense of location, however, the player needs to be in full view of GPS satellites. As the GPSr boots up, it is searching for signals from satellites, attempting to acquire an exact location through the correspondence of four of the 24 GPS satellites. Until this signal is strong, the player remains in a state of detachment from embodiment in the gaming space: the location on the interface does not match the material landscape and thus the relationship between the player's body, the cache, and the digital data augmenting the landscape remains fragmented. In this "patchwork of dis-connected states," as Bassett puts it, our sense of presence fluctuates between the gaps of connection and disconnection and also takes into account our attentiveness to the ways we inhabit mixed reality space. Bassett argues,

> As we increasingly switch our attention from one place to another, each time at the expense of the last (perhaps because we increasingly seek the sensation of connection over any sustained engagement with the discrete content it affords), our lives become fragmented. To an extent we become a "patchwork of dis-connected states". On the other hand, since attention never presumes absolute presence it cannot presume absolute disconnection. When I switch my attention into my phone, I leave some part of myself behind and as a consequence I have some part of myself to return to: to reconcile with. Perhaps indeed, I need to think harder not only about what and who I am between and across these states, between and across these spaces, but also about how I operate to make these moves in the first place.[28]

Since the player is seeking to engage the gaming space as an embodied interactor, he or she is dependent on the cohesive link between the various sites that produce locative gaming space. Until these sites cohere, the player remains unable to embody the gaming space of geocaching. The two halves that create augmented space—data and materiality—must correspond in order to produce this space and the bodies that inhabit it. Thus, a key to embodiment in this mixed reality space is being witnessed and acknowledged by the GPS satellites. This machinic gaze establishes locative presence in the gaming space and is confirmed by the interface of the mobile device. Gamers are keenly aware of the embodied gaze by the satellites due to the limitations of the technology: the GPS signal fades or does not function when there are objects (including cloud cover) blocking the view between GPSr and the satellites. This constant awareness of the proprioceptive space between the gamer's mobile device and the gaze of the satellites does much more than simply transform the GPSr into a type of prosthetic; instead, a sense of embodiment in locative gaming space is indelibly tied to the technology. As bodies and technologies work in concert, augmented space can be navigated as part of the locative gaming landscape.

This sense of technological proprioception works in conjunction with the embodied sign systems that players perform. By attempting to make their purposes

inconspicuous, players are not only aware of the gaze of the GPS satellite, but also aware of the gaze from the surveillance technologies and the people that are in proximity. While this engages the "being-for-others" phenomenology that Merleau-Ponty theorized, it also engages the inscriptions of embodiment and identity performance in public space. As noted in the example of the Auckland bomb scare, people who are perceived to be lurking and displaying suspicious behavior are often categorized as a threat to public safety. Gamers thus need to embody the sign systems of "purposeful movement" through public space in order to conceal their engagement with the space as gamers. This simultaneous phenomenology and embodied sign systems—sensory-inscription—develops a sense of embodiment that emerges from sensorial experience but also from socio-cultural texts that saturate the locale. This is the body of phenomenology converging with the inscribed body-as-text in a world of stimuli and signs. It is a body that co-produces spatial meaning with cultural objects such as GPS and surveillance technologies while simultaneously reading and being read as a particular body. It is a body that is space but also a body that inscribes the spaces it inhabits. In locative gaming, in which the player must inhabit the hybrid landscape of augmented space, the sensory-inscribed body affords players the ability to move beyond the determinism of a certain technology to engage the ways that meaning in the space is created by the sensorial stimuli with the socio-cultural texts. Technologies and bodies continually inform each other in the ways that they produce space and the significance of that space.

Hypermediating Locative Games

Flanagan writes in her book *Critical Play* that many of the games that I have been discussing throughout this chapter only address a small and privileged audience. Even the ethical dilemmas that I discuss that take place in games like *Momentum* or geocaching are the problems of those with access, privilege, and often power. Flanagan argues, "At a time when the gap between the richest and the poorest Americans is wider than it has been since World War II . . . it seems as though the transformations of the city as a game board have been destined for the enjoyment of the privileged."[29] She goes on to write,

> The use of location is a delicate matter, and artists making locative work need to recognize the prevalence of site as a social, discursive category. Scholars and artists must beware of a discussion of locative media that is ensconced in an unexamined rhetoric of innovation, liberation, and possibility . . . If play and interaction in the streets are to be empowering, exactly *who is to be empowered?*[30]

These are important questions and get at the essence of what these games are capable of and the audiences they are able to engage (and the audiences they

exclude). However, Flanagan's assertion that "few of the projects in this medium address key concerns like biotechnology, consumption, war, identity, militarization, or terrorism" overlooks many important projects (from the recent work of Ester Polak to the game-maps of Paula Levine) and also overlooks the potential of the games within what Flanagan terms the "entertainment colonization" category of games to be fully transformed to become sites of social critique.[31] What I hope to demonstrate here is how the arts and game design are essentially created out of a process of *bricolage* and the assumption that games need to be designed with social good in mind in order to ultimately meet the needs of social good is, ultimately, illusory. Instead, all games and spaces can be reimagined and formed out of a process of *bricolage* (all games, in fact, are created out of *bricolage*), a process that transforms them into something they were never initially designed for but in which they find their significance. Jacques Derrida describes this process as done by a *bricoleur*,

> someone who uses "the means at hand," that is, the instruments he finds at his disposition around him, those which are already there, which had not been especially conceived with an eye to the operation for which they are to be used and to which one tries by trial and error to adapt them, not hesitating to change them whenever it appears necessary, or to try several of them at once, even if their form and their origin are heterogeneous.[32]

Such is not only the basic form of games, but also the process of art and creation: we draw from the tools at hand to create something that was perhaps never intended from the design of the equipment we are given.

Here, I will point to several games that use *bricolage* as a form of creative misuse. Paula Levine's project *San Francisco ↔ Baghdad*, which was discussed in Chapter 2, uses geocaching in way that serves to critique the very infrastructure on which the game is built. Using GPS technology to find several geocaches Levine hid throughout San Francisco (each located at a spot related to where a bomb was dropped on Baghdad, positioned at various locations throughout San Francisco by overlaying a map of Baghdad on top of San Francisco), the contents of each game container held a list of military personnel who had been killed in the war up until that point. Thus, through a locative game, Levine's work utilizes the military technology of the GPS satellites to critique the military's actions in the war. Here, the game components are used to criticize and to bring to light the very structure that supports the game—military technologies and structures. While GPS were never designed with playful purposes in mind, Levine's use of the game of geocaching demonstrates one way that a locative game can engage creative misuse toward social change.

Similarly, popular entertainment games that use mobile devices have been transformed into sites of social critique through creative misuse. For example, the handheld game *Barcode Battler* was released in 1991 as a game that utilized barcodes

on game cards to perform character actions. By scanning the barcode on an in-game card, the player's in-game character would be able to perform actions from fighting enemies to leveling up various attributes. This game, though short-lived because of the emergence of handheld game systems such as the GameBoy released around the same time as the *Barcode Battler*, found its significance in the fact that any barcode could be incorporated into the in-game battles. Thus, much of the game play that emerged from the game was done by scanning objects in everyday space, even wandering grocery stores and shopping malls and scanning barcodes on random items to see the effects these objects would have on the in-game action and characters. Claus Pias writes in his article "Play as Creative Misuse,"

> But with this little handheld in your pocket, there exists the prospect of a "new legibility of the world"—or at least the commodity portion of it . . . Now, playing means going out into the real world, suspending the logistics of commodity economics and shelf-lives for which these barcodes were originally designed and diverting them experimentally in the direction of the logic of the game.[33]

This redirection of the meaning and purpose of a barcode for play allowed everyday objects to signify in a way that is completely unrelated to their cost, value, or purpose. Commodities are here only useful because they offer an in-game element, the barcode, which is incorporated into the playfulness of the game without regard for what the actual product is. Pias notes, "How could we possibly know whether cornflakes are more powerful magicians than sweaters or socks? Why should we assume that red wine possesses greater curative powers than a book of poetry by Trakl or a packet of sparkplugs?"[34] Ultimately, the materiality of the product and its use and exchange values are meaningless to the game play. The players are unaware how the scanned barcode will affect the game until it is done—object price or quantity does not affect how the barcode plays out in the game. Pias writes,

> Quantitative and qualitative distinctions between large and small, cheap and expensive, foodstuffs and electronic devices, clothing and household appliances, suddenly become invalid, and all use and exchange values become reconfigured. The difference between Coke and Pepsi is no longer a question of taste, conviction or lifestyle, but can be decided objectively in a contest between the two products. Your favorite chocolate bar may turn out to be a pitiful warrior when examined for its effectiveness in the game.[35]

Both *Barcode Battler* (when taken out into everyday life and used to scan various objects) and the geocaching project of *San Francisco ↔ Baghdad* work to reconfigure the ways we engage with the game spaces and how they interact with everyday life. For *San Francisco ↔ Baghdad*, GPS was never initially intended for

game play, but geocaching has taken this technology and made it one of the essential components of the game. Levine's work with this project goes further to undo the original intent of geocaching to make game play a part of a larger social critique of military technologies. By taking the original structure of the game and finding a means of creative misuse, *San Francisco* ↔ *Baghdad* functions as a means of hypermediating this locative game. Levine's project aims to get players to move beyond the immersion of hybrid game space, to instead step back and contemplate the technologies they have been using and to realize the current uses of those technologies in locations like Baghdad. Similarly, in *Barcode Battler*, when an expensive item is scanned but does little good against a cheap item, the ideas of exchange value can be critiqued. By reimagining what the use value is of an object according to the game, the everyday exchange value of an object ultimately doesn't mean very much. This form of *bricolage*, of bringing things together that were never meant to be collaborators, gives a new sense of the relationship between everyday life and emerging locative game spaces. These forms of creative misuse with popular entertainment games ultimately hypermediates the games and play environment for the purpose of socio-cultural critique.

However, it is important to note that although these games provide the space for social critique through *bricolage* and hypermediacy, this does not mean that players will automatically engage these alternate readings of space and culture. Flanagan rightly argues, "While art must indeed break borders, there are many instances where the borders broken are misguided and actually reinforce existing class, ethnic, and other power structures."[36] Thus, hypermediacy in a game doesn't automatically equate critical engagement, empowerment, or political change. In fact, it is possible that hypermediacy can instead simply reiterate the power structures present in everyday space. Flanagan goes on to argue, "If Lefebvre is correct in his belief that the creation of new spaces has the ability to change social relations, locative games must address history, lived experience, and site in order for both participants and designers to learn how to produce something better—another city, another space, a space for social equality and change."[37] Here, the ultimate goal of hypermediating locative games should be for the purpose of engaging users in the production of space and how these spaces can either reinforce or resist the dominant power structures.

One site-specific game that sought to engage and critique the everyday use of urban space is the *Big Urban Game*. In 2003, the Design Institute at the University of Minnesota created a game in which, over the course of five days, three teams raced to move 25-foot inflatable game pieces around the cities of Minneapolis and St. Paul, Minnesota (Figure 4.2). Designer Frank Lantz describes the game:

> Each day, local newspapers and the game's website showed the current locations of the three pieces along with two possible routes to each piece's next checkpoint. Players chose the route that they wanted their piece to take, submitting their votes online or through an 800 number. Each afternoon, a

team of volunteer movers carried the pieces through the city, following the selected route. The time needed to travel the route was recorded and added to the respective team's total time.[38]

For Lantz and his team of designers, which included Katie Salen and Nick Fortugno, the ultimate goal of the game was to hypermediate the city. He notes, "The goal of the project was to develop a tool that would change people's perspective on the urban space around them. In pursuit of this goal, the designers transformed the 'Twin Cities' into the world's largest board game."[39] Here, the space of the urban environment is transformed not only for players who actively engage the alternate purposes of the city, but also for passersby who experienced the spectacle of the streets being navigated by players pushing around a 25-foot game piece.

This sensory-inscribed embodiment of space produces an alternate purpose of the cityscape that draws people out of an immersive relationship to that space and instead forces people to question the prescribed routes that they navigate on a daily basis. For locals, who often take pride in knowing the various routes that are the fastest and least congested in a city, the purpose for these paths of least resistance

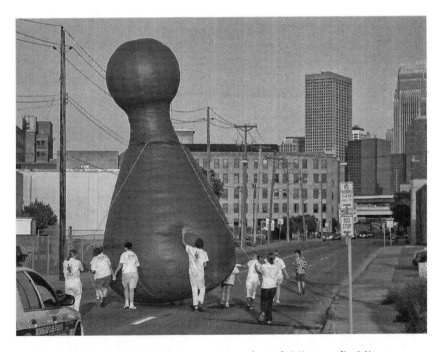

FIGURE 4.2 One team moving their game piece through Minneapolis, Minnesota as part of the *Big Urban Game.*

is not simply to avoid congestion during a work commute but is here used for the playful engagement with these routes.

As the production of space continues to emerge as a collaboration between the material environment and digital media, the relationship between these new spaces as they form hybrid space often is so immediate and natural that the actual *production* of the space goes uncritiqued. As these spaces become immersive and the interfaces become natural extensions of our everyday gestures, game designers and players need to seek ways that the interface becomes a space of critique rather than something that is looked past toward the content of the space. The content, rather than being that which exists once users move through the interface, is so intimately tied to the media it is conveyed through that any idea of the interface is insufficient if it does not take these to be bound together. As designers and players hyper-mediate the game interfaces by drawing attention to the modes of mediation, this is only the first step in transforming these spaces for socio-cultural critique. Ultimately, the significance of locative media to gaming and the arts is the way that embodied engagement with mobile devices allows users to function as a hinge between play and everyday spaces. By performing across these spaces, gamers will be able to expose the ways that the categories of "the virtual" and "the actualized" (to draw on Deleuze's terminology) never occupy the status of grounded signifiers. Locative games serve as a key demonstration of how gaming can fluctuate between the categories of play, the everyday, virtual, and actualized, combining them at times, dismantling them at others, in order to create a distinct sense of embodiment in pervasive computing space. Allowing the critical distance that is achieved through hypermediation of these games to serve as the springboard into meaningful dialog about the structures and limitations of space and the amount of agency people have in navigating those spaces is key. While *bricolage* offers a significant step toward this space of critique by forcing the juxtaposition of dissimilar and seemingly incongruous objects (such as the large game piece in the *Big Urban Game* against the backdrop of the city), these experiences of space must continually be reiterated and given locations where the communities may be able to engage and express these new perspectives. In the chapters that will follow, I will analyze several projects that explore the possibilities for various ways to document these experiences of space—a process that serves to reinforce and even reinscribe the modes of production of locative space.

5

PERFORMANCES OF
ASYNCHRONOUS TIME

Simon Faithfull begins his performance art piece *0.00 Navigation* by swimming ashore at the southern end of England in the town of Peacehaven. As he emerges from the waters of the English Channel, he is fully dressed in black pants and a black sweater. He takes the GPS receiver out of his pocket. He is exactly at the Prime Meridian and starts his walk along this longitude. His project is to walk the entire length of the Meridian across England, regardless of what may get in his way. Immediately obstructing his walk are the large white cliffs of Peacehaven that begin at the edge of the beach. His slow climb up the side of the sheer cliff takes several minutes, but once he reaches the top, he again pulls out his GPS receiver and continues his journey along the line that demarcates Greenwich Mean Time. We see all of the action from the point of view of the camera that is filming him, which is always from behind. Through the black-and-white footage, we follow Faithfull as he stays as true to the Meridian as possible. At times, however, the single cinematographer cannot follow Faithfull's journey down steep ledges or wading slowly across canals that go up to his chest. Instead, we watch from afar. At other times, we are right on his heels as he hops over picket fences and through the homes of strangers. As Faithfull says of the piece, "I am interested in the maps that we create in our heads. These maps are a combination of our immediate locale (the humdrum everyday world we move in) and the other psychological world that we hear of from afar."[1] *0.00 Navigation* is a performance of the process of signifying the space of the Prime Meridian. In other words, his is a performance of the lived practice of life along the Meridian as it contrasts with the many imaginaries around this space. For me (somewhat foolishly), the Prime Meridian signaled an emphatic relationship to north-south bearings, yet in most of the footage of Faithfull's performance streets took odd angles, rarely conforming to the north-south trajectory I had inscribed on my imaginaries of this space. This is

one key element to this project: how our practices of space conform or disrupt the imaginaries of those spaces.

Faithfull's locative performance also brought up an important question for me: Who is the audience of this piece? Am I, as the viewer of the film, the intended audience? Is it the person following him with the camera (whoever he or she may be)? Perhaps the audience is made up of the passersby on the streets or the owners of the homes he walks through. Alternatively, maybe Faithfull is performing for the technology he is engaging: his performance is for the gaze of the GPS satellites. While we can answer by saying "all of the above," the question itself provokes another meaningful inquiry that resonates throughout mobile media culture: where does the *primary action* take place? Intimately tied to this inquiry is the question of time (especially since Faithfull's project is to walk along the line that, for most, represents the standardization of global time): in what time does the primary action take place? By staging his performance of the Prime Meridian as a document that must be accessed at a later time, we confront these questions of audience presence and performance time.

Throughout this chapter, I look at performances that utilize mobile and locative media to engage participants and performers in the tension over ideas of co-presence and mediatized interactions. How do our mediated interactions—especially ones that take place in asynchronous time—foster a sense of embodied connection across space? The history of Western culture has practiced its affinity for logocentrism: the idea that the human voice (and all that's coupled with it, such as embodied proximity and face-to-face interactions) has been the seat of full, embodied "presence." But our recent practices with mobile technologies have showed a different prioritization: we are increasingly connecting through asynchronous technologies like text messaging instead of through synchronous technologies like phone calls. By looking at performances similar to Faithfull's *0.00 Navigation*, I will argue that our practices of embodied engagement with mobile devices are challenging the temporal nature of presence and ideas about what constitutes a primary action.

Interrogating Notions of "Co-Presence" and "Mediated" Interactions

Performance has had an historic tension with asynchronous engagement, especially with recording technologies that, as Peggy Phelan has argued, transform performance into something else. A document that is accessed at a later time is different than the performance itself. Phelan argues,

> Performance's life is in the present. Performance cannot be saved, recorded, documented, or otherwise participate in the circulation of representations *of* representations: once it does so, it becomes something other than performance. To the degree that performance attempts to enter the economy

of reproduction it betrays and lessens the promise of its own ontology. Performance's being, like the ontology of subjectivity proposed here, becomes itself through disappearance.[2]

As digital technologies began to be used extensively in the performing arts, the tension around issues of liveness became a distinct focus of emerging debates and scholarship. At the foundation of these debates were the practices of distance and reproducibility. In the digital age (of coded reproduction and virtual simulation) the question seems to pivot on whether or not art needs to exist in a singular time and place—thus existing as something "rare"—in order for it to be truly art. Responding to Phelan's "ontology of performance," Philip Auslander's 1999 book, *Liveness*, countered notions that there remain clear-cut distinctions between the "live" and the "mediated." Instead, for Auslander, the categories of live and mediated have taken on such intimacy that they no longer function as opposites. Instead, the categories inform each other. The blending and blurring of the lines between what was once considered live and mediated have prompted scholars and practitioners to question the validity of imbuing such terms with significance. Writing in the context of performance studies, Auslander frequently turns to rock concerts as an example of the interplay between these once-distinct categories. He writes:

> Live performance now often incorporates mediatization such that the live event itself is a product of media technologies. This has been the case to some degree for a long time, of course: as soon as electric amplification is used, one might say that an event is mediatized. What we actually hear is the vibration of a speaker, a reproduction by technological means of a sound picked up by a microphone, not the original (live) acoustic event.[3]

He continues by showing how the live event is completely altered by such mediatization. The effects of the intimate interplay between these categories are cyclical. Documents often become the referents for a live performance, as seen in the practices of people who memorize every pitch and intonation of a performer on a recording, subsequently comparing the live act to the "document." Thus, the live is in reference to the recorded (rather than the recording being a referent to the live).[4]

Perhaps all encounters are imbued with some form of mediatization. As performance art scholar and historian Amelia Jones argues, "[T]here is no possibility of an unmediated relationship to any kind of cultural product, including body art." She goes on to state:

> Although I am respectful of the specificity of knowledges gained from participating in a live performance situation, I will argue here that this specificity should not be privileged over the specificity of knowledges that

develop in relation to the documentary traces of such an event. While the live situation may enable the phenomenological relations of flesh-to-flesh engagement, the documentary exchange (viewer/reader <-> document) is equally intersubjective.[5]

This notion of mediated knowledge even holds sway over interactions that we would typically call "non-mediated." For example, face-to-face encounters with a new person are often informed ahead of time by some form of mediated information such as a presence the person maintains online. Also, these encounters are often structured around interactions that are established, practiced, and reified through media forms such as television, cinema, and online media.

Yet, there continues to be cultural investment in notions of liveness and immediacy: as the layers of mediation seemingly distance people from each other, social relationships that are developed in these spaces are often labeled as less "real" than face-to-face social interactions. While I still (surprisingly) see these responses in the university classroom when I have students study virtual communities (such as chat rooms, MMORPGs like *World of Warcraft*, and even the social networks discussed in the previous chapter), I am aware that these tensions are very time- and media-specific. A mediated social environment that students are resistant to one year is often embraced the next (and vice versa). Also, forms of mediated interaction that have become less used, such as the text-based chat room, are considered by students to be ill-suited for embodied engagement. The resistance to mediated social interaction is very much a companion to the resistance felt in the performing arts around the status of the live body. For many, like performance scholar Herbert Blau, the power of theater is, "In a very strict sense . . . the actor's mortality which is the actual subject [of any performance], for he is right there dying in front of your eyes."[6]

These debates around the status of liveness have a profound impact on performance art projects that utilize mobile technologies. This impact also extends into our everyday uses of mobile devices. For example, in his book *New Tech, New Ties*, Rich Ling interrogates the relationship between "co-presence," which is understood as face-to-face interaction, and "mediated" interactions that take place over a device such as the mobile phone. While Ling does little to define or justify the opposition between these terms, such a stance is quite common in analyses of mobile phones and their impact on interpersonal communication. For Ling, mobile technologies are constantly testing the ways we prioritize face-to-face contact. He writes, "When the phone rings, we need to act quickly to either disallow the call and give priority to the co-present activity or rearrange the social furniture and give the call priority. In either case, the sanctity of the co-present interaction is put to a test."[7] Ling's categorization of the "co-present" as functioning as an opposite to the "mediated" demonstrates the cultural capital placed in the co-present as something sacred, something that should not be interrupted by mediated forms of interaction. He continues,

The use of a mobile telephone in a co-present situation helps us understand the sanctity of the primary engagement and its vulnerability to other secondary interactions. As an amplification of Collin's centrality of co-presence, the use of the mobile telephone as a secondary device, and more importantly our willingness to put it away when the main event starts, points to the importance of the main engagement.[8]

Ling's analysis of the relationship between these two categories does hold some weight. The cultural mores that delineate the acceptable times to use a mobile phone do indeed seem to point toward the primacy of the co-present interaction. Yet, Ling's approach is deficient in a couple of important ways. First, his emphasis on the co-present as the "primary engagement" and the "main event" in contrast to the interaction over the mobile phone as "secondary" mischaracterizes the significantly embodied way we connect over mobile devices. Secondly, his analysis overlooks how the "co-present" itself has been transformed by mediated interactions. This alteration of our cultural understanding of what "co-present" means has been so vastly overhauled to the point that even the categories themselves have become problematic. So, while Ling's analysis is compelling at times, it fails us simply by utilizing the opposition between "co-present" and "mediated." Though his analysis does seek to show how the two categories are blending in interesting ways, his approach does little to discredit the opposition.

When read through the lens of performance studies, especially in the debates concerning liveness, this distinction between the co-present and the mediated does not hold. Auslander's work seeks to undo the hierarchy between these two spheres by showing how intimately connected they are: "The rhetoric of mediatization embedded in such devices as the instant replay, the 'simulcast,' and the close-up, at one time understood to be secondary elaborations of what was originally a live event, are now constitutive of the live event itself."[9] Thus, while not discrediting Ling's observation of the social mores still in place about when it is appropriate to take a call on a mobile phone, categorizing such forms of communication as "secondary interactions" is no longer valid in an era in which the mediated can actually constitute the live event. I argue instead that these mediated interactions over mobile devices offer us a distinct sense of social proprioception that leads to our sense of embodiment in the digital age. Emerging practices of mobile communication point to the various ways we engage each other through our devices: increasingly, we use our mobile phones to maintain social, embodied connection through asynchronous means.

Text Messaging and Co-Presence

2009 marked the first year that mobile phones were used predominantly for data transfer instead of for voice communication. Data transfer on mobile devices now takes many shapes, including email, websites, apps that draw from online databases,

video and image sharing, and digital downloads from stores like iTunes. Even the standard text message is carried out as a data transfer. The practice that Howard Rheingold noticed of mobile phone users in Tokyo in 2002, when they were staring at their phones rather than talking into them (as chronicled in the opening passage of his book *Smart Mobs*), has now become the main way these devices are used.[10] As I began to see this trend emerge, especially in teens and college students, who were more inclined to text instead of make a phone call, it began to dawn on me that the anxiety between these two modes of using a mobile phone has deep historical roots in the tension between co-presence and mediatization. The tension between these categories can be traced back to the very inception of modes of art and documentation, as seen in Plato's diatribe against art and writing in the *Phaedrus*. For Plato, forms of documentation (which included art and poetry) signaled distance and could never achieve embodied presence the ways synchronous forms of art and communication could. Such value judgments still run through many cultures, especially in discussions of how mobile devices are used. As Kenneth J. Gergen argues in his analysis of forms of art and communication that prioritize "absent presence" rather than synchronous engagement: "The erosion of face-to-face community, a coherent and centered sense of self, moral bearings, depth of relationship, and the uprooting of meaning from material context: such are the repercussions of absent presence. Such are the results of the development and proliferation of our major communication technologies of the past century."[11] These sentiments invest in a nostalgia that overlooks the role distance and asynchronicity play in all community building and forms of communication. This relationship between asynchronous communication and community building is especially noticeable as the categories of co-presence and mediated have become intertwined and collaborative concepts.

But why are we drawn to asynchronous forms of communication with our mobile devices? In one sense, asynchronous forms like text messaging best address the medium of the mobile phone. As Ling rightly notes, voice calls between mobile phones directly address the individual regardless of his or her current location, activity, or availability. Voice calls to a mobile phone can thus intrude on a person's everyday life. Text messages, on the other hand, allow people to connect and interact within the fabric of the day.[12] The text message assumes that the person will respond as the situation allows. Recent studies of mobile phone used by teens in several countries, including Norway,[13] Korea,[14] and Taiwan,[15] have also shown that asynchronous communication over mobile devices helps develop and sustain intimacy among small groups of friends. Ling's reasoning for this "fostering of internal cohesion" parallels Manuel Castells' idea that, although "groups are often born in co-present situations, they are reinforced via wireless interaction."[16] What Castells and Ling fail to acknowledge, which directly relates to mobile media performances, is how the asynchronous wireless interactions become the site of the primary engagement, which then carries over into everyday, face-to-face interactions. The assumption that mobile devices only serve to

reinforce co-present activities fails to acknowledge the intimacy fostered by asynchronous mobile communication, which often functions as the main, embodied space for social interaction.

Asynchronous Dance

The production of embodied space as an intersubjective process is a core concern for the performing arts. With the emergence of digital technologies, performers have sought to experiment with embodied interactions across digitally mediated spaces. Increasingly, the mobile phone is becoming an important medium for this kind of exploration. Susan Kozel, who is a dance practitioner and scholar, wanted to investigate the level of embodied intimacy and engagement afforded by asynchronous mobile communication and thus designed an ongoing dance project called "IntuiTweet." Started in 2009 as part of the "Intuition in Creative Processes" initiative (a Helsinki-based collaboration between dance researchers associated with the Theatre Academy—Leena Rouhiainen, Mia Keinänen, and Susan Kozel—as well as designers from the Media Lab of the University of Arts and Design), IntuiTweet connects dancers on Twitter and asks them to compose movements for each other throughout the day. The guidelines of IntuiTweet are as follows:

a. take a moment to listen to your body and notice a movement intuition or sensation
b. code it into a Tweet of 140 characters or less
c. send it to other participants by SMS through Twitter
d. when a Tweet is received, improvise it immediately or with a time lag (hours or days)
e. notice how it has morphed in your own body over time and through space
f. re-code it into a fresh Tweet and re-send it to be received and improvised once more.

The dancers engaging in this piece would thus communicate their embodied state to the other dancers, wherever and whenever they may be. The recipients interpret this message, sent through Twitter and received as a text message on the mobile phone, as a call to movement, as a call to dance. Kozel compares this type of distant connection to a mediated version of contact improvisation, in which the movements of one dancer against another dancer's body alter the overall composition of the dance. By taking this mode of contact improvisation and making it asynchronous, the action of "contact" morphed into something new as it dwelled over time with the person who received the message. For example, Kozel received a message from one of the other dancers that read: "fluid legs made me want to walk sideways or at least to waver, no more straight lines. soft peripheral focus make me a bad pedestrian." When received, Kozel was driving home, thus unable to enact her reading of the call to movement: to fall on all fours.

Once arriving home, Kozel fell to her knees in her kitchen and then responded back to the dancers: "Bad pedestrian made go on all fours and crawl which I happily did in the comfort of my kitchen :-)" Kozel says of this type of asynchronous call to movement: "This was another dimension of asynchronicity: it was possible to let a particular gesture or movement quality enter one's body and morph into something else over time, to be transformed and sent off once again."[17] The asynchronicity is inscribed into the movements of the performers. Their contact with each other is something that takes on a particular character because of the expectations of delay and the ability to fold the movements into the fabric of everyday life.

This mode of embodied engagement in asynchronous performance reinforces an idea of social proprioception. Connecting with others—especially with their inscriptions over Twitter about the state of their embodiment—throughout the day transforms how the receiver's relationship to social space is encoded and experienced. As Kozel notes, "The temporal dimension of duration is folded in with the 'circumlocution' of life: as I weave through my daily existence, the movement trace stays with me, fading or embedding itself in my imagination, to be forgotten or transformed into another message."[18] This mode of social proprioception is, of course, also possible with synchronous forms of communication: artist Jen Southern created a mobile media app called CoMob that tracked people's real-time location through GPS, connecting each participant with a line that created an ever-changing web of visible connectivity. Southern made a long-distance walk across England (similar to Simon Faithfull's journey), using CoMob as a means for her network to keep up with her movements in real time (and vice versa). However, an important distinction between real-time social proprioception, like Southern's CoMob project, and asynchronous social proprioception, like Kozel's IntuiTweet, is the ways these modes of temporality reinforce notions of presence and absence. Asynchronicity assumes distance and thus a form of disembodied engagement. The work that performers like Kozel are trying to accomplish exposes this false relationship and reconnects modes of asynchronicity with significant experiences of embodied engagement.

Within these asynchronous performances, media specificity plays a vital role in the sensory-inscribed relationship to embodied engagement. By using Twitter, Kozel is seeking to create intensely embodied encounters through a medium that, early on, was described as "pointless email on steroids," and "stupefyingly trivial."[19] Especially in the wake of uses of Twitter in the 2011 revolutions in Egypt and Tunisia as a form of social consciousness and an embodied collaborative medium, the uses of asynchronous forms of communication on mobile devices is creating social engagement in significant, embodied ways. Kozel's IntuiTweet project, by using a medium that restricts communication to 140 characters at a time, demonstrates that the potentials of a particular medium are found in practices that embrace its media specificity. As Clive Thompson notes, "But the true value of Twitter . . . is cumulative. The power is in the surprising effects that come from receiving

thousands of pings."[20] Thus, reading an individual tweet outside of the context of the particularities of the medium through which it is conveyed (and the medium on which it is received) would produce a misreading of the platform's effect on embodied space.

The relationship between media specificity and issues of presence and absence was performed by the troupe plan b in their performance *A Message to You*. Plan b is a collaboration between Sophia New and Daniel Belasco Rogers, artists from the UK who explore the relationship between locative technologies and place. While much of their collaborative work as plan b focuses on the relationship between inscriptions of embodied space through technologies, *A Message to You* stands out because of its stripping of the media specificity away from the mobile device. From 2006 to mid-2008, New and Rogers saved every text message they sent to each other and decided to perform a reading of these texts at the 2008 Anti Festival in Finland. Stationed on opposite sides of a stadium, they shouted the nearly 600 text messages back and forth for three hours. The experience of hearing these text messages read aloud provides for an uncanny relationship to the content that is stripped from its medium and forced onto another (the human voice). In this performance, plan b engages a medium that is distinctly out of context, both in format and time. The performance takes place through the human voice (which, for New and Rogers, gets hoarse from attempting to shout across the width of the stadium) instead of through text. Also, the performance takes place in synchronous time, removing the temporal nature of the text message. Though the performers are within earshot of each other, *A Message to You* performs the incongruity between proximity, synchronicity, and presence. The human voice and co-presence are insufficient here to bridge the distance between the performers to provide the sense of intimacy provided through asynchronous media like the text message. Though there is weight to the social connections that take place through text messages, it would be dangerous to imbue these forms with full presence in the ways that have historically been associated with synchronicity and the human voice. Instead, as Derrida has noted, ideas of presence and absence need to be undone. These categories need to be read as ongoing processes that flow in and out of each other, never fully arriving at either end of the spectrum.

Rider Spoke and the Absent Voice

One of the most poignant performance pieces to explore the tension between community, presence, art, and documentation is Blast Theory's *Rider Spoke*. This mobile-media performance engages participants in the production of social, asynchronous space, and will serve as my primary focus of the rest of this chapter. When arriving at the Barbican Museum in London, visitors to the *Rider Spoke* "performance game" were given a bicycle, a helmet, and a mobile device (Figure 5.1). The device, a Nokia N800J, was equipped with an earpiece and a micro-phone. Not the typical museum installation piece, *Rider Spoke* asked participants

FIGURE 5.1 *Rider Spoke* by Blast Theory. A participant listening in on another person's recorded narrative near the Barbican Museum in London, October 2007.

Image © Blast Theory.

to ride around the streets of London, guided along their journey by the voice of Blast Theory co-founder, Ju Row Farr. The first objective for participants, as directed by Farr, was to "relax and find somewhere that you like. It might be a particular building or a road junction. When you have found somewhere you like, give yourself a name and describe yourself." When located in a spot of their choosing, the participants would press "record" on the device's interface and speak into the microphone. Their narrative would be geotagged through a triangulation by mobile phone towers or WiFi access points. The recordings were then archived and accessible by any other participant who happened upon that same location. Participants in *Rider Spoke* were prompted to either "Hide," which allowed them to find a location related to one of Farr's prompts such as "Find a place that reminds you of your father and record a story about it," or "Find others," which allowed users to "seek" other people's narratives located throughout the city. These two options were the mobile device's main interface and highlighted the piece's relationship to social gaming and a common history of childhood play.

The performance premiered in London in October 2007 and subsequently traveled to Athens, Brighton, Budapest, Sydney, and Adelaide. *Rider Spoke* is a key example of the type of work produced by Blast Theory, work that dynamically intersects mobile devices, performance art, and gaming in urban environments. Their first foray into working with locative media in pervasive computing space was the 2001 game *Can You See Me Now?*, which toured worldwide. This game,

similar to many of the locative games discussed in the previous chapter, functioned like a high-tech game of tag: *Can You See Me Now?* involved 20 online players, who were chased through a virtual simulation of the city hosting the game. Four players with GPS receivers ran through the material city, attempting to catch the virtual players who were displayed on the mobile device. Online and physical-world players communicated to each other via text message, and the players in the physical city could communicate to each other on a walkie-talkie channel. Online players were able to eavesdrop on the physical-world players' conversations and develop a strategy out of the information gathered. Performances by Blast Theory in the years following *Can You See Me Now?* typically involved mobile devices and interactions between everyday space and digital interfaces. *Rider Spoke* stands out from games like *Can You See Me Now?* in the alteration of the "affinity space" that participants inhabit: a space where the interactors bond through a common purpose and goal. As the interactors cycle around London, there are no competitors, the pace is decidedly slow to match Farr's soothing tone of voice over the headset, and there are no winners or losers. Instead, the performance functions more as a comment on the ways in which intimacy is established and sustained between people over mobile devices.

Rider Spoke is thus a performance about documentation: by leaving messages scattered around the city for others to find at a later time, the piece asks participants to perform the tension between the voice and asynchronous forms of communication. By geotagging oral narratives recorded on the mobile device, *Rider Spoke* participants are able to assert their embodied "presence" in this emerging mixed-reality space; however, this assertion of presence is complicated by the various levels of mediatization that occur. What this chapter seeks to demonstrate, through the example of *Rider Spoke*, is how the use of voice over mobile phones is a way to create embodied connections and a sense of presence between interlocutors.[21] While such presence gained through the voice has a long history dating back to Plato's *Phaedrus* and sustained through psychoanalytic theories, this embodied presence is highly complicated by the ways that the subject is created through a vast network of mediatized elements. *Rider Spoke*'s use of the participants' voices as the primary mode of communication over the mobile devices demonstrates the ways that embodied presence and disembodied absence are not simply binary opposites. Instead, they are complimentary notions that cooperate to redefine what it means to inhabit space in the digital age of pervasive computing.

Listening in on participants' voice messages on *Rider Spoke* invokes the various ways the voice over telephone was perceived at different moments in history. For example, media artist Nam June Paik said in his 1984 essay "Art and Satellite":

> Thoreau, the author of *Walden, Life in the Woods*, and a nineteenth-century forerunner of the hippies, wrote, "The telephone company is trying to connect Maine and Tennessee by telephone. Even if it were to succeed,

though, what would the people say to each other? What could they possibly find to talk about?" Of course, history eventually answered Thoreau's questions (silly ones, at that). There developed a feedback (or, to use an older term, dialectic) of new contacts breeding new contents and new contents breeding new contacts.[22]

Though he misquoted Thoreau, Paik's point comes across very clearly, since the problems with communication over the telegraph carried over into worries about the telephone.[23] At a certain point in the early development of the telephone, the voice symbolized distance. It represented the distance between neighbors who no longer had to stop by to keep in touch but could simply call.[24] It represented the distance of embodied communication, since by reducing the self to a voice meant that most non-verbal cues vanished. It represented the kind of contact people maintained because the person on the other end of the line often could not be physically present. Though the early adoption of the telephone went without much fanfare (due to the earlier excitement of the telegraph—a technology that people felt, once established, met all their requirements; thus, why should they move over to the telephone?), critiques that this emerging medium would create an unnecessary distance between people and create a technological depersonalization of culture soon arrived.[25]

In performance, however, the voice *is* the self, the identity of the character, full presence. Voice is action. Action confirms embodiment. Thus, Blast Theory's connection with the context of performance invokes this relationship between the actor and voice-as-action that fills the performance with embodied presence. This understanding of the voice confirming the self's full presence echoes throughout psychoanalysis. From Freud through Lacan, the voice was used to talk beyond the ego in order to get at the true self. Full presence of the self was gained through a "talking cure." By speaking about your problems to the therapist, you were able to use dialog as a means to talk beyond the false fronts established by the ego. Through the voice, you potentially arrived at the full presence of the self. Blast Theory's performance harkens back to the correspondence between voice and therapy: Farr's voice guiding the participants operates very much like that of a therapist. Her questions prompt the users to open up and talk about personal stories to total strangers. Questions interrogate topics such as family, sexuality, and taboo. Through getting participants to talk, the performance game calls upon the psychoanalytic ideas of presence gained and established through the voice.

By utilizing the voice as the primary mode of communication, *Rider Spoke* also draws on the rich historical tension between the voice and the arts. As mentioned at the beginning of this chapter, Plato's diatribe against the arts in his dialog *Phaedrus* famously notes that the arts give people the illusion of understanding but are unable to give *true* understanding because they cannot speak and answer questions that the viewer or reader might have. Plato writes:

But the king said, "Theuth, my master of arts, to one man it is given to create the elements of an art, to another to judge the extent of harm and usefulness it will have for those who are going to employ it . . . Thanks to you and your invention [writing], your pupils will be widely read without the benefit of a teacher's instruction; in consequence, they'll entertain the delusion that they have wide knowledge, while they are, in fact, for the most part, incapable of real judgment."[26]

According to Plato, because a student could read but not be in dialog with an instructor, writing and the arts symbolized distance. They were simply representations by someone not physically present and thus unable to answer questions concerning the work. As Plato argues, if you were to ask a painting what it meant, it would sit silent, unresponsive. In contrast, an embodied person who was able to speak up signified full presence.

Plato's arguments obviously overlook the intricate relationship between writing, representation, knowledge, and presence as argued by many scholars and artists, perhaps most famously done in Jacques Derrida's essay "Plato's Pharmacy." To summarize (at the threat of oversimplification), Derrida's argument was that, though the voice was seen as originary and writing as secondary by many philosophers, our relationship to the ways signification occurs is constantly in a state of deferral. Signification is never grounded or settled and is always in process, regardless if the mode of signification is through the synchronous spoken word or the asynchronous text message or voicemail. As Barbara Johnson summarizes:

> Derrida does not simply reverse this value system and say that writing is better than speech. Rather, he attempts to show that the very possibility of opposing the two terms on the basis of presence vs. absence or immediacy vs. representation is an illusion, since speech is *already* structured by difference and distance as much as writing is. The very fact that a word is divided into a phonic *signifier* and a mental *signified*, and that, as Saussure pointed out, language is a system of differences rather than a collection of independently meaningful units, indicates that language as such is already constituted by the very distances and differences it seeks to overcome.[27]

And while this poststructural position has been argued for decades, the cultural value placed in synchronous time as opposed to asynchronous time in mobile communication (i.e., talking over the phone in real time versus sending texts or leaving messages) renews this discussion. The study of mobile technologies is highly concerned with the impact of mobile devices on social time. From Castells' argument that "timeless time as the temporality that characterizes the network society is also enhanced by mobile communication"[28] to Nicola Döring and Sandra Pöschl's discussion of the interpretations of the time lag in text

message conversations, theorizations of the mobile phone's impact on conceptions of time cover a wide array of perspectives.[29]

Rider Spoke engages the tension between the categories of presence and absence as they relate to synchronicity and asynchronicity. Though the voice is utilized as the primary mode of engagement with this performance piece, the voice (that which has been argued to signal full presence) is never placed in synchronous time. There are no conversations in real time. Instead, there are only voice documents that augment the city landscape. The voice becomes a document. Significantly, in *Rider Spoke*, the document becomes the event itself, and thus there is a reversal over what constitutes primary and secondary elaborations of an action. While the traditional trajectory has been from the "live" event to the production of a document of that event, here, the entire event *is* a document (and documents are events). Finding recordings and leaving recordings around London is the main activity in which participants engage. Thus, documentation is the primary action. Rather than the document being subordinate to the event, it is the event itself. The act of engaging documents and creating them transforms the purpose of the city streets the riders navigate. The "live" city becomes imbued with meaning in the performances of self and place that litter street corners and entrances to buildings.

GPS and Embodied Space-Time

Embodied intimacy gained through the voice is done asynchronously in *Rider Spoke*, but this intimacy is achieved through an alteration of the ways mobile devices transform time. Though communication over mobile devices can take place asynchronously at times, there is a sense of being what Sherry Turkle terms "the tethered self":

> We are tethered to our "always-on/always-on-you" communications devices and the people and things we reach through them . . . Animate and inanimate, they live for us through our tethering devices, always ready-to-mind and hand. The self, attached to its devices, occupies a liminal space between the physical real and its digital lives on multiple screens . . . With cell technology, rapid cycling stabilizes into a sense of continual co-presence.[30]

Mobile technologies have transformed the categories of synchronous "presence" and asynchronous "absence" into simply a social proprioception of "continual co-presence." This notion stands in contrast to the opposition between co-presence and mediatization. As Castells puts it, "Personal networks of communication never leave the individual."[31] Thus, simply by being tethered to the device, we are engaging in a sensory-inscription of continual co-presence that does not require the modes of immediacy typically attached to the practices of synchronous communication.

Extending Turkle's argument, the "things" we connect to are equally important in embodying us in this new conception of time gained through the mobile device. This is especially poignant in the relationship between the mobile devices used in *Rider Spoke* and *0.00 Navigation* and the GPS technology that locates the performers in a specific place at a specific time. Mark Hansen, in his article "Movement and Memory: Intuition as Virtualization in GPS Art," quotes GPS artist Laura Kurgan's discussion of the relationship between the performer's sense of embodiment in specific time and space through GPS technology:

> Frozen in the second that defines a point's registration, the satellites constitute or imply a network of planes . . . the planes of a transmission, of the relay or passage of information at the speed of light, and of information that amounts to nothing more than the record of their own positions . . . Their orbital paths define the movements which link them as a network, a series of nodes defined only in relation to one another, but the pathways followed by their radio transmissions are as much temporal as spatial.[32]

For Hansen, such a statement ushers in a new moment of embodied relations to technology. Now, a person is able to locate him or herself in space and time in a concrete way and such an action fundamentally alters our embodied conception of "placetime." Hansen writes, "As the contemporary specification of clocktime, GPS opens the possibility for a measurement of time—or better, of placetime— that, while remaining homogenous from the perspective of mathematical abstraction, inscribes a concrete material delay, a concrete complex of material oscillations, at the very core of our contemporary experience of time."[33] Thus, by having their voices geotagged, participants in *Rider Spoke* are able to document their embodied presence in the city at a specific moment in time. The technology of the GPS functions as a silent and machinic witness to the state of physical embodiment and presence in the mixed-reality space of the city. So, although the network of participants is connected asynchronously, they are equally embodied through their relationship to the locative technology that engages them in a reciprocal feedback loop of space-time information. This blending of heightened asynchronicity and intense synchronicity inform the sensory-inscribed embodied interaction that takes place in these performances. This analysis of *Rider Spoke* has brought up many of the issues faced by users of mobile devices including the status of embodied presence or disembodied absence and synchronicity and asynchronicity. Such oppositions rarely hold under scrutiny. While the tensions between these categories are necessarily confronted when participating in *Rider Spoke*, the participants must perform the tension in order to embody a dialectic response to these false oppositions. As Marsha Kinder argues, "One productive way of avoiding these two extremes . . . is to position the user or player as a 'performer' of the narrative."[34]

Critiquing Interpellation by Locative Technology

Thus far, I have established ways that embodiment and telepresence across mobile devices is achieved asynchronously. Such embodiment is essential for mixed media performance games like *Rider Spoke* to engage participants. However, the locative arts, like those produced by Blast Theory, have come under intense fire for the ways their engagement with embodiment intersects with corporate and military interests. Those who critique such pieces are willing to acknowledge that embodiment in the locative arts does happen. The problem is that such embodiment comes through a process of interpellation from infrastructure and capital that are placed in an agenda-laden context. As Marc Tuters and Kazys Varnelis note:

> The reluctance of many locative-media practitioners to position their work as political has led some theorists, such as Andreas Broeckmann (director of the Transmediale Festival), to accuse locative media of being the "avant-garde of the 'society of control'", referring to Gilles Deleuze's description of the contemporary regime of power. Broeckmann suggests that, since locative media is fundamentally based on the appropriation of technologies of surveillance and control, its practitioners have a duty to address that fact in their work.[35]

Tuters and Varnelis go on to cite Brian Holmes, who argues, "Because the U.S. Army controls GPS satellites, in using them we allow ourselves to be targeted by a global military infrastructure and to be 'interpellated into Imperial ideology'."[36] By engaging the military infrastructure without enacting a critique of that infrastructure, locative artists like Blast Theory are encouraging an embodied subjectivity that is necessarily established through the ideologies that contextualize the technology. The embodied subjects of *Rider Spoke* are contextualized within the military structure, rather than subverting such controlling structures or operating outside of them. Joining the critique of the uncritical ways locative artists engage their technology, media artist Coco Fusco argues, "It is as if more than four decades of postmodern critique of the Cartesian subject had suddenly evaporated . . . In the name of a politics of global connectedness, artists and activists too often substitute an abstract 'connectedness' for any real engagement with people in other places or even in their own locale."[37]

Beyond the utilization of military infrastructure as one of the core technologies they employ, Blast Theory are also well known for their corporate collaborations. *Rider Spoke*, for example, was sponsored by Trek, the bicycle company, and Sony NetServices. Tuters and Varnelis note, "It appears that for the moment a fair number of locative media producers seem content to collaborate with industry and government . . . This new media art practice is often eager to blur distinctions between art and capital. It is no coincidence that one of the most important media-art blogs today goes by the name 'We Make Money Not Art'."[38] So, while users

may indeed embody each other across the space of the augmented city landscape as it is overlaid with geotagged narratives, the users are also embodied as corporate subjects (consumers) and subjects of the state (citizens). Such a level of embodied interpellation typically goes unnoticed or is dealt with as though it were unremarkable.

In seeking ways that artists can deal with this level of embodied interpellation, artists and scholars alike continue to explore a wide array of solutions. Though the issue of how to confront the controlling structures of corporations and government while creating art *within* those structures is not new to new media (I am thinking, for example, of Audre Lorde's famous phrase, "The master's tools will never dismantle the master's house"), such issues have taken on new currency with corporate and national interests in the uses of locative art. One approach is that of the *bricoleur* discussed in Chapter 4, as seen in the projects by Paula Levine and the uses of the *Barcode Battler* mobile game. Another approach, one that is elaborated by Tuters and Varnelis, is to move away from the focus on mapping the flow of human subjects and shift the focus toward mapping the flow of objects. Their primary concern is that locative performances like *Rider Spoke* focus too much on the human subject and seem to overlook "more than four decades of postmodern critique of the humanist subject."[39] By instead charting the genealogy and flow of objects, we can "more fully understand how products are commodified and distributed through the actions of global trade, thereby making visible the networked society."[40] By seeking to understand the ways societies are linked by tracing the flow of the objects they produce, Tuters and Varnelis are gesturing toward what Mark Poster has termed as the category of "humachine." He writes, "I use the awkward term 'humachine' to designate not a prosthesis but an intimate mixing of human and machine that constitutes an interface outside the subject/object binary."[41] In creating a category that escapes the subject/object binary, Poster is able to locate the potential of such locative artworks like *Rider Spoke* in the ways that it creates "serious points of resistance to those powers and may serve as a base for developing auspicious, decentralized, multicultural global networks."[42] However, if such potential for resistance was to be fulfilled (as Tuters and Varnelis note), the focus would have to shift away from the human subject to the correlation between subject and object as dissolving into the category of humachine.

This is the interface of everyday life—the correspondence between digital objects and the material environment that both creates them and is altered by them. While I do not seek to dismantle the category of subject in the way that the category of humachine does, I do argue that such embodied subjects are only embodied by the interplay between the physical world, digital interfaces, and the societies that are linked across those spheres. The final request made by Farr over the mobile device's earpiece is, "Will you make me a promise? It might be small . . . a promise about tomorrow, or a friend. It might be something more profound. But now, tonight, say your promise out loud, into the air." In this final request, to whom are the participants making the promise? I argue that the promise is not

made simply to the self or spoken into the ether of the night air. Instead, by responding to Farr and recording a promise as the last action of the performance, participants are engaging the relationship they have with the others in this networked society that connects across these various interfaces. By employing the mobile devices as a site of social and personal responsibility and accountability, *Rider Spoke* confronts the intimate connection that is made between people, their society, and their interfaces.

In the next chapter, I explore the uses of site-specific stories to create a sense of community across the network. Most of the projects I discuss focus on crowdsourced narratives that employ asynchronous time in ways very similar to *Rider Spoke*. Ultimately, the problems of presence/absence and synchronicity/ asynchronicity aren't the only concerns when studying the uses of mobile devices for storytelling: the interface also becomes a major hurdle. In the next chapter, I will discuss the problems of utilizing a device that was made for individual consumption for community reading and storytelling. How do we attach story to a site and engage a community in the process of telling the various histories of a locale? The problem, as we will see, is an historic one and the mobile media age heightens these historic tensions between communities, histories, and place.

6

SITE-SPECIFIC STORYTELLING AND READING INTERFACES

Every story is a travel story—a spatial practice.

—Michel de Certeau[1]

The spatial nature of the mobile phone as a reading interface made itself obvious to me one morning as I was driving to work with a colleague from my university. The previous day I had my undergraduate class of 35 students each connect to a system that shared text messages to each other's phones and had instructed them to send updates about their location and activities to the class at least once a day. As I carpooled with my colleague to our campus, my phone began to beep every few minutes with a new update from the students. As we drove, I would respond to the intonations from my phone by taking the device out of my pocket, looking at the screen, and then putting it away again after I had read the text message. One of the messages was particularly hum orous and I chuckled as I put the phone back in my pocket. My colleague responded, "Would you please stop doing that?" "Doing what?" I asked. I explained the assignment and why I found it an important exploration of social proprioception and connecting in intimate ways when not in immediate proximity. "Well, it feels like two people are whispering back and forth right next to me and I'm not included in the conversation." In this moment, the obvious tension between the mobile device as an individual interface and as a tool for connecting socially with others finally made itself very clear. In the car, I felt a distinct sense of connectivity with my class; however, the mode of connectivity was simultaneously an isolating and excluding activity due to the nature of the interface and its design for individual, rather than group, consumption.

The tension between interfaces that are private yet simultaneously bound up in social structures of connectivity mirrors many of the debates around reading

interfaces throughout history.[2] Reading interfaces are produced in, and serve to reify, the social settings that contextualize them. Thus, the process of reading can never be a wholly individual act. However, the specificity of the interface through which we read has a profound effect on the degree to which the community is folded into the process of engaging and interpreting a text. As Italo Calvino writes in his novel *If on a Winter's Night a Traveler*, "If you think about it, reading is a necessarily individual act, far more than writing. If we assume that writing manages to go beyond the limitations of the author, it will continue to have meaning only when it is read by a single person and passes through his mental circuits." Yet, Calvino is quick to note that this process is not so clear-cut between individual reader and author, but is encircled in a much larger social structure: "Only the ability to be read by a given individual proves that what is written shares in the power of writing, a power based on something that goes beyond the individual."[3] The move toward technologies that privilege (or are perceived as privileging) individual space-time as opposed to those that privilege community space-time have perpetuated a popular belief that emerging technologies are damaging the sense of community and local history (I topic I look at extensively in the Conclusion of this book). Our mobile devices, while connecting us to our community as communication tools, are also perceived as separating us from engagement with the physical space of that community. For example, in the opening scene to the documentary *Digital Nation*, producer Rachel Dretzin says,

> It really hit me one night not that long ago. I was in the kitchen and I was cooking dinner, chopping vegetables, and my husband was in the next room on his laptop, and across the table from my husband was my oldest son, who was also on a laptop doing his homework. My younger kids had picked up my iPhone and were playing a game on it. And, I don't know, it just hit me—we're all in the same house, but we're also in other worlds.[4]

In this story of her family sharing the same physical space, yet so far apart from each other due to their connections with technologies (notably, mobile technologies), these devices can be perceived as privileging individual space rather than community space. For example, the body's connection to the mobile phone interface relies on the ability to navigate a very small screen that can be difficult to transform from a private interface to a public interface. While the connectivity that these devices enable is to a broader social world (through the ability to communicate with an audience that doesn't require spatial proximity), the immediate space of the mobile phone is that of the individual. As noted at other points throughout this book, the cultural perceptions of interacting with the mobile phone in public settings is understood as moving away from community space to individual space (the move from "co-present" to "mediated" as discussed in the previous chapter).

The narrative projects I discuss in this chapter offer interventions into this opposition by utilizing the individual space of the mobile phone as the space of

community storytelling. In doing so, these projects utilize a technology that is perceived as privileging the individual and transform it into a technology that captures community narratives. Here, the mobile device is used in a way that uniquely takes advantage of its ability for site-specificity, voice recording, textual communication, and portability. For example, Paul Notzold's project *TXTual Healing* addresses this tension between the private interface of the mobile phone and the ways it is used to connect to a broader community (see Figure 6.1). Started in 2006, the project transforms text messages into public acts of reading by projecting the messages onto walls and encouraging passersby to contribute. As Notzold says, "The projector is run by my laptop that's connected to my cell phone . . . People can text me at my number, and their message goes straight into a speech-bubble graphic that gets thrown up on a wall."[5] The project demonstrates this tension between private interfaces and public reading practices. As Rita Raley notes, "It tells us that digital poetics, like mobile media poetics, are tending toward multiple rather than single screens, live performance rather than private consumption, and crowds rather than the single reader."[6] Here, the relationship between a community and the space-time characteristics of their modes of communication clearly happens at the convergence between public and private interfaces. The text messages that are a part of *TXTual Healing* are communicated

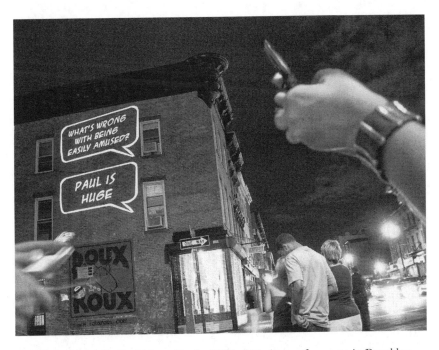

FIGURE 6.1 Photo by Paul Notzold of a *TXTual Healing* performance in Brooklyn, New York, 2007. The words inside the comic strip bubbles that are projected onto the side of this building come from passersby's text messages.

through a medium that is primarily interacted with in a very private fashion. *TXTual Healing*'s transformation of the privacy of the SMS message into an act of public reading serves (in a similar fashion to plan b's *A Message to You* as discussed in Chapter 5) to wrest the text message out of its media specificity and engage it through a public interface in synchronous time. In so doing, the project addresses the productive tension between these spheres and the specificity of these reading interfaces. As Raley notes, "In this context, the cell phone becomes a device to explore public space, rather than a device to remove oneself from it, or a means of enveloping oneself in what Michael Bull has called mobile media bubbles." She continues:

> Many media artists have sought to puncture such zones in the interests of relationality and community. Practically, they have sought to break the closed-circuit networks of mobile communication technologies by inviting participants to contribute text, to make private text public. Such performance spaces are often exterior to the gallery and designed for crowded public spaces, bridges, street corners, public squares.[7]

Throughout this chapter, I will be exploring this productive tension between practices of the interface that inscribe it as either intensely individual or implicated in broader social interactions. Through an analysis of locative story projects, I attach this tension between individual and community interfaces to the history of reading platforms. Ultimately, by again returning to the notion that the interface is not a *thing* but is instead a nexus of social conventions and practices of embodied spatiality, I argue that the design of mobile interfaces—which tends to privilege individual consumption—can be utilized to connect individuals and communities to the ephemeral histories and narratives of place that situate them. By linking the locative storytelling interface to the historical ebb and flow between individual and community interfaces for reading, I situate these stories as site-specific modes of addressing multiple histories. These histories are embodied engagements with the practices of space and the meanings that can be ascribed to a space. I conclude the chapter with an investigation of the relationship between these stories and the embodied nature of information, drawing on the recent debates over the opposition between the database and narrative.

Interfaces of Re-Membering

The mobile media narratives that will be analyzed throughout this chapter utilize modes of historical and community-generated narrative that draw on an embodied understanding of Plato's use of the term *anamnesis*, as a "re-membering" or a literal putting back together of body parts to create a whole. Here, the individual stories (or histories) of a community combine to create a whole sense of the body of the community. This whole, however, often remains fragmented, since many of

the histories remain untold or are lost to time. One project that sought to utilize mobile phones as a means to create and disseminate community histories of place is *[murmur]*. To explain the project, let me look at one instance. In Toronto, attached to a light post on the corner of Spadina Ave. and Cecil St., is a large, green, ear-shaped sign with a phone number on it (see Figure 6.2). Once the number is called, listeners can hear stories recorded by others about the location at which they are standing. Here, on Spadina and Cecil, one user recorded a story about the major Canadian poet Milton Acorn: in 1970, after being nominated for, but not winning, the Governor General's Award for poetry, Acorn's friends threw him a party here at Grossman's Tavern. As the storyteller goes on to describe, Acorn's friends "presented him with the People's Poet Award. Reports from those attending the night indicate that it was a hell of a party and it spilled out onto the street right here. The Milton Acorn People's Poetry Award is still presented to this very day."[8] This recording about an important event in this community of artists fits well with the overall goals of *[murmur]*, which has posted the green signs throughout 12 cities worldwide. Participants record stories about each location, contributing the site-specific histories of the cities.

This mode of mobile media storytelling further informs my study of the sensory-inscribed body. This engagement with the world, both phenomenological and culturally inscribed, must always be understood as conceived out of a variety of contexts. The narrative forms that conceive these contexts, through a linguistic engagement with place, are arrived at through the sensory-inscribed mode of

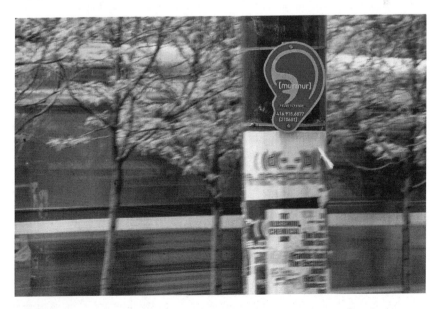

FIGURE 6.2 One of the *[murmur]* signs posted in Toronto, at 270 Spadina Avenue.

Photo © Bryce MacFarland for *[murmur]*, 2004. Toronto, Ontario.

embodiment. The language of mobile media narratives, from oral stories to text messages, must be understood as simultaneously requiring a textual engagement with space (e.g., how does the text of the narrative inform the inscription of the spaces around me and also engage the inscriptions of my body), but also requires a phenomenological understanding of the role of language in the ways we embody community spaces. Extending the popular adage that "we are the stories we tell," N. Katherine Hayles writes, "It is not the triumph of the Regime of Computation that can best explain the complexities of the world and, especially, of human cultures but its *interactions with the stories we tell* and the media technologies instrumental in making, storing, and transmitting."[9] Taken further, as one approach to explaining the relationship between being-in-the-world and storytelling, Indian director Shekhar Kapur has argued, "We are the stories we tell ourselves. In this universe, and in this existence, where we live with this duality of whether we exist or not and who are we, the stories we tell ourselves are the stories that define the potentialities of our existence . . . We tell our stories, and a person without a story does not exist."[10] Here, it must also be argued that the storytelling that comes to define the self and the self's relationship to the communal space around him or her is also a phenomenological narrative. As we look at the stories created for specific locales using mobile media, we must analyze the phenomenologies and the socio-cultural inscriptions that are foundational to the act of storytelling and the act of reading.

The act of storytelling is indeed an act of inscription. It is a writing of place, of identities, and of relationships. It is also true that the body's relationship to specific spaces is informed out of a relationship to the narratives told about those spaces. Looking at another example from the *[murmur]* project, one storyteller stood at the corner of North Almaden Boulevard and Carlysle Street in San Jose, California to discuss a building that has personal significance for his family:

> I'm looking at a sign on the side of this building that represented a place where my grandfather ran a market for about 55 years in the late-1940s and the early-1950s. I only discovered this sign for the first time last year after the building that stood in this lot at the corner of Carlysle and North Almaden was torn down and exposed the side of this building. And I can remember for many, many years hearing stories from my grandfather about the grocery store he ran downtown. I always knew vaguely where it was, but it wasn't until we saw the sign that we were able to pinpoint it once and for all . . . The building is going to be destroyed shortly. We're going to see it go the way of many old lots and infill here in downtown. We anticipate it's going to be high-rise housing with some parking as well. The lot right adjacent to it is also currently under construction for high-rise housing. So, as we see it here in 2006 the whole city is being transformed—the skyscape, as well as the ground floor—and the Notre Dame Market sign may not be visible for much longer.[11]

What oral histories such as this *[murmur]* story represent are the potential losses of community histories among the constantly changing shapes of cities and towns. The media-specificity of *[murmur]* utilizes the perfect interface for narratives that confront issues of loss and the ephemerality of local histories. By conveying these narratives through the human voice over a mobile phone as a recording, the medium addresses the seeming incompatibility between the fleeting nature of spoken words, the creation of a site-specific archive of these histories, and the platform that limits simultaneous group engagement with the story.

Walter Ong famously notes the unique production of space for sound-based media when he writes, "All sensation takes place in time, but sound has a special relationship to time unlike that of other fields that register in human sensation. Sound exists only when it is going out of existence."[12] This space-time-movement relationship between sound and the listener must remain in motion across space or go completely silent. This characteristic of sound makes it exterior, outside of the body, between interlocutors, founded on the concept of shared space. Conversely, textual culture has been characterized as developing a sense of interior space. As Marshall McLuhan has argued, "The interiorization of the technology of the phonetic alphabet translates man from the magical world of the ear to the neutral visual world."[13] The process of reading is one of deep attention, focused between the text and the individual. Only when a text is read aloud does it enter the sphere of the exterior, group space. Otherwise, the text is ingested internally as a function between the eye and the individual. While a document might chronicle a community's history, it simultaneously wrests that history from the group space. This dislocation privileges the longevity of the document and the individual space between the reader and the text over the public space of the spoken narrative. Mobile media narratives instead offer a way to develop oral narratives in a group setting through technologies that often privilege the production of individual space. The development of community narratives over mobile technologies dislocates the sense of the mobile interface as an individual space and overlays it onto the space of the community.

Historicizing Reading Interfaces

The perspective touted by McLuhan is, at least partially, divorced from the histories of reading interfaces and the continual changes these interfaces have undergone, including the ongoing interplay between reading interfaces that address individuals or groups. Yet, attempting to historicize the reading interface has challenges of its own that must be confronted. As Robert Darnton notes, though the act of reading is something that is seemingly outside of socio–cultural time (in that I can pick up a book written thousands of years ago and connect with it on a deeply personal level), our practices of reading can never be identical to our ancestors'. He writes, "But even if their texts have come down to us unchanged—a virtual impossibility, considering the evolution of layout and of

books as physical objects—our relation to those texts cannot be the same as that of readers in the past."[14] Likewise, individual practices of reading are vastly different even within a single culture. Therefore, the clear historical breaks that McLuhan gestures toward (between orality and textuality) are never so distinct. Darnton notes, for example, that the emergence of book culture did not signal the loss of oral culture. There was no clear-cut move away from community storytelling toward private acts of reading. Instead, reading was often carried out socially, as people took turns reading aloud to each other. This is seen in the ways some early texts were written, often with the preemptory phrase, "What you are about to hear . . ." Darnton explains, "In the nineteenth century groups of artisans, especially cigar makers and tailors, took turns reading or hired a reader to keep themselves entertained while they worked. Even today many people get their news by being read to by a telecaster. Television may be less of a break with the past than is generally assumed."[15] Darnton concludes: "In any case, for most people throughout most of history, books had audiences rather than readers. They were better heard than seen."[16]

The reading interface as a social practice that varies greatly from culture to culture and even from individual to individual comes to bear on the practices of the mobile interface. Mobile interfaces are often designed with particular uses in mind; however, our practices dictate the role the technology will play in culture and in the relationship between individual and community modes of engagement. While designers seek to find ways to create globally usable gestures for haptic interfaces, we must recognize that the mobile interface is, ultimately, a practice and not a set of predetermined fixtures. The mobile interface-as-practice confronts the idea that the consumption of our media is passive (similar to some claims that reading is a passive activity). Instead, historically, we see that the process of engaging the reading interface (and community) is an active process that is never grounded as a static, single-mode relationship. The practices of mobile media storytelling engage the multiplicity that defines narrative projects: by placing the mobile interface at the point of convergence between orality and archive and between individual and community, the [murmur] project serves to highlight the various modes of engagement that are addressed by this interface.

Site-Specificity and Urban Markup

[murmur] also engages another important history of narrative interfaces: in being site-specific, [murmur] engages the historical process of urban markup. A concern for storytellers throughout history has been how to attach stories to specific places. A companion concern is, "Who is allowed to tell the story of this place?" Oftentimes, the polyvocal history of a place (i.e., the many stories that constitute the narrative of a place's history rather than the notion of an "official" history that gets attached to a place) is lost in favor of a totalizing narrative that is better suited to the nature of site-specific interfaces (i.e., traditionally, material infrastructures

have had limited ability to support multiple narratives effectively for an audience of readers—a single inscription is favored over multiple narratives that clutter the space and the ideologies of that space). In his article "Epigraphy and the Public Library," Malcolm McCullough has argued that cities have been augmented throughout history in order to leave site-specific messages, often carved into stone. He contrasts these durable inscriptions, which include examples such as decrees and dedications written into buildings and the milestones and boundary markers of ancient Rome, to the ephemera of the ambient, "everyday urban markup" such as graffiti or signs and banners.[17] Cultural value is often attributed to the source and durability of a message, here seen in the distinction between the inscription under a statue and the messages spray-painted onto a wall: one is seen as lasting and marked by those with wealth and authority, and the other is a temporary nuisance caused by vandals. New forms of urban markup that utilize mobile technologies are "neither organized 'media' as the twentieth century knew them, nor random graffiti as all the ages have witnessed." These forms of site-specific markup are seen in the "new practices of mapping, tagging, linking, and sharing [that] expand both possibilities and participation in urban inscription."[18] With these forms of urban markup, the medium typically determines our relationship to the content and informs ideas about who wrote the inscription, who it addressed, how reliable the message is, among a host of other factors. Similarly, in addressing the question of "Who is allowed to tell the story of this place?" mobile technologies also force us to confront the question, "Who is allowed to access the story of this place?" This is especially notable when the story requires a technological interface that not everyone has access to.

Mobile media narratives like *[murmur]* intervene by allowing polyvocality to exist over one of the most pervasive technologies currently in use: the mobile phone (which, here, does not need to be an internet-capable phone). *[murmur]* thus utilizes a storytelling mode that is accessible along the line between durable and ephemeral urban markup. These locative narratives similarly address multiple audiences simultaneously (including the individual and the community) and address these audiences across various temporal modes. For Michel de Certeau, the practice of storytelling in these places allows for a redefinition of the site while allowing that definition to remain ongoing and never settled. Thus, while the site itself may change along with how the locale is defined, the histories of a place are its foundational context. This context is a many-layered story and here, through location-aware technologies or through the use of the mobile device as a means to narrate one of a multitude of histories, storytellers and readers/listeners alike can "awake [the] inert objects" of the local histories, as de Certeau argued for.[19]

Other examples of this current form of urban markup continue to proliferate, including the Yellow Arrow project and Grafedia. Yellow Arrow, launched in the summer of 2004, is a "kind of geographical blogging" project, as the *Washington Post* termed it. The *Post* article continues:

Adherents have been placing the palm-size stickers—each with a unique code —on street signs, city monuments, store windows, abandoned buildings— anywhere, really, that observers encounter what they deem to be "art." Then, using a cell phone, they send a brief text message—which could be an interesting historical fact, a restaurant review or just some goofy poetry—to Yellow Arrow. People who come across an arrow can call the Yellow Arrow phone number, punch in the sticker's code and receive that message. Outside a building at Seventh and S streets in Northwest Washington, for example, the sticker offers up this discovery: Old wonderbread factorys not abandoned. a bike graveyard inside.[20]

Yellow Arrow has also used urban markup to chronicle the hidden histories of place, including projects like "Capitol of Punk" placed around Washington, DC. These Yellow Arrows are placed around significant locations related to the growing punk scene in DC, including the walk from the National Sylvan Theatre next to the Washington Monument to Lafayette Park near the White House. Videos are linked with the codes of each of these stickers, accessed through the mobile internet. For example, the band Fugazi played at both of these locations and, in the linked video, the band discusses the changes that have taken place at these sites as security is increased and bands are no longer allowed to play. This site has a hidden history of the counterculture of the punk scene standing in stark contrast—and in opposition to—the federal government. This musical practice of site-specific resistance has since vanished. As mobile phone users watch the videos associated with this Yellow Arrow tour, they are given a very different context of the National Mall. Standing at this site with significant national history, mobile media narratives bring the subcultural histories that reflect one area of the underground music scene in DC to bear on the location.

In a similar vein, Grafedia was a type of mobile urban markup that drew on the historical roots of the ephemeral markup of graffiti by linking the spray paint on the wall to a hyperlink. Typically painted or written in blue, a piece of Grafedia was underlined similar to a hyperlink on a webpage. These words were painted on the sides of buildings, written on stalls of bathrooms, or written in chalk on the ground. People spotting a piece of Grafedia (and knowing what it was) would send an email message from their mobile devices to an address utilizing the underlined word @grafedia.net (such as "wanted@grafedia.net"). A rich media message decided by the author of the Grafedia—from plain text to images or video—would be sent back to the user about the location of the Grafedia. The ephemerality of this form of urban markup is emphasized in this project, especially seen in some of the main examples given by founder John Geraci: Grafedia found written on a cigarette in a public ashtray, on a note card stuck to a New York City firebox, and written in chalk on a busy sidewalk in Washington, DC. Though these contemporary examples of mobile media narratives demonstrate ways that we can attach stories and messages to place using digital technologies, the ephemerality of both

the cultural histories of a place and the modes of inscribing those histories into a place are key concerns for the archiving of these stories. The ephemerality of a community's history is one of the main drives to tell these histories using mobile phones.

Memory and Representation

The interface of the mobile device serves these locative stories in positioning the user at the nexus of the individual and the community while simultaneously involving both audiences in the processes of signifying place. This process of capturing history and involving readers in the process of enacting that history in a site-specific way is a common theme that has run through locative narrative projects since their inception. In 2002, Jeremy Hight, Jeff Knowlton, and Naomi Spellman created what many acknowledge to be the first locative media narrative, *34 North 118 West*. Set in downtown Los Angeles, the piece uses a GPS-enabled tablet computer, headphones, and an interface that locates the users on an historic map of the area (see Figure 6.3). The site the artists chose was a former railroad depot, currently being used by the Southern California Institute of Architecture.

FIGURE 6.3 Jeff Knowlton (right), one of the designers of *34 North 118 West,* navigates the project with a student in downtown Los Angeles.

© 2001 Jeremy Hight, Naomi Spellman, and Jeff Knowlton. Photo by Naomi Spellman, Los Angeles.

As Hight describes the work, they wanted to create "a project looking at the similarities between GPS, space, information packets, and the early railroad and city infrastructure of Los Angeles."[21] As users moved throughout the area, they would trigger location-based hotspots that would unlock part of the narrative about the history of the railroad industry in Los Angeles. As Raley describes the piece: "Jeremy Hight, the author of the fictional text, researched the history of the freight yard and discovered the surprising and macabre stories of the line watchers, workers who were on suicide watch and charged with cleaning human debris off the tracks."[22] She goes on to quote from part of the narrative archeology that the readers can uncover: "35 years I cleared the tracks. Those men, along the rails, tired. Death by train we called it. They waited and wandered. Hoped . . . for the sound that comes too late to take them from this life. It was my job to assist . . . to help . . . kind words . . . or help clear the tracks after the impact . . . Such failures. My failures. Such small horrors."[23] Hight describes the place where readers encounter this scene: "This text triggers at the edge of a large dirty lot as a remnant of old railroad tracks becomes briefly visible under layers of street asphalt, rising briefly like some metal sea snake."[24] For the author of *34 North 118 West*, the stark disjunction between the past and the present, grounded in embodied space-time, acts as a "commentary on the lost versions of the city and area from the early 1900s" and "creates an odd feeling of being aware of two places at once."[25]

Hight terms this mode of locative storytelling "narrative archeology," which "use[s] technology to place the artifacts of place lost over time into the present."[26] Here, I draw from two notions of history that inform a reading of *34 North 118 West*, as well as the other locative narratives discussed thus far: representation and remembering. These notions are confronted by differing modes of embodiment. I begin with Elaine Scarry's description of an emphatic body's relationship to representation and power in her book *The Body in Pain*:

> In discussions of power, it is conventionally the case that those with power are said to be "represented" whereas those without power are "without representation" . . . But to have no body is to have no limits on one's extension out into the world; conversely, to have a body, a body made emphatic by being continually altered through various forms of creation, instruction (e.g. bodily cleansing), and wounding, is to have one's sphere of extension contracted down to the small circle of one's immediate physical presence. Consequently, to be intensely embodied is the equivalent of being unrepresented and . . . is almost always the condition of those without power.[27]

Scarry's understanding of the relationship between representation and power resonates strongly with the impetus behind many mobile media storytelling projects. Without representation, the community that is shaped by the story must either go unrepresented (and thus become non-visible) or be represented by others. She quickly shifts this relationship by demonstrating how any form of

representation that is reliant on embodiment is also in danger of being disseminated through a fragile medium (the body). The body, which can always be injured and destroyed, limits "one's extension out into the world" and typically represents "those without power."

Emphatic embodiment is, to Scarry, a mode of disempowerment through lack of representation. However, this understanding of the relationship between embodiment and representation is countered by the inclusion of the sensory-inscribed body. The sensory-inscribed mode of embodiment places the subject in a vital role in the writing and practice of history as that which is defined as a present recognizing itself as a formulation of the past. Here, the process of "re-membering" (i.e., the construction of community history and the battle that ensues over who is able to construct history) is very much an embodied experience. Re-membering is a construction of various pieces that, while not the Grand Narrative of history, is instead an experience of ongoing creation. This type of creation is not simply a retelling of what was, but is an embodied experience of the phenomenology of temporality. The body plays a role in at least two ways here. First, it serves as the metaphor for the self's constructive relationship to history (similar to Frankenstein's monster or to the re-membering of Osiris' body by Isis in Egyptian mythology). Secondly, the body is integral to the construction of history because culture and bodies are indelibly linked to representation and history. Thus, it is vital to contrast a sensory-inscribed relationship to historical narratives with Scarry's notion of intense embodiment as that which equates a lack of power. The key thing that Scarry's analysis overlooks is that all forms of representation are entirely reliant on embodiment. The creation of sign systems and the process of reading those signs are done through the body. Thus, the power to represent is an embodied power. Connecting this observation to a sensory-inscribed understanding of historical narratives shows that history is ultimately an embodied construction of related signs.

Thus, history and historical representations like the locative storytelling project *34 North 118 West* need to be analyzed as simultaneously phenomenological and culturally inscribed. History is a convergence of the proprioceptive sense of embodied space (spatial and cultural context) and the ways that the sign systems are read (the construction of various modes of representation). How these two converge is, to the likes of Walter Benjamin, a battle of utmost consequence. Benjamin writes:

> The past carries with it a temporal index by which it is referred to redemption. There is a secret agreement between past generations and the present one. Our coming was expected on earth. Like every generation that preceded us, we have been endowed with a weak Messianic power, a power to which the past has a claim. That claim cannot be settled cheaply . . . Even the dead will not be safe from the enemy if he triumphs. And this enemy has not ceased triumphing.[28]

In Benjamin's battle over history, Scarry's notion of disembodied representation is undone. Instead, we see that the fight for representation depends on wresting history from the epic tale and instead grounding it in materiality. As Benjamin notes in the *Arcades Project*,

> The replacement of the epic element by the constructive element proves to be the condition for this experience. The immense forces bound up in historicism's "once upon a time" are liberated in this experience. To put to work an experience with history—a history that is original for every present—is the task of historical materialism. The latter is directed toward a consciousness of the present which explodes the continuum of history.[29]

For if history is understood as existing outside of the material sense of cultural bodies, then it simply remains a series of signs that are to be read by bodies while remaining outside of these bodies (as transcendental signifiers). Understanding history as simply an epic narrative without construction or embodied interpretation/contextualization ultimately disguises it as something that takes place outside of the body. This type of thinking is exactly what Scarry is pointing toward: those with an intense sense of embodiment typically equate that intensity with an inability to engage the process of historical representation since history is something that is more closely related to objectivity and not subjectivity. Here, objectivity is typically associated with a detachment that relies on the removal of the body from the object. By inserting the body in an emphatic way, history becomes something that is constructed by the flawed human perception instead of simply being a series of events that are chronicled without need or reliance on the body.

Memory, Databases, and Narrative

Here, I want to shift my focus a bit to discuss a different relationship between narrative and embodied practices of the interface: moving from Scarry's notion that intense embodiment is antithetical to empowerment, I want to discuss the emerging notion that embodied narrative is antithetical to information. Here, narrative is contrasted with information because one is organized around the structure of the art form and the other remains raw data until formulated into something consumable. This resonates with Lev Manovich's understanding of the relationship between narrative and the database:

> As a cultural form, the database represents the world as a list of items, and it refuses to order this list. In contrast, a narrative creates a cause-and-effect trajectory of seemingly unordered items (events). Therefore, database and narrative are natural enemies. Competing for the same territory of human culture, each claims an exclusive right to make meaning out of the world.[30]

Manovich's distinction points to the separation between the object (data) and the meaning of the object (narrative). It also understands that there is a specific temporal relationship in the formation of cultural imaginaries of the object: we begin with the unordered object and, to fully understand that object, we insert it into a narrative structure. Meaning, in this instance, comes only from relational structure. This structure, it can be argued, can actually apply to the database, since it must always exist within a structure (though may appear to resist such structuring). For Manovich, even beyond the similarity of structure, the database becomes the epitome of the digital age, since all art forms rely on the database as their source. He writes,

> Regardless of whether new media objects present themselves as linear narratives, interactive narratives, databases, or something else, underneath, on the level of material organization, they are all databases . . . It is not surprising, then, that databases occupy a significant, if not the largest, territory of the new media landscape. What is more surprising is why the other end of the spectrum—narratives—still exist in new media.[31]

Applied to mobile media narratives, especially their site-specificity, we begin to see this argument break down. The relational ontology that is argued for by Manovich is that the database serves as the core of most of our new media experience. As Hayles notes about Manovich's claim, "In this imagined combat between narrative and database, database plays the role of the Ebola virus whose voracious spread narrative is helpless to resist."[32] Hayles argues that Manovich's claim misses the symbiotic relationship that sustains both database and narrative: "Because database can construct relational juxtapositions but is helpless to interpret or explain them, it needs narrative to make its results meaningful."[33] While I agree with Manovich that the database is indeed a significant "territory" of the new media landscape, the very terms he uses to describe this are spatial. Thinking of the database in spatial terms, as a "territory" or "landscape" in Manovich or as creating "relational juxtapositions" in Hayles, we return to the embodied necessity of the production of all spaces, including the space of the database. From an embodied sensory-inscribed analysis, Manovich's theory of the database does little to transform the new media landscape from being a static site to being a lived place. Here, the databases represent the unlived space of new media activity. This space truly only exists in theory, since any meaning attached to this space requires direct activity with it. Any activity with the database immediately transforms it into something altogether new, something that resembles narrative space. Just as a place that is interacted with becomes lived space, so a database that is interacted with becomes lived narrative.

To apply this theoretical exploration to a mobile media narrative, let us look at two examples of barcode applications for mobile devices: Tales of Things and Stickybits (both launched in 2010). Drawing from the ability for Quick Response

codes (QR) to contain many more characters than a standard UPC barcode (and thus link to URLs and rich media files), the Tales of Things app sought to find a way to connect barcodes to meaningful content. By photographing an object, then associating that photo with a short narrative (text, audio, or video), the user then uploads the content to the web and prints out a QR code that is attached to the item. Recently, Tales of Things teamed up with Oxfam to attach narratives to second-hand items donated to UK charity shops. For example, one woman donated a red silk purse and recorded an audio narrative about the object's history: "It was one of the very first things I bought when I went to visit my uncle and his wife Noy who live just outside Bangkok. It was also one of the very first times I got a tuk tuk and I nearly fell out in the middle of a motorway on the way back. So I risked life and limb to get that bag!"[34]

Another item was donated so its owner could actually forget the memory associated with the object. The object—a woman's pink and white-striped jumper shirt—was worn by the original owner to a barbecue where she met a man who became her boyfriend. Now that they are broken up, she is donating it to get rid of the memory. One news report describes the consequences of this project as follows:

> The advent of digital tagging technology means that every new object in the future will be tagged and logged in a database accruing logistical information such as temperatures, prices, owners and transportation. The exhibition RememberMe [in collaboration with Tales of Things] introduces an opportunity to build an Internet of Old Things based upon stories not data. By attaching a barcode loaded with memories about the clothes and artifacts that visitors donate to the Whitworth Park branch of Oxfam, things will gain a social and cultural value.[35]

These barcodes link users directly to a database of information associated with the object. However, from Hayles' point-of-view, the database here automatically assumes the narrative. The notion of an "unlived" or "unacted" database, as simply unordered items without context, is a mythology that frames one ideal of information. Not only can these database items never be understood if they are detached from narrative, they would also never exist if they weren't attached to narrative from their conception. If, as de Certeau argues, "space is practiced place," then we must argue here that stories are practiced databases, with the understanding that the very conceptions of unpracticed space and unpracticed databases are ideologies that posit the categories as disembodied.

To conceive of a place that is unpracticed is purely philosophical, and the same is true of unpracticed databases. Databases exist through our interactions with them and these interactions serve as organizing structures that transform these free-floating objects into relational objects. The second of these barcode applications, Stickybits, serves to emphasize this point: the hidden histories of objects, which

give significance to the information that accompanies the objects (dates, prices, locations, and the like), posit us in a sensory-inscribed relationship to the objects around us. Users of Stickybits are able to scan any barcode on a product they use (or, alternatively, simply stick their own barcode on any object) and attach rich media content to the object. If a user scans a common barcode—on a can of Coca-Cola, for example—the narratives, videos, and images many users upload as associated with that object culminate to produce crowdsourced narratives about the object and its use in daily life. Collaboratively, we give relational narratives to our objects, which serve to embody us in space as sensory and culturally inscribed subjects. The crowdsourced nature of Stickybits demonstrates the intersubjective process of engaging the narrative of an object (perhaps the company's marketing story of why we should buy the object) and giving it new meaning. Here, the object does not necessarily take on cultural capital because of the marketing narratives, but takes on value because of the ways the object is used in everyday life. This spatial tactic of attaching crowdsourced narratives to objects resignifies our sensory-inscribed relationship to the objects that shape our daily lives.

Here, the space of the database becomes practiced place by projects such as the Tales of Things and Stickybits by organizing select parts of this information into a contextualizing narrative. While the particular narratives that emerge are quite different from the stories of use that are marketed for these objects, the utilization of mobile media offers a unique history into our embodied interactions with both our devices and the objects that define our day-to-day lives.

Be Here Now

Throughout this chapter, the hidden histories of our objects and of community engagement with place emerge through a medium that has historically been designed as an individual space. By analyzing the mobile device as a reading interface, the tensions around the relationship between an individual and his or her community are highlighted. Mobile devices at this moment in history encapsulate the tensions around distance and proximity, the frustrations that exist because of being proximate yet experiencing a sense of distance. This tension was highlighted in a 2010 commercial for the Microsoft Windows Phone. The advertisement, titled "Be Here Now," showed a series of encounters between people, one who was staring at a mobile phone, and the other one typically expecting social interaction. There is a son on the baseball field with his father; the son is waiting to throw the ball but the father doesn't stop staring at his phone. There is a woman in lingerie standing at the edge of a bed, waiting for her partner to look up from his phone. There is a woman getting married, being walked down the aisle by her father while she looks at content on her phone. People jogging with their phones run into each other, people staring at their phones trip down stairs and fall into strangers, and a person occupied by her cell phone and unaware of her surroundings sits in a chair already occupied by a person. The commercial

ends with Microsoft's tag line for the ad: "We need a phone to save us from our phones."

The nostalgia for a time before mediated distance that is central to this commercial is a topic that I cover in the Conclusion of this book, yet it is a topic that mirrors the tensions around the experience of the mobile phone as a reading interface. Do we engage these reading activities as individuals or as members of a larger community? Can we engage these interfaces as both, despite the design limitations that preclude group involvement? Does my phone essentially remove me from social interactions with those groups who are nearby? By understanding the interface as a nexus of these social relations and individual practices, locative narratives engage the anxiety of these forms of mediated connection. Ultimately, the mobile media narratives discussed in this chapter are able to transform this individual interface into a site of community engagement and crowdsourced histories through various modes of storytelling. Such stories ultimately transform the sites they contextualize and serve to demonstrate the ways that narratives are all site-specific and all sites depend on narratives.

CONCLUSION

Movement/Progress/Obsolescence: On the Politics of Mobility

Human beings are among the most mobile of animals. We are beings of the between, always on the move between places. When one place threatens to become vacuous (uninteresting, unsatisfying, desolate, or empty), we hasten on to another.

—Edward Casey[1]

By the time you read this, many of the examples I have discussed in this book will be obsolete. In fact, as I'm writing this, I can think of several examples that already are (including the Grafedia project discussed in the previous chapter, as well as the purchase and elimination of certain locative social networks, such as Whrrl). Not too long from now, the mere mention of an iPhone or of Facebook will solicit responses marking them as the media of an older generation, replaced by better and faster ways of connecting. Likely, "digital" media will also occupy this obsolete position one day. This isn't terribly surprising—this kind of obsolescence has become something we're quite used to. As I began writing this book, I faced the challenge of discussing a moment and a medium that are so rapidly changing that it is extremely difficult to keep up, to stay current, and to not be immediately outdated. One colleague suggested to me, "Make sure they don't put a picture of a cell phone on the cover of your book! Nothing will date it more quickly than that!"

In an era in which computer technologies are replaced and updated faster than almost any other product produced, things become outdated at an extremely rapid pace. Accordingly, we tend to feel like we are caught up in a culture that is getting increasingly fast. To conclude this book, I want to examine the speed of mobile media culture and its resulting intimacy with obsolescence; however, I also want to suggest that the contemporary nostalgic musings about how we are losing meaningful connection because of the speed of digital culture are they themselves

disconnected from media history. Here, I hope by revisiting the construction of the sensory-inscribed body, I can frame these ideas of speed within the overall historical imaginaries of emerging technologies. The production of embodied space for a mobile media age (which, it can be argued, spans back to at least the emergence of papyrus as a medium for inscription) is necessitated on ideas of movement—the medium of a mobile technology is distinct because it allows you to move around due to its portable nature. However, the cultural imaginaries around movement that are almost always attached to emerging technologies have tended to stir up embodied, social experiences of an increase in speed. By tracing ideas of movement as it is often mapped onto ideas and experiences of progress and speed, I am asking for a renewed evaluation of the kinds of movement that produce space and the implications of linking mobility to progress and speed.

For example, in his book, *Life Inc*, Douglas Rushkoff argues:

> Instead of serving to reconnect us, our technologies now serve to disconnect us further, reducing our contact to virtual prods and pokes. Meanwhile, corporations are finding online a path toward incarnation: Chase and Coca-Cola build avatars in online environments such as the Second Life "virtual world" that are as real as we are. Sometimes more so, especially as our life and status online dictate or even supersede our life and status in the former real world.[2]

Rushkoff's nostalgia for a time before technology became simultaneously distancing and more real than the "former real world" is one that is frequently echoed in academic works about digital media and in the popular press. For example, Sherry Turkle—who, similar to Rushkoff, I would consider a cautious advocate for emerging media—has also recently made these familiar claims about emerging media disconnecting us. In an interview about her book *Alone Together: Why We Expect More From Our Technology and Less From Each Other*, Turkle discussed moments when people are distanced from one another and from being "present" because of technology:

> Well, for example, when people just plug their earphones in. I live on the Cape during the summer, and there are these magnificent dunes that I walk on the Cape. When you walk these dunes—and I've been walking them for years, I mean, decades of going to the Cape. And recently, people have their earphones in and are listening to their music. And more recently, people have their earphones in and are walking them with their handheld devices and are texting as they walk them . . . I'm not like a romantic or I don't have a crazy nostalgia for, you know, an unplugged life in cabins in the woods, not at all. I'm just saying that we have to ask ourselves really what is served by having an always-on, always-on you, open-to-anyone-who-wants-to-reach-us way

of life? Because in my research, I've found that it actually cuts off conversations as much as it opens out conversations.[3]

While I can easily commiserate with Turkle's cautions of using a mobile device in socially frowned upon ways and in spaces that a community has decided should be without these devices, I find her (and Rushkoff's) ideas about mobile technology profoundly disconnected from the history of embodied, emerging media. I do agree with Turkle on many points: as a self-professed technophile who loves his mobile phone and uses it many times throughout the day, I have still enforced limits of my uses of the phone that I find beneficial to my everyday life (e.g., never looking at my phone during dinner with family or friends). However, these tensions over the intrusion of media into the social sphere—as that thing which is disconnecting us from each other while simultaneously sending us into a head spin from how fast everything is moving—have been with us throughout history.

Nostalgic sentiments like those of Rushkoff and Turkle (among an unending host of others) are what prompted computer scientist Alan Kay to say, "Technology is anything that was invented after you were born."[4] His sarcasm highlights our short cultural memory around emerging media. Cultures are quick to proclaim their discontents with a new technology; however, they often overlook how similar these claims are to previous emerging media (many of which have moved into the sphere of cultural acceptance). This can even be traced back to Plato's lamentations over the emergence of writing because of the ways it would disconnect us from real presence (a topic I cover in Chapter 5). For Plato, the spreading of ideas across geographic distances—far beyond the body of the author—limited our ability to engage in dialog and produce true knowledge. Instead, reading gave us the illusion of knowledge. Writing accelerated culture but simultaneously distanced people within that culture. Similar sentiments accompanied nearly every form of emerging media that followed. James Burke has noted that the printing press not only troubled those in power who wanted to be gateways to knowledge, but also created a sense of information overload and cultural acceleration as ideas spread faster and wider than ever.[5] These familiar claims were also applied to the emergence of the telegraph and the telephone. Claude S. Fischer notes that, around the turn of the twentieth century, these emerging media caused extensive discussion about the implications of using these devices. He cites a 1926 meeting by the Knights of Columbus Adult Education Committee to discuss how "modern inventions help or mar character and health."[6] Some of the questions raised at the meeting included, "Does the telephone make men more active or more lazy?" and "Does the telephone break up home life and the old practice of visiting friends?"[7] Fischer writes, "Worry about the moral implications of modern devices was especially appropriate in 1926, for middle-aged Americans had by then witnessed radical material changes in their lives. Despite the awe that many express about today's technological developments, the material innovations in our everyday lives are incremental compared to those

around the turn of the century."[8] At this time, the automobile was also receiving criticism about creating social distance and an acceleration of culture (quite literally). Fischer discusses how churches at the turn of the century condemned emerging forms of mobility (from the bicycle to the automobile) for drawing parishioners away from church toward "the enticements that it brought within reach—roadhouses, movies, and the like—[which] undermined the family and encouraged promiscuity."[9] This constant interplay between acceleration and distance falls in line with what Paul Virilio writes, as "the attentive impatience for a world that does not stop coming, that we can't stop waiting for."[10]

While movement and mobility are the foundational concepts for the ways we design and use mobile devices, our practices of movement and mobility are actually at the core of the way we produce every single embodied space we encounter. Yet, how we define movement and mobility greatly determines the ways that we perceive ourselves (as embodied) in culture. Do we conceive of movement and mobility in terms of speed? Are notions of dwelling and stillness antithetical to notions of movement and mobility? Such questions are central to the production and practice of space. The embodied space argued for throughout this book is a sensory-inscribed bodily space, a space that is understood and experienced through perception and the senses as well as through the cultural inscriptions that inform our everyday lives. One key attribute I noted about this form of embodied space in Chapter 1 is that it is not dependent on geographical space. We can (and do) connect with each other across very vast distances, and our devices serve to offer us an embodied and spatial experience with one another. While this kind of "distant intimacy" almost always builds and extends our foundational under-standings of embodied space in material, face-to-face interactions, it is vital that we think of emerging media *as spaces*. They are spaces that attract us, give us a sense of embodied interaction, and foster a sense of community and home. Using our mobile devices (from the current mobile phone/computing device to whatever future imaginings of mobile communications becomes) produces a social space through our interactions with these technologies.

For these interactions to successfully become spatial (enough for us to want to frequent and inhabit them), they must generate a sense of movement. I note this because it is impossible to think about space without thinking about movement: space implies a distance that can be traveled, even if this distance isn't actually traversed. Similarly, when we connect with each other, we do so as embodied beings, and our bodies are essentially linked with the ways that we think about ourselves and our identities. Bodies require space; they are simultaneously space in and of themselves. Since space, movement, bodies, and social interaction depend on one another, these elements must all be present and experienced for connection across our mobile devices.

While the connection between spaces and social bodies has been argued for throughout this book, I want to offer a more sustained look at the aspect of movement in this chapter. When we invoke the notion of "movement" in our

contemporary computing age, a very specific idea of movement comes up: move-ment forward. In the digital age, movement is almost always linked to ideas of progress. Technology, it seems, only has this one direction, as newer devices are better than older ones. The predominant selling point for mobile devices is that the latest mobile phone or mobile computing technology is far superior to the device you are currently using. This mode of thinking gets pushed to the extreme of labeling certain technologies and platforms as obsolete with the latest advance.

The collaboration between embodied space, movement, and progress offers a lens for reading obsolescence in the mobile computing age, in which the average mobile phone lasts only 18 months before it is discarded.[11] Is the trend toward rapid obsolescence tied to the embodied production of space that is necessitated on movement (including speed and progress)? Ultimately, as communal space is produced through digital media (including mobile phones), we see that obsoles-cence is often at the very heart of the production of these social spaces, which embody the relationship between progress, movement, and a sense of place. As noted by Edward Casey (in the quote that serves as this chapter's epigraph), once a digital social space "threatens to become vacuous (uninteresting, unsatisfying, desolate, or empty), we hasten on to another."[12] Without a sense of progress, of movement, of migration, the embodiment of the "space" of our network begins to break down, leading to the certain obsolescence of one social medium for the next.

Movement and Obsolescence

The term "progress" is a notion that is fundamentally associated with obsolescence. This term has a deep resonance with mobile media culture, which is renowned for its excess of electronic waste. By linking this mode of obsolescence to the desire to move to new spaces, we see an alarming cohabitation between the embodied movement that creates a sense of space in digital environments and the rapid obsolescence that is characterizing the mobile media era. The juxtaposition between these two modes of being can be strongly seen in Walter Benjamin's description of the "Angel of History" in his "Theses on the Philosophy of History." He writes:

> This is how one pictures the angel of history. His face is turned toward the past. Where we perceive a chain of events, he sees one single catastrophe which keeps piling wreckage and hurls it in front of his feet. The angel would like to stay, awaken the dead, and make whole what has been smashed. But a storm is blowing in from Paradise; it has got caught in his wings with such a violence that the angel can no longer close them. The storm irresistibly propels him into the future to which his back is turned, while the pile of debris before him grows skyward. This storm is what we call progress.[13]

Thus, in this stark image discussed by Benjamin, movement forward (progress) is a storm that leaves a trail of wreckage in its wake (obsolescence). While this has been discussed extensively in terms of the digital objects we buy and discard at a frightening rate (see, for example, Giles Slade's book, *Made to Break: Technology and Obsolescence in America*), such obsolescence also characterizes our various digital environments. Since the process of inhabiting these digital spaces as embodied interactors requires a sense of movement, users will continue to seek out environments that foster a sense of movement and progress. The fundamental flip side to this coin is that users will also migrate once movement in the digital environment appears to slow. This sense of movement can be offered by the embodied actions of making connections with friends, building your network, establishing your presence in the digital space, among other factors. This establishment of the self in the space is often seen in the gaming elements many locative social media offer, such as earning badges, mayorships, and other rewards (as discussed in detail in Chapter 3). Once users feel the sense that these connections and incentives have slowed or plateaued, the network no longer offers the embodied movement necessary for meaningful connections in hybrid space.

The intimate kinship between movement, progress, and obsolescence became painfully obvious to me in April of 2009 (the same year I purchased my first smartphone), when I visited the Seattle Art Museum. There was a special exhibit on display of the work of Chris Jordan, who is known for creating amazing mosaics out of objects that serve as an artistic form of information visualization. Walking around his latest series, *Running the Numbers: An American Self Portrait*, I spotted a huge canvas (60" by 100") that simply looked like television static from where I was standing (Figure 7.1). As I approached the work, I realized that the static was made up of very tiny images, though I still could not make out what they were. As I moved right up to the work—only inches away—I saw that the entire canvas was covered with images of cell phones (Figure 7.2). I pulled back to read the label, which read, "*Cell Phones 2007*. 60" x 100"." Depicts 426,000 cell phones equal to the number of cell phones retired in the US every day." Returning to the work, I was in awe, reminding myself of Benjamin's quote: "This storm is what we call progress."

The process of viewing this piece requires movement: from afar, it looks like television static, so a viewer has to change his or her perspective—to move closer—in order to understand what the tiny dots on the canvas actually are. The piece demands movement for its impact. It is founded on the very notion of a change in perspectives. At the same time, once a certain perspective is gained, the piece asks for one to dwell in the immensity of the visualization. Such dwelling resists the speed that is associated with the progress that leads to obsolescence. What *Cell Phones 2007* actually accomplishes is a mirroring of the tension between movement/progress and dwelling/speed. Moving through the space of the museum toward the work of art offers an unsettling view of obsolescence. However, instead of asking the viewer to continue moving, the piece asks for stillness.

FIGURE 7.1 Chris Jordan's *Cell Phones 2007* from afar. 60 × 100". Depicts 426,000 cell phones equal to the number of cell phones retired in the US every day.

© Chris Jordan.

FIGURE 7.2 Detail of Chris Jordan's *Cell Phones 2007*.

© Chris Jordan.

Dwelling with the work of art here transforms the status of the mobile phone. Instead of simply standing in for discarded objects, the objects themselves reflect the viewer as implicated in the overwhelming obsolescence visualized in the piece. This relational gaze between subject and object is explained well by Robert A. Davidson in his discussion of "animate objects":

> In *The Vision Machine*, Paul Virilio cites the painter Paul Klee's subtle, paranoiac phrase, "Now objects perceive me," as a means of introducing his closing arguments regarding the innovation of artificial vision. Klee's words are suggestive and germane to more than theories of telematics and speed phenomena; they apply also to a discussion of how "things" seemingly assumed a sense of self—a subjectivity of objects—within the rapidly evolving discourses of early twentieth-century modernism.[14]

Here, the materiality of the objects is highlighted and, as objects which "assumed a sense of self," they enter into an ethical relationship with our understandings of movement, progress, and obsolescence. This is similar to the ethical reciprocity that I discuss in Chapter 3: a reciprocal relationship that positions the self through movement and proprioception while simultaneously inscribing the bodies involved as particular bodies (here, as either people who equate movement with progress/obsolescence or seek to find a way to make movement and dwelling compatible).

Movement and Dwelling

Mobility studies have tended to focus on the processes of movement (of people, information, cultural objects, through transportation, architecture, and urban design) rather than focusing on the production of location. As Adriana de Souza e Silva and Jordan Frith note, emerging practices of mobile media "[invert] traditional networks, such as transportation and information networks, [which] have generally emphasized speed and flow in order to circulate things and information from node to node in a fast and efficient way."[15] However, mobility studies and emerging location studies both take a similar view of movement: it has more to do with the continued progress through a space and typically stands in opposition to stillness or dwelling.

It is here where performance studies and dance intervene. Movement and social bodies are a core concern for dance scholars and practitioners. In recent years, the tension between stillness and movement has become a key point of discussion in this field. Many dances in recent years have actually had very little "movement" in them, according to some. A 2010 performance of *Desire Lines*, by Simon Ellis, prompted this review from the writers at LondonDance.com:

> The movement, when it's happening, has a lovely relaxed and internal quality; even when the unshowy dancers stretch an arm or a leg into

extension, it seems to come from deep within the body. I say "when it's happening" because four of *Desire Lines'* seven sections contain no live dance at all. The dancers (Ellis himself and Marika Rizzi) remain motionless in the dark while an amusing film featuring a labrador and a four-poster bed plays on the downstage screen. When they do dance, the movement has a spontaneous, improvised quality that is enjoyable to watch but also leaves me wondering if Ellis spent any time in rehearsal at all.[16]

For most of dance's history, as it is mirrored in mobility studies, there is an obvious antithesis between the practices of movement and stillness. One of dance study's most well-known works on this tension between movement and stillness is André Lepecki's book *Exhausting Dance*. In this work, Lepecki demonstrates an important shift happening in dance: the emergence of a "slower ontology."[17] This slower ontology is "engaged in dismantling a certain notion of dance—the notion that ontologically associates dance with 'flow and a continuum of movement.'"[18] For Lepecki, this unending continuum of movement marks dance's modernity and is even a marker of modernity's ontology: "so the project of Western dance becomes more and more aligned with the production and display of a body and a subjectivity fit to perform this unstoppable motility."[19]

What emerges in dance and performance is a reconsideration of what constitutes movement. Here, as it applies broadly to the study of mobility, the production of space via movement does not exclude the "pauses" in life. Pauses are not simply moments of the "in-between" or, as in the review of Ellis' work, moments spent waiting until "something happens." Pauses need to be reconsidered as a particular type of movement, not the exclusion of movement. In dance, Lepecki points to the emergence of "still-acts" as the practice of stillness-as-movement. Lepicki argues, "The insertion of stillness in dance, the deployment of different ways of slowing down movement and time, are particularly powerful propositions for other modes of rethinking action and mobility through the performance of still-acts, rather than continuous movement."[20] Stillness is not a lack of action; it is instead a particular kind of action.

To demonstrate the practice of stillness-as-movement, I turn to work in Science and Technology Studies (STS) and its collaboration with the performing arts. STS scholars have recently collaborated with performance artist Chris Salter to create a museum installation titled *jnd*. The acronym "jnd" is used in psychophysics to refer to "just noticeable difference" in perception, those moments that serve as the boundary between the things we perceive and the things we are not cognitively aware of. In the piece, a participant enters a large box alone and lies down in an environment that is pitch black. The box is designed to block any outside noise or vibrations. Then begin the experiments with *jnd*: the participants are lying on a custom-designed foam floor made up of 12 individual plates, each with vibro-tactile actuators, that are, in Salter's words, "essentially things that are put into theatre seats to create intense vibrations. The interesting thing about these actuators

is that they have a full frequency range of audio."[21] The piece then sends sound and vibration at the participant: sometimes loud and intense enough to make the body feel noticeable movement beneath them and sometimes so subtle that it is barely within the range of human perception. The participant's movements become interactive with the piece, informing the system when something has perceptual impact on the body (in other words, the moment when the sensory moves into the realm of "just noticeable difference" of cognitive awareness). As one participant says in his interview soon after experiencing *jnd*: "As soon as I went in, I figured out that my movement on the foam was interactive and that I could control—to some extent, at certain points—the vibrations."[22] Another participant began to get at the heart of the *jnd* project and its exploration of what constitutes movement in performance (and as it applies to ideas of mobility for my study): "It's also about, 'What is interaction?' Interaction is not hitting things. Maybe I'm laying down and if I'm breathing you can detect the changes in pressure from my ribs. And that also can be very beautiful. So, there is this [question] of, 'What are the thresholds of your actions?'"[23] Salter's installation is drawn from his work as a dance practitioner: he collaborated with famed choreographer William Forsythe in various dance pieces that investigated the convergence of technologies, bodies, and movement. At the core of many of these performances are questions about how bodies and technologies work together to produce new practices of space and movement.

Movement is deeply interrogated in this work. While lying apparently motion-less inside of the *jnd* installation, participants are keenly aware that their bodies are in constant motion. As Susan Jones writes in her article on dance and stillness, "The musculature remains alert, in readiness to move; energy spirals through the body even as it alights on the perfect stillness of a moment. This moment is full of potential, where the possibility of movement fills the stillness, the mind reaching within, toward, and beyond an apparently temporal confinement of the body."[24] In *jnd*, participants are aware of their muscles' responses to the environment. This reminds me of the simple practice of holding your arms straight out in front of you: while you are standing still, apparently without movement, your body's fight against gravity puts your muscles into constant motion. Stillness, it seems, is never without movement.

As we think of how these projects relate to a mobile media age, I want to push the concept of stillness one step further to advocate for a practice of *dwelling* in our everyday lives. Noting the quote from Jones above, she argues that stillness is "full of potential, where the possibility of movement fills the stillness." This is how many see stillness—as potential. It is often seen as a pause or a moment in between movements. Instead, if we think of stillness as a practice of dwelling, we can embrace the idea of movement without abandoning stillness. Dwelling is an active engagement with your surroundings and the people and objects within those surroundings. Instead of being the absence of movement, dwelling is the practice of a particular kind of movement.

The consequences of this correlation are far-reaching. As we produce the social spaces around us, both materially and across digital networks, we are engaging in the production of space through movement. How we conceive of this movement determines how we will practice and live in the spaces we create. Ultimately, we must move beyond the nostalgic musings for a time when culture wasn't accelerating. In fact, culture has always had the perception of acceleration. By connecting with this history and inserting an idea of dwelling within the ideas of movement within culture, we can see that speed and progress are not the only modes of movement for a sensory-inscribed body. As has been evident in each example used throughout this book, the sensory-inscribed body is always implicated as a sensory-inscribing body. Therefore, as we engage the emerging mobile media era and the various spaces produced, we can find ways to practice this mobility as a type of dwelling. We can practice movement that is not indelibly linked to ideas of progress and obsolescence. Instead, we can practice movement as a dwelling, as a sensory-inscribed practice of location rather than flow. The result will be a practice of embodied space that values the unique characteristics of place, the ways that mobile media inform those characteristics, and a dwelling that gives both the environment and the people within that space deeper significance.

NOTES

Introduction

1 Qtd. in Malcolm McCullough, *Digital Ground: Architecture, Pervasive Computing, and Environmental Knowing* (Cambridge, MA: MIT Press, 2004), 7.

2 Sherry Turkle, "Introduction: The Things That Matter," in *Evocative Objects: The Things We Think With*, ed. Sherry Turkle (Cambridge, MA: The MIT Press, 2007), 5.

3 Deborah Lupton, "The Embodied Computer/User," in *Cybercultures Reader*, ed. David Bell and Barbara Kennedy (New York: Routledge Press, 2000), 477–488.

4 Jon Agar, *Constant Touch: A Global History of the Mobile Phone* (Cambridge: Icon Books, 2003).

5 Allen W. Palmer, "Negotiation and Resistance in Global Networks: The 1884 International Meridian Conference," *Mass Communication and Society* 5, no. 1 (2009): 9.

6 Mizuko Ito, Daisuke Okabe, and Ken Anderson, "Portable Objects in Three Global Cities: The Personalization of Urban Places," in *The Reconstruction of Space and Time*, ed. Rich Ling and Scott W. Campbell (New Brunswick, NJ: Transaction Press, 2009), 74.

7 Howard Rheingold, *Smart Mobs: The Next Social Revolution* (Cambridge, MA: Perseus Books, 2002), xi.

8 Ibid., 85.

9 Ibid., 84–85.

10 Adam Greenfield, *Everyware: The Dawning Age of Ubiquitous Computing* (Berkeley: New Riders Press, 2006), 1.

11 Mark Weiser, "The World is Not a Computer," www.ubiq.com/hypertext/weiser/ACMInteractions2.html.

12 Paul Dourish, "Seeking a Foundation for Context-Aware Computing," *Human-Computer Interaction* 16, nos. 2–4 (2001): 231.

13 Ibid.

14 Jay David Bolter and Richard Grusin, *Remediation* (Cambridge, MA: The MIT Press, 1999), 23.

15 Mark Weiser, "The Computer for the 21st Century," www.ubiq.com/hypertext/weiser/SciAmDraft3.html.

16 Adam Greenfield, *Everyware: The Dawning Age of Ubiquitous Computing* (Berkeley: New Riders Press, 2006), 40.

17 Pew Internet Research Center, "Internet, Broadband, and Cell Phone Statistics," www.pewinternet.org/Reports/2010/internet-broadband-and-cell-phone-statistics.aspx.
18 International Data Corporation, "Number of Mobile Devices Accessing the Internet Expected to Surpass One Billion by 2013," www.idc.com/getdoc.jsp?containerId= prUS22110509.
19 Frank Bures, "Broadband Services Available Worldwide, But Few Can Afford It," *Wired* 15, no. 9 (2007): 60–61, www.wired.com/special_multimedia/2007/st_atlas_1509.
20 This is true even within the United States and other developed countries. See, for example, Katie Brown, Scott Campbell, and Rich Ling, "Mobile Phones Bridging the Digital Divide for Teens in the US," *Future Internet* 3 (2011), www.mdpi.com/journal/futureinternet/special_issues/mobile-social.
21 William Pike, interview with author, May 20, 2010.
22 Adriana de Souza e Silva and Daniel Sutko, "Merging Digital and Urban Playspaces: An Introduction to the Field," in *Digital Cityscapes: Merging Digital and Urban Playspaces* (New York: Peter Lang, 2009), 5.
23 Ibid.
24 Scott Brown, "Why Hollywood Should Avoid Gadget Close-Ups," *Wired* 18, no. 4 (2010), www.wired.com/magazine/2010/03/pl_scott_brown_agingtech.

1 Embodiment and the Mobile Interface

1 Nick Kaye, *Site-Specific Art: Performance, Place and Documentation* (New York: Routledge, 2000), 1. Emphasis original.
2 Henri Lefebvre, *The Production of Space* (Oxford: Blackwell Publishing, 1991), 170. Emphasis original.
3 Ibid., 83, 116.
4 N. Katherine Hayles, "Flesh and Metal: Reconfiguring the Mindbody in Virtual Environments," *Configurations* 10, no. 2 (2002): 297.
5 Edward S. Casey, *Getting Back into Place: Toward a Renewed Understanding of the Place-World* (Bloomington: Indiana University Press, 2009), xv.
6 Ibid., 13.
7 Rich Ling, *New Tech, New Ties: How Mobile Communication is Reshaping Social Cohesion* (Cambridge, MA: The MIT Press, 2008), 3.
8 Steven Levy, "On FaceTime and Sharing the View," *Wired*, August 30, 2010, www.wired.com/magazine/2010/08/pr_levy_facetime/.
9 Ken Ling-Pei Kung, "Visual Communication: Past, Present, and Future," MIT Lab Publications, http://pubs.media.mit.edu/pubs/papers/visualcom.pdf.
10 Kenneth Lipartito, "Picturephone and the Information Age: The Social Meaning of Failure," *Technology and Culture* 44, no. 1 (2003): 61.
11 Ibid., 63.
12 Allucquére Roseanne Stone, "Split Subjects, Not Atoms; or, How I Fell in Love with My Prosthesis," *Configurations* 2, no. 1 (1994): 176.
13 Ibid., 177.
14 Paul Dourish, *Where the Action Is: The Foundations of Embodied Interaction* (Cambridge, MA: The MIT Press, 2001), 101.
15 "Virtual, adj. (and n.)," *OED Online*, March 2011, www.oed.com/view/Entry/223829.
16 John Rajchman, "The Virtual House," *Constructions* (Cambridge, MA: The MIT Press, 1998), 116.
17 See Dave Lamble et al., "Cognitive Load and Detection Thresholds in Car Following Situations: Safety Implications for using Mobile (Cellular) Telephones while Driving," *Accident Analysis and Prevention* 31, no. 6 (1999); Paul J. Treffner and Rod Barrett, "Hands-Free Mobile Phone Speech while Driving Degrades Coordination and

Control," *Transportation Research* Part F 7 (2004); and Annie Rydström et al., "Driving Behaviour during Haptic and Visual Secondary Tasks," *Proceedings of the First International Conference on Automotive User Interfaces and Interactive Vehicular Applications* (2009).

18 Elizabeth Grosz, *Volatile Bodies: Toward a Corporeal Feminism* (Bloomington: Indiana University Press, 1994), 23.

19 Paul Dourish, *Where the Action Is: The Foundations of Embodied Interaction* (Cambridge, MA: The MIT Press, 2001), 126.

20 N. Katherine Hayles, *Electronic Literature: New Horizons for the Literary* (Notre Dame, IN: University of Notre Dame Press, 2008), 87.

21 Ibid., 88.

22 Ibid., 100–101.

23 Ibid., 102, 104.

24 Mark Hansen, *New Philosophy for New Media* (Cambridge, MA: The MIT Press, 2004), 80.

25 Maurice Merleau-Ponty, *The Phenomenology of Perception*. Trans. Colin Smith. (New York: Routledge Press, 1958), 241.

26 Ibid., 94–95.

27 Ibid., xi–xii.

28 John van Buren. Quoted in Jeff Malpas, *Heidegger's Topology* (Cambridge, MA: The MIT Press, 2006), 6. Emphasis mine.

29 Maurice Merleau-Ponty, *The Primacy of Perception* (Evanston: Northwestern University Press, 1955), 115.

30 The term "social proprioception" was coined by Clive Thompson in his June 2007 *Wired* magazine article, "How Twitter Creates a Social Sixth Sense," *Wired* 15, no. 7 (2007), www.wired.com/techbiz/media/magazine/15-07/st_thompson.

31 John F. Kihlstrom, "The Cognitive Unconscious," *Science* 237 (1987), 1455.

32 James S. Uleman, "Introduction: Becoming Aware of the New Unconscious," *The New Unconscious*, ed. Ran R. Hassin, James S. Uleman, and John A. Bargh (Oxford: Oxford University Press, 2005), 5.

33 John F. Kihlstrom, "The Cognitive Unconscious," *Science* 237 (1987), 1450.

34 Martin Heidegger, *Being and Time* (Oxford: Wiley-Blackwell, 1962), 99.

35 Louis Althusser, *Lenin and Philosophy and Other Essays*. Trans. Ben Brewster (New York: Monthly Review Press, 2001), 85.

36 N. Katherine Hayles, "Flesh and Metal: Reconfiguring the Mindbody in Virtual Environments," *Configurations* 10, no. 2 (2002): 297.

37 Jacques Derrida, *Of Grammatology*. Trans. Gayatri Chakravorty Spivak (Baltimore: The Johns Hopkins University Press, 1998), 158–159.

38 Mark Hansen, *New Philosophy for New Media* (Cambridge, MA: The MIT Press, 2004), 230.

39 Ibid., 228.

40 Maurice Merleau-Ponty, *The Phenomenology of Perception* (New York: Routledge Press, 1958), 143.

41 Frantz Fanon, *Black Skin, White Masks*. Trans. Richard Philcox (New York: Grove Press, 2008), 91.

42 Ibid., 93.

43 N. Katherine Hayles, *How We Became Posthuman: Virtual Bodies in Cybernetics, Literature, and Informatics* (Chicago: University of Chicago Press, 1999), 193.

2 Mapping and Representations of Space

1 Elizabeth Grosz, *Architecture from the Outside: Essays on Virtual and Real Space* (Cambridge, MA: The MIT Press, 2001), 76.

2 Ibid., 88, 79.

3 Ibid., 86.
4 "Virtual, adj. (and n.)," *OED Online*, March 2011, www.oed.com/view/Entry/ 223829.
5 Adriana de Souza e Silva and Daniel Sutko, "Theorizing Locative Technologies Through Philosophies of the Virtual," *Communication Theory* 21 (2011): 25.
6 Ibid., 26.
7 Umberto Eco, cited in Adriana de Souza e Silva and Daniel Sutko, "Theorizing Locative Technologies Through Philosophies of the Virtual," 29.
8 John Rajchman, "The Virtual House," *Constructions* (Cambridge, MA: The MIT Press, 1998), 116.
9 Ibid.
10 Tony Kushner, "A Conversation with Tony Kushner," Dean's Lecture Series, University of Maryland, College Park, February 22, 2011.
11 John Rajchman, "The Virtual House," *Constructions* (Cambridge, MA: The MIT Press, 1998), 116.
12 Gilles Deleuze. *Difference and Repetition* (New York: Columbia University Press, 1994).
13 Tom Corby, "Landscapes of Feeling, Arenas of Action: Information Visualization as Art Practice," *Leonardo* 41, no. 5 (2008): 462.
14 Edward Casey, *Getting Back into Place: Toward a Renewed Understanding of the Place-World* (Bloomington: Indiana University Press, 2009), 36–37.
15 Jacques Derrida, "Signature Event Context," in *Margins of Philosophy*. Trans. Alan Bass (Chicago: University of Chicago Press, 1982), 310.
16 Though I am distinguishing here between digital and material spaces, this is more of a gesture toward the relationship between digital information and hardscapes. The digital must be understood as material, since the infrastructure that makes it possible and the interfaces that allow us to interact with data are always material.
17 Lev Manovich, *The Language of New Media* (Cambridge, MA: The MIT Press, 2001), 25.
18 Paul Jahshan, *Cybermapping and the Writing of Myth* (New York: Peter Lang, 2007), 53.
19 Jean Baudrillard, *Simulacra and Simulation*. Trans. S.F. Glaser (Ann Arbor: The University of Michigan Press, 1994), 1.
20 Raymond B. Craib, "Cartography and Power in the Conquest and Creation of New Spain," *Latin American Research Review* 35, no. 1 (2000): 8.
21 Drew Hemment, "Locative Arts," *Leonardo* 39, no. 4 (2006): 349–350.
22 Tom Corby, "Landscapes of Feeling, Arenas of Action: Information Visualization as Art Practice," *Leonardo* 41, no. 5 (2008): 465.
23 Chris Perkins, "Community Mapping," *The Cartographic Journal* 44, no. 2 (2007): 128.
24 Tom Corby, "Landscapes of Feeling, Arenas of Action: Information Visualization as Art Practice," *Leonardo* 41, no. 5 (2008): 465.
25 Jason Farman, "Mapping the Digital Empire: Google Earth and the Process of Postmodern Cartography," *New Media and Society* 12, no. 6 (2010).
26 Paula Levine, "Shadows from Another Place," *Proceedings of the Media in Transition 4 Conference*, http://web.mit.edu/comm-forum/mit4/papers/levine.pdf.
27 Guy-Ernest Debord, "Introduction to a Critique of Urban Geography," *The Situationist International Text Library*, http://library.nothingness.org/articles/SI/en/display/2.
28 Ibid.
29 Mary Flanagan, *Critical Play: Radical Game Design* (Cambridge, MA: The MIT Press, 2009), 195.
30 Matthew Edney, *Mapping an Empire: The Geographical Construction of British India, 1765–1843* (Chicago: University of Chicago Press, 1990), 2.
31 Liqiu Meng, "Egocentric Design of Map-Based Mobile Services," *The Cartographic Journal* 42, no. 1 (2005): 7.
32 Christian Heipke, "Crowdsourcing Geospatial Data," *ISPRS Journal of Photogrammetry and Remote Sensing* 65 (2010): 550–557.

33 This SMS message was sent to Ushahidi on January 23, 2010 and is chronicled, along with the English translation and the pinpoint on the Open Street Map, at: http://haiti. ushahidi.com/reports/view/1772.

3 Locative Interfaces and Social Media

1 Pattie Maes, "Pattie Maes and Pranav Mistry demo SixthSense," TED Talks, www.ted. com/index.php/talks/pattie_maes_demos_the_sixth_sense.html.
2 David Goldman, "MySpace to Cut 30% of Workforce," *CNNMoney.com*, June 16, 2009, http://money.cnn.com/2009/06/16/technology/myspace_layoffs/.
3 Yuki Noguchi, "In Teens' Web World, MySpace Is So Last Year," *Washington Post*, October 29, 2006.
4 Ibid.
5 Jason Scott Sadofsky, *BBS: The Documentary*, Released under Creative Commons, 2005.
6 Richard Bartle, "Early MUD History," www.mud.co.uk/richard/mudhist.htm.
7 Julian Dibbell, "A Rape in Cyberspace," www.juliandibbell.com/articles/a-rape-in-cyberspace/.
8 "Affinity space" is a term coined by James Paul Gee in *Situated Language and Learning: A Critique of Traditional Schooling* (New York: Routledge Press, 2004).
9 Kathryn Zickuhr and Aaron Smith, "4% of Online Americans use Location-based Services," *Pew Research Center's Internet & American Life Project*, November 4, 2010, http://pewinternet.org/Reports/2010/Location-based-services.aspx.
10 Sarah Perez, "Study: Location-Based Services Users Are Passionate but Niche," *New York Times*, September 9, 2010, www.nytimes.com/external/readwriteweb/2010/09/09/09readwriteweb-study-location-based-services-users-are-pas-83631.html.
11 Johanna Drucker, "Humanities Approaches to Interface Theory," *Culture Machine* 12 (2011): 10.
12 Alexander R. Galloway, "The Unworkable Interface," *New Literary History* 39 (2009): 936.
13 Jef Raskin, *The Humane Interface: New Directions for Designing Interactive Systems* (Boston: Addison-Wesley, 2000), 20.
14 Quoted in Alexander R. Galloway, "The Unworkable Interface," *New Literary History* 39 (2009): 936.
15 James Thompson Bottomley, *Hydrostatics; or Theoretical Mechanics, Part II* (London: William Collins and Sons, 1882), 13.
16 See Donald Norman, *Living with Complexity* (Cambridge, MA: The MIT Press, 2010).
17 Johanna Drucker, "Humanities Approaches to Interface Theory," *Culture Machine* 12 (2011): 8.
18 Ibid., 8, 9.
19 Maurice Merleau-Ponty, "Eye and Mind," in *The Primacy of Perception* (Evanston, IL: Northwestern University Press, 1964), 168.
20 Here I gesture toward Sartre's use of the term, which, in elementary terms, is a being that seeks to have full control of his or her identity as a singular being, resisting the act of being-in-the-world or being-for-others.
21 Ben Shneiderman, "A Grander Goal: A Thousand-Fold Increase in Human Capabilities," *Educom Review* 32, no. 6 (1997): 4.
22 Maurice Merleau-Ponty, *Signs*. Trans. Richard C. McCleary (Evanston, IL: Northwestern University Press, 1964), 159.
23 Jack Reynolds, *Merleau-Ponty and Derrida: Intertwining Embodiment and Alterity* (Athens, OH: Ohio University Press, 2004), 128–129.
24 It should be noted that different social media have different levels of intended intimacy and, even in those networks that seemingly foster intimate connections, the level of experienced intimacy will vary greatly from user to user. As locative media scholar

Jordan Frith rightly pointed out to me, "social media" is a broad and varied term that covers a range of interpersonal connections such as an open blog that receives many comments and conversations versus a closed blog. Facebook is a very different social network than Last.fm, and individuals within those networks each have different perceptions of online intimacy.

25 Marina Fiedler, Ernan Haruvyb, and Sherry Xin Lic, "Social Distance in a Virtual World Experiment," www.utdallas.edu/~eharuvy/papers/SocialDistanceinVirtual Worlds.pdf.

26 Edward T. Hall, *The Hidden Dimension* (New York: Random House, 1966), 14. Emphasis original.

27 Quoted in Nicola Döring and Sandra Pöschl, "Nonverbal Cues in Mobile Phone Text Messages: The Effects of Chronemics and Proxemics," in *The Reconstruction of Space and Time*, ed. Rich Ling and Scott W. Campbell (New Brunswick, NJ: Transaction Press, 2009), 114.

28 Ibid., 111.

29 Sarah Perez, "Study: Location-Based Services Users are Passionate but Niche," *New York Times*, September 9, 2010, www.nytimes.com/external/readwriteweb/2010/09/09/09readwriteweb-study-location-based-services-users-are-pas-83631.html.

30 Anders Albrechtslund, "Online Social Networking as Participatory Surveillance," *First Monday* 13, no. 3 (2008), http://firstmonday.org/htbin/cgiwrap/bin/ojs/index.php/fm/article/viewArticle/2142/1949.

31 Ibid.

32 Hasan Elahi, interview by Stephen Colbert, *The Colbert Report*, Comedy Central, May 7, 2008.

33 Lili Berko, "Surveying the Surveilled: Video, Space and Subjectivity," in *American Television: New Directions in History and Theory*, ed. Nick Browne (Langhorne, PA: Harwood Academic Publishers, 1994), 223–253.

34 Anders Albrechtslund, "Online Social Networking as Participatory Surveillance," *First Monday* 13, no. 3 (2008), http://firstmonday.org/htbin/cgiwrap/bin/ojs/index.php/fm/article/viewArticle/2142/1949.

35 N. Katherine Hayles, *How We Became Posthuman: Virtual Bodies in Cybernetics, Literature, and Informatics* (Chicago: University of Chicago Press, 1999), 25.

36 danah boyd, "Why Youth (Heart) Social Network Sites: The Role of Networked Publics in Teenage Social Life," in *MacArthur Foundation Series on Digital Learning—Youth, Identity, and Digital Media Volume*, ed. David Buckingham (Cambridge, MA: The MIT Press, 2007), 13.

37 danah boyd, "White Flight in Networked Publics? How Race and Class Shaped American Teen Engagement with MySpace and Facebook," in *Race After the Internet*, ed. Lisa Nakamura and Peter Chow-White (New York: Routledge, 2011 forthcoming).

38 Adriana de Souza e Silva and Jordan Frith, "Locative Mobile Social Networks: Mapping Communication and Location in Urban Spaces," *Mobilities* 5, no. 4 (2010): 492.

39 Jack Reynolds, *Merleau-Ponty and Derrida: Intertwining Embodiment and Alterity* (Athens: Ohio University Press, 2004), 125.

40 Ibid.

41 In Maurice Merleau-Ponty, *The Primacy of Perception* (Evanston, IL: Northwestern University Press, 1964), 28.

42 Michael Yeo, "Perceiving/Reading the Other: Ethical Dimensions," in *Merleau-Ponty, Hermenutics, and Postmodernism*, ed. Thomas W. Busch and Shaun Gallagher (Albany: State University of New York Press, 1992), 38.

43 Jack Reynolds, *Merleau-Ponty and Derrida: Intertwining Embodiment and Alterity* (Athens: Ohio University Press, 2004), 128.

44 Ibid.

45 Adriana de Souza e Silva, "From Cyber to Hybrid: Mobile Technologies as Interfaces of Hybrid Spaces," *Space and Culture* 9, no. 3 (2006): 262.

4 The Ethics of Immersion in Locative Games

1 Markus Montola, Jaakko Stenros, and Annika Waern, *Pervasive Games: Theory and Design* (New York: Morgan Kaufmann, 2009), 111.

2 Jaakko Stenros et al., "Momentum Evaluation Report," *Integrated Project on Pervasive Computing*, http://iperg.sics.se/Deliverables/D11.8-Appendix-C-Momentum-Evaluation-Report.pdf.

3 Mary Flanagan, *Critical Play: Radical Game Design* (Cambridge, MA: The MIT Press, 2009), 206.

4 Adriana de Souza e Silva, "From Cyber to Hybrid: Mobile Technologies as Interfaces of Hybrid Spaces," *Space and Culture* 9, no. 3 (2006): 262.

5 Jay David Bolter and Richard Grusin, *Remediation: Understanding New Media* (Cambridge, MA: The MIT Press, 1999), 23.

6 Ibid., 33–34.

7 Ibid.

8 See Khanh T.L. Tran, "U.S. Videogame Industry Posts Record Profits," *Wall Street Journal*, February 7, 2002, and Nadine Dolby and Fazal Rizvi, *Youth Moves: Identities and Education in Global Perspective* (New York: Routledge Press, 2008), 54.

9 Craig Anderson, "Violent Video Games Increase Aggression and Violence," www.psychology.iastate.edu/faculty/caa/abstracts/2000-2004/00Senate.html.

10 Jason Farman, "Hypermediating the Game Interface: The Alienation Effect in Violent Videogames and the Problem of Serious Play," *Communication Quarterly* 58, no. 1 (2010): 101.

11 Simon Penny, "Representation, Enaction, and the Ethics of Simulation," in *First Person: New Media as Story, Performance, and Game*, ed. Noah Wardrip-Fruin and Pat Harrigan (Cambridge, MA: The MIT Press, 2004), 75.

12 Ibid., 76.

13 Quoted in Daniel Seiberg, "Manhunt 2: Most Violent Game Yet?" *CBS Evening News*, www.cbsnews.com/stories/2007/10/30/eveningnews/eyeontech/main3433101.shtml.

14 Mary Flanagan, *Critical Play: Radical Game Design* (Cambridge, MA: The MIT Press, 2009), 206.

15 Bertolt Brecht, *Brecht on Theatre: The Development of an Aesthetic*, ed. and trans. John Willett (New York: Hill and Wang, 1957), 71.

16 Johan Huizinga, *Homo Ludens: A Study of the Play-Element in Culture* (Boston: Beacon Press, 1950), 12.

17 Ibid., 13.

18 Mary Flanagan, "Locating Play and Politics: Real World Games & Activism," *Leonardo Electronic Almanac* 16, no. 2–3 (2008): 3.

19 Henri Lefebvre, *The Production of Space*. Trans. Donald Nicholson Smith (Oxford: Blackwell Press, 1991), 170.

20 Christian Licoppe and Yoriko Inada, "Emergent Uses of a Multiplayer Locationaware Mobile Game: the Interactional Consequences of Mediated Encounters," *Mobilities* 1, no. 1 (2006): 52.

21 Friedrich Kitler, *Gramophone, Film, Typewriter*. Trans. Geoffrey Winthrop-Young and Michael Wutz (Stanford: Stanford University Press, 1999).

22 Mark Hansen, *New Philosophy for New Media* (Cambridge, MA: The MIT Press, 2004), 82.

23 N. Katherine Hayles, *Electronic Literature: New Horizons for the Literary* (Notre Dame, IN: University of Notre Dame Press, 2008), 104.

24 Lev Manovich, "The Poetics of Augmented Space," www.manovich.net/nnm%20 map/Augmented_2004revised.doc.

25 Mark Hansen, "Movement and Memory: Intuition as Virtualization in GPS Art," *MLN* 120 (2005): 1216–1217.

26 Caroline Bassett, "'How Many Movements?' Mobile Telephones and Transformations in Urban Space," *Open: Cahier on Art and the Public Domain* 9 (2003), www.skor.nl/article-2854-en.html.

27 Marc Tuters and Kazys Varnelis, "Beyond Locative Media: Giving Shape to the Internet of Things," *Leonardo* 39, no. 4 (2006): 359.

28 Caroline Bassett, "'How Many Movements?' Mobile Telephones and Transformations in Urban Space," *Open: Cahier on Art and the Public Domain* 9 (2003), www.skor.nl/article-2854-en.html.

29 Mary Flanagan, *Critical Play: Radical Game Design* (Cambridge, MA: The MIT Press, 2009), 204.

30 Ibid., 205.

31 Ibid.

32 Jacques Derrida, *Writing and Difference*. Trans. Alan Bass (Chicago: The University of Chicago Press, 1978), 285.

33 Claus Pias, "Play as Creative Misuse: Barcode Battler and the Charm of the Real," in *Space Time Play: Computer Games, Architecture, and Urbanism: The Next Level*, ed. Friedrich von Borries, Steffen P. Walz, and Matthias Böttger (Boston: Birkhäuser Verlag AG, 2007), 230–231.

34 Ibid., 231.

35 Ibid.

36 Mary Flanagan, *Critical Play: Radical Game Design* (Cambridge, MA: The MIT Press, 2009), 207.

37 Ibid.

38 Frank Lantz, "Big Urban Game: A Playful Connection of the 'Twin Cities,'" in *Space Time Play: Computer Games, Architecture, and Urbanism: the Next Level*, ed. Friedrich von Borries, Steffen P. Walz, and Matthias Böttger (Boston: Birkhäuser Verlag AG, 2007), 390.

39 Ibid.

5 Performances of Asynchronous Time

1 Annet Dekker, "Interview with Simon Faithfull," *Visual Correspondents Berlin*, November 2, 2009, www.visualcorrespondents.com/faithfull.html

2 Peggy Phelan, *Unmarked: The Politics of Performance* (New York: Routledge, 1993), 146.

3 Ibid., 24.

4 I talk about this cyclical nature more fully in my article "Gertrude Stein in QuickTime: Documenting Performance in the Digital Age," in *Complex Worlds: Digital Culture, Rhetoric, and Professional Communication*, ed. Adrienne Lamberti and Anne R. Richards (Amityville, NY: Baywood, 2011), 79–94.

5 Amelia Jones, "'Presence' in Absentia: Experiencing Performance as Documentation," *Art Journal* 56, no. 4 (1997): 12.

6 Herbert Blau, *Blooded Thought: Occasions of Theatre* (New York: Performing Arts Journal Publications, 1982), 134.

7 Rich Ling, *New Tech, New Ties: How Mobile Communication is Reshaping Social Cohesion* (Cambridge, MA: The MIT Press, 2008), 102.

8 Ibid.

9 Ibid.

10 Howard Rheingold, *Smart Mobs: The Next Social Revolution* (Cambridge, MA: Perseus Books, 2002), xi.

11 Kenneth J. Gergen, "The Challenge of Absent Presence," in *Perpetual Contact: Mobile Communication, Private Talk, Public Performance*, ed. James E. Katz and Mark A. Aakhus (Cambridge: Cambridge University Press, 2002), 236.

12 See Mizuko Ito and Daisuke Okabe, "Technosocial Situations: Emergent Structuring of Mobile E-Mail Use," in *Personal, Portable, Pedestrian*, ed. Mizuko Ito, Daisuke Okabe, and Misa Matsuda (Cambridge, MA: The MIT Press, 2005), 263.

13 Rich Ling, "Mobile Communications Vis-à-vis Teen Emancipation, Peer Group Integration and Deviance," in *The Inside Text*, ed. Richard Harper, Leysia Ann Palen, and Alex S. Taylor (Norwell, MA: Springer, 2005).

14 Hyo Kim et al., "Configurations of Relationships in Different Media: FtF, Email, Instant Messenger, Mobile Phone, and SMS," *Journal of Computer-Mediated Communication* 12, no. 4 (2007).

15 Ran Wei and Ven-Hwei Lo, "Staying Connected While on the Move: Cell Phone Use and Social Connectedness," *New Media & Society* 8, no. 1 (2006): 53–72.

16 Rich Ling, *New Tech, New Ties How Mobile Communication is Reshaping Social Cohesion* (Cambridge, MA: The MIT Press, 2008), 164.

17 Susan Kozel, "Social Networking: Contra Choreography," presented at *Dance Technology and Circulations of the Social, 2.0*, April 22, 2011, MIT.

18 Ibid.

19 Clive Thompson, "How Twitter Creates a Social Sixth Sense," *Wired* 15, no. 7 (2007), www.wired.com/techbiz/media/magazine/15-07/st_thompson.

20 Ibid.

21 Over the course of 2009, data traffic became the dominant use of mobile devices, overtaking voice communication for the first time. See Tricia Duryee, "A New First in Mobile: Data Traffic Outstripped Voice Traffic Last Year," *mocoNews.net*, April 1, 2010, http://moconews.net/article/419-a-new-first-in-mobile-data-traffic-outstripped-voice-traffic-last-year/.

22 Nam June Paik, "Art and Satellite," in *Theories and Documents of Contemporary Art*, ed. Kristine Stiles and Peter Howard Selz (Los Angeles: University of California Press, 1996), 435.

23 Thoreau actually wrote, "Our inventions are wont to be pretty toys, which distract our attention from serious things. They are but improved means to an unimproved end, an end which it was already but too easy to arrive at; as railroads lead to Boston or New York. We are in great haste to construct a magnetic telegraph from Main to Texas; but Main and Texas, it may be, have nothing important to communicate." Henry David Thoreau, *Walden: or, Life in the Woods* (Boston: Beacon Press, 1854/1997), 48.

24 Claude S. Fischer, *America Calling: A Social History of the Telephone to 1940* (Los Angeles: University of California Press, 1992), 3.

25 Christopher H. Sterling, "CBQ Review Essay: History of the Telephone (Part One): Invention, Innovation, and Impact," *Communication Booknotes Quarterly* 35, no. 4 (2004): 222.

26 Quoted in Jacques Derrida, *Dissemination*. Trans. Barbara Johnson (Chicago: University of Chicago Press, 1981), 104–105.

27 Ibid., ix.

28 Manuel Castells, Mireia Fernández-Ardèvol, Jack Linchuan Qui, and Araba Sey, *Mobile Communication and Society: A Global Perspective* (Cambridge, MA: The MIT Press, 2007), 174.

29 Nicola Döring and Sandra Pöschl, "Nonverbal Cues in Mobile Phone Text Messages: The Effects of Chronemics and Proxemics," in *The Reconstruction of Space and Time*, ed. Rich Ling and Scott W. Campbell (New Brunswick, NJ: Transaction Press, 2009), 109–136.

30 Sherry Turkle, "Always-On/Always-On-You: The Tethered Self," in *Handbook of Mobile Communication Studies*, ed. James E. Katz (Cambridge, MA: The MIT Press, 2008), 122.

31 Manuel Castells, Mireia Fernández-Ardévol, Jack Linchuan Qui, and Araba Sey, *Mobile Communication and Society: A Global Perspective* (Cambridge, MA: The MIT Press, 2007), 175.
32 Mark Hansen, "Movement and Memory: Intuition as Virtualization in GPS Art," *MLN* 120 (2005): 1216–1217.
33 Ibid., 1210–1211.
34 Marsha Kinder, "Hot Spots, Avatars, and Narrative Fields Forever: Bunuel's Legacy for New Digital Media and Interactive Database Narrative," *Film Quarterly* 55, no. 4 (2002): 5–6.
35 Marc Tuters and Kazys Varnelis, "Beyond Locative Media: Giving Shape to the Internet of Things," *Leonardo* 39, no. 4 (2006): 360.
36 Ibid.
37 Qtd. in Marc Tuters and Kazys Varnelis, "Beyond Locative Media: Giving Shape to the Internet of Things," *Leonardo* 39, no. 4 (2006): 360.
38 Marc Tuters and Kazys Varnelis, "Beyond Locative Media: Giving Shape to the Internet of Things," *Leonardo* 39, no. 4 (2006): 359.
39 Ibid., 362.
40 Ibid.
41 Mark Poster, "The Information Empire," *Comparative Literature Studies* 4, no. 3 (2004): 318.
42 Ibid., 319.

6 Site-Specific Storytelling and Reading Interfaces

1 Michel de Certeau, *The Practice of Everyday Life* (Los Angeles: University of California Press, 1984), 115.
2 An important place to start when studying these debates is Adrian Johns' *The Nature of the Book: Print and Knowledge in the Making* (Chicago: University of Chicago Press, 1998).
3 Italo Calvino, *If on a Winter's Night a Traveler* (Orlando, FL: Harcourt & Brace, 1981), 176.
4 Rachel Dretzin and Douglas Rushkoff, *Digital Nation*, DVD. Directed by Rachel Dretzin (Arlington, VA: PBS, 2010).
5 "I, New York," *Time Out New York*, http://newyork.timeout.com/articles/i-new-york/4546/boy-with-the-bubble.
6 Rita Raley, "Mobile Media Poetics," *Proceedings of the Digital Arts and Culture Conference* (2009): 4.
7 Ibid.
8 John Degan, "379 Spadina Ave." *[murmur] Toronto*, http://murmurtoronto.ca/place.php?229608.
9 N. Katherine Hayles, *My Mother Was a Computer: Digital Subjects and Literary Texts* (Chicago: University of Chicago Press, 2005), 55. Emphasis mine.
10 Shekhar Kapur, "We are the Stories We Tell Ourselves," *TEDIndia* www.ted.com/talks/shekhar_kapur_we_are_the_stories_we_tell_ourselves.html.
11 Sam Liccardo, "(former) Notre Dame Market," *[murmur]*, http://sanjose.murmur.info/place.php?467544.
12 Walter Ong, *Orality and Literacy* (New York: Routledge, 2002), 66–67.
13 Marshall McLuhan, "The Gutenberg Galaxy," in *The Essential McLuhan*, ed. Eric McLuhan and Frank Zingrone (New York: Basic Books, 1995), 113.
14 Robert Darnton, "History of Reading," in *New Perspectives on Historical Writing*, ed. Peter Burke, 2nd edition (Cambridge: Polity Press, 2001), 158.
15 Ibid., 167.
16 Ibid.

17 Malcolm McCullough, "Epigraphy and the Public Library," in *Augmented Urban Spaces: Articulating the Physical and Electronic City*, ed. Alessandro Aurigi and Fiorella de Cindio (Burlington, VT: Ashgate Publishing, 2008), 64.
18 Ibid., 69.
19 Michel de Certeau, *The Practice of Everyday Life* (Los Angeles: University of California Press, 1984), 118.
20 Tommy Nguyen, "Targeting the 'Art' Around Every Corner," *Washington Post*, July 2, 2005, www.washingtonpost.com/wp-dyn/content/article/2005/07/01/AR20050 70102280.html.
21 Jeremy Hight, "Views from Above: Locative Narrative and the Landscape," *Leonardo Electronic Almanac* 14, no. 7–8 (2006), http://leoalmanac.org/journal/vol%5f14/lea%5fv 14%5fn07-08/jhight.asp.
22 Rita Raley, "Walk this Way: Mobile Narrative as Composed Experience," in *Beyond the Screen: Transformations of Literary Structures, Interfaces and Genre*, ed. Jörgen Schäfer and Peter Gendolla (Bielefeld, Germany: Transcript Verlag, 2010), 312.
23 Ibid.
24 Jeremy Hight, "Views from Above: Locative Narrative and the Landscape," *Leonardo Electronic Almanac* 14, no. 7–8 (2006), http://leoalmanac.org/journal/vol%5f14/lea% 5fv14%5fn07-08/jhight.asp
25 Ibid.
26 Ibid.
27 Elaine Scarry, *The Body in Pain: The Making and Unmaking of the World* (Oxford: Oxford University Press, 1985), 207.
28 Walter Benjamin, "Theses on the Philosophy of History," in *Illuminations*, ed. Hannah Arendt. Trans. Harry Zohn (New York: Schocken Books, 1968), 255.
29 Howard Caygill, "Walter Benjamin's Concept of Cultural History," *The Cambridge Companion to Walter Benjamin* (Cambridge: Cambridge University Press, 2004), 90.
30 Lev Manovich, *The Language of New Media* (Cambridge, MA: The MIT Press, 2001), 225.
31 Ibid., 228.
32 N. Katherine Hayles, "Narrative and Database: Natural Symbionts," *PMLA* 122, no. 5 (2007): 1603.
33 Ibid.
34 Richard Turner, "Tales for Sale at Oxfam Charity Shop in Manchester," BBC, May 13, 2010, http://news.bbc.co.uk/local/manchester/hi/people_and_places/newsid_86 80000/8680310.stm.
35 Digital Urban, "RememberMe: Future Everything and the Internet of Things," www.digitalurban.org/2010/05/rememberme-future-everything-and.html.

Conclusion

1 Edward Casey, *Getting Back into Place* (Bloomington: Indiana University Press, 1993), xii.
2 Douglas Rushkoff, *Life Inc: How Corporatism Conquered the World, and How We Can Take it Back* (New York: Random House, 2011), 19.
3 Sherry Turkle, "Alive Enough? Reflecting on Our Technology," *Krista Tippett on Being*, American Public Media, April 7, 2011, http://being.publicradio.org/programs/ 2011/alive-enough.
4 Qtd. in Stefan Poslad, *Ubiquitous Computing: Smart Devices, Environments and Interactions* (West Sussex: Wiley & Sons, 2009), 12.
5 James Burke, "A Matter of Fact," *The Day the Universe Changed: A Personal View by James Burke*, Directed by Richard Reistz, 1986, London: BBC.
6 Claude S. Fischer, *America Calling: A Social History of the Telephone to 1940* (Berkeley: University of California Press, 1992), 1.

7 Ibid.
8 Ibid., 2.
9 Ibid., 3.
10 Paul Virilio, *The Aesthetics of Disapperance* (Paris: Semiotext(e), 1991), 59.
11 Data drawn from Environmental Protection Agency and United States Geologic Survey studies. See www.epa.gov/waste/education/pdfs/life-cell.pdf and pubs.usgs.gov/fs/2006/3097/fs2006-3097.pdf.
12 Edward Casey, *Getting Back into Place* (Bloomington: Indiana University Press, 1993), xii.
13 Walter Benjamin, *Illuminations*. Trans. Hannah Arendt (New York: Schocken Books, 1968), 257.
14 Robert A. Davidson, "Animate Objects: Being, Obsolescence and the Limits of Citizenship in Gómez de la Serna," *MLN* 123, no. 2 (2008): 274.
15 Adriana de Souza e Silva and Jordan Frith, "Locative Mobile Social Networks: Mapping Communication and Location in Urban Spaces," *Mobilities* 5, no. 4 (2010): 487.
16 Lise Smith, "The Place Prize 2010, Semi-finals, The Place," LondonDance.com, www.londondance.com/reviews_details.asp?C=The+Place+Prize+2010&P=Semi-finals&V=The+Place.
17 Here, Lepecki is citing Gaston Bachelard. André Lepecki, *Exhausting Dance: Performance and the Politics of Movement* (New York: Routledge, 2006), 15.
18 Ibid., 2.
19 Ibid., 3.
20 Ibid., 15.
21 Chris Salter, "Alien Action/Alien Agency: Choreography, Technology, and Systems of Aliveness," presentation at *Dance Technology and Circulations of the Social, Version 2.0* at MIT, April 2011.
22 Qtd. in Chris Salter, "Alien Action/Alien Agency: Choreography, Technology, and Systems of Aliveness."
23 Ibid.
24 Susan Jones, "'At the still point': T.S. Eliot, Dance, and Modernism," *Dance Research Journal* 41, no. 2 (2009): 35–36.

BIBLIOGRAPHY

Agar, Jon. *Constant Touch: A Global History of the Mobile Phone*. Cambridge: Icon Books, 2003.

Albrechtslund, Anders. "Online Social Networking as Participatory Surveillance." *First Monday* 13, no. 3 (2008), http://firstmonday.org/htbin/cgiwrap/bin/ojs/index.php/fm/article/viewArticle/2142/1949#4a.

Althusser, Louis. *Lenin and Philosophy and Other Essays*. Translated by Ben Brewster. New York: Monthly Review Press, 2001.

Auslander, Philip. *Liveness: Performance in a Mediatized Culture*. New York: Routledge, 1999.

Bassett, Caroline. "'How Many Movements?' Mobile Telephones and Transformations in Urban Space." *Open: Cahier on Art and the Public Domain* 9 (2003), www.skor.nl/article-2854-en.html.

Baudrillard, Jean. *Simulacra and Simulation*. Translated by S.F. Glaser. Ann Arbor: The University of Michigan Press, 1994.

Benjamin, Walter. *Illuminations*. Translated by Hannah Arendt. New York: Schocken Books, 1968.

Berko, Lili. "Surveying the Surveilled: Video, Space and Subjectivity." *American Television: New Directions in History and Theory*. Edited by Nick Browne, 223–253. Langhorne, PA: Harwood Academic Publishers, 1994.

Bolter, Jay David and Richard Grusin. *Remediation: Understanding New Media*. Cambridge, MA: The MIT Press, 1999.

Bottomley, James Thompson. *Hydrostatics; or Theoretical Mechanics, Part II*. London: William Collins and Sons, 1882.

boyd, danah. "White Flight in Networked Publics? How Race and Class Shaped American Teen Engagement with MySpace and Facebook." *Digital Race: An Anthology*. Edited by Lisa Nakamura and Peter Chow-White. New York: Routledge, 2011.

boyd, danah. "Why Youth (Heart) Social Network Sites: The Role of Networked Publics in Teenage Social Life." *MacArthur Foundation Series on Digital Learning—Youth, Identity, and Digital Media Volume*. Edited by David Buckingham, 119–142. Cambridge, MA: The MIT Press, 2007.

Brecht, Bertolt. *Brecht on Theatre: The Development of an Aesthetic.* Edited and translated by John Willett. New York: Hill and Wang, 1957.

Calvino, Italo. *If on a Winter's Night a Traveler.* Orlando, FL: Harcourt & Brace, 1981.

Carr, Nicholas. "Is Google Making Us Stupid?" *Yearbook of the National Society for the Study of Education* 107, no. 2 (2008): 89–94.

Casey, Edward S. *Getting Back into Place: Toward a Renewed Understanding of the Place-World.* Bloomington: Indiana University Press, 2009.

Castells, Manuel, Mireia Fernández-Ardévol, Jack Linchuan Qui, and Araba Sey. *Mobile Communication and Society: A Global Perspective.* Cambridge, MA: The MIT Press, 2007.

Caygill, Howard. "Walter Benjamin's Concept of Cultural History." *The Cambridge Companion to Walter Benjamin.* Edited by David S. Ferris, 73–96. Cambridge: Cambridge University Press, 2004.

Corby, Tom. "Landscapes of Feeling, Arenas of Action: Information Visualization as Art Practice." *Leonardo* 41, no. 5 (2008): 460–467.

Craib, Raymond B. "Cartography and Power in the Conquest and Creation of New Spain." *Latin American Research Review* 35, no. 1 (2000): 7–36.

Darnton, Robert. "History of Reading." *New Perspectives on Historical Writing.* 2nd edition. Edited by Peter Burke, 157–186. Cambridge: Polity Press, 2001.

Davidson, Robert A. "Animate Objects: Being, Obsolescence and the Limits of Citizenship in Gómez de la Serna." *MLN* 123, no. 2 (2008): 274–293.

de Certeau, Michel. *The Practice of Everyday Life.* Los Angeles: University of California Press, 1984.

de Souza e Silva, Adriana. "From Cyber to Hybrid: Mobile Technologies as Interfaces of Hybrid Spaces." *Space and Culture* 9, no. 3 (2006): 261–278.

de Souza e Silva, Adriana and Jordan Frith. "Locative Mobile Social Networks: Mapping Communication and Location in Urban Spaces." *Mobilities* 5, no. 4 (2010): 485–506.

de Souza e Silva, Adriana and Daniel Sutko. "Merging Digital and Urban Playspaces: An Introduction to the Field." *Digital Cityscapes: Merging Digital and Urban Playspaces.* Edited by Adriana de Souza e Silva and Daniel Sutko, 1–17. New York: Peter Lang, 2009.

Debord, Guy-Ernest. "Introduction to a Critique of Urban Geography." *The Situationist International Text Library,* http://library.nothingness.org/articles/SI/en/display/2.

Derrida, Jacques. *Dissemination.* Translated by Barbara Johnson. Chicago: University of Chicago Press, 1981.

Derrida, Jacques. *Margins of Philosophy.* Translated by Alan Bass. Chicago: University of Chicago Press, 1982.

Derrida, Jacques. *Of Grammatology.* Translated by Gayatri Chakravorty Spivak. Baltimore: The Johns Hopkins University Press, 1998.

Derrida, Jacques. *Writing and Difference.* Translated by Alan Bass. Chicago: University of Chicago Press, 1978.

Dolby, Nadine and Fazal Rizvi. *Youth Moves: Identities and Education in Global Perspective.* New York: Routledge Press, 2008.

Döring, Nicola and Sandra Pöschl. "Nonverbal Cues in Mobile Phone Text Messages: The Effects of Chronemics and Proxemics." *The Reconstruction of Space and Time.* Edited by Rich Ling and Scott W. Campbell, 109–136. New Brunswick, NJ: Transaction Press, 2009.

Dourish, Paul. "Seeking a Foundation for Context-Aware Computing." *Human-Computer Interaction,* 16, no. 2–4 (2001): 229–241.

Dourish, Paul. *Where the Action Is: The Foundations of Embodied Interaction.* Cambridge, MA: The MIT Press, 2001.

Drucker, Johanna. "Humanities Approaches to Interface Theory." *Culture Machine* 12 (2011): 1–20.

Edney, Matthew. *Mapping an Empire: The Geographical Construction of British India, 1765–1843.* Chicago: University of Chicago Press, 1990.

Fanon, Frantz. *Black Skin, White Masks.* Translated by Richard Philcox. New York: Grove Press, 2008.

Farman, Jason. "Gertrude Stein in QuickTime: Documenting Performance in the Digital Age." *Complex Worlds: Digital Culture, Rhetoric, and Professional Communication.* Edited by Adrienne Lamberti and Anne R. Richards, 79–94. Amityville, NY: Baywood, 2011.

Farman, Jason. "Hypermediating the Game Interface: The Alienation Effect in Violent Videogames and the Problem of Serious Play." *Communication Quarterly* 58, no. 1 (2010): 96–109.

Farman, Jason. "Mapping the Digital Empire: Google Earth and the Process of Postmodern Cartography." *New Media and Society* 12, no. 6 (2010): 869–888.

Fischer, Claude S. *America Calling: A Social History of the Telephone to 1940.* Los Angeles: University of California Press, 1992.

Flanagan, Mary. *Critical Play: Radical Game Design.* Cambridge, MA: The MIT Press, 2009.

Flanagan, Mary. "Locating Play and Politics: Real World Games & Activism." *Leonardo Electronic Almanac* 16.2–3 (2008), http://leoalmanac.org.

Galloway, Alexander R. "The Unworkable Interface." *New Literary History* 39 (2009): 931–955.

Gee, James Paul. *Situated Language and Learning: A Critique of Traditional Schooling.* New York: Routledge Press, 2004.

Gergen, Kenneth J. "The Challenge of Absent Presence." *Perpetual Contact: Mobile Communication, Private Talk, Public Performance.* Edited by James E. Katz and Mark A. Aakhus, 227–241. Cambridge: Cambridge University Press, 2002.

Goldman, David. "MySpace to Cut 30% of Workforce." *CNNMoney.com,* June 16, 2009, http://money.cnn.com/2009/06/16/technology/myspace_layoffs/.

Greenfield, Adam. *Everyware: The Dawning Age of Ubiquitous Computing.* Berkeley: New Riders Press, 2006.

Grosz, Elizabeth. *Architecture from the Outside: Essays on Virtual and Real Space.* Cambridge, MA: The MIT Press, 2001.

Grosz, Elizabeth. *Volatile Bodies: Toward a Corporeal Feminism.* Bloomington: Indiana University Press, 1994.

Hall, Edward T. *The Hidden Dimension.* New York: Random House, 1966.

Hansen, Mark. "Movement and Memory: Intuition as Virtualization in GPS Art." *MLN* 120 (2005): 1206–1225.

Hansen, Mark. *New Philosophy for New Media.* Cambridge, MA: The MIT Press, 2004.

Haraway, Donna. *Simians, Cyborgs, and Women: The Reinvention of Nature.* New York: Routledge Press, 1991.

Hayles, N. Katherine. "The Condition of Virtuality." *Language Machines: Technologies of Literary and Cultural Production.* Edited by Jeffrey Masten, Peter Stallybrass, and Nancy Vickers, 183–206. New York: Routledge, 1997.

Hayles, N. Katherine. *Electronic Literature: New Horizons for the Literary.* Notre Dame, IN: University of Notre Dame Press, 2008.

Hayles, N. Katherine. "Flesh and Metal: Reconfiguring the Mindbody in Virtual Environments." *Configurations* 10, no. 2 (2002): 297–320.

Hayles, N. Katherine. *How We Became Posthuman: Virtual Bodies in Cybernetics, Literature, and Informatics.* Chicago: University of Chicago Press, 1999.

Hayles, N. Katherine. *My Mother Was a Computer: Digital Subjects and Literary Texts.* Chicago: University of Chicago Press, 2005.

Hayles, N. Katherine. "Narrative and Database: Natural Symbionts." *PMLA* 122, no. 5 (2007): 1603–1607.

Heidegger, Martin. *Being and Time.* Oxford: Wiley-Blackwell, 1962.

Heipke, Christian. "Crowdsourcing Geospatial Data." *ISPRS Journal of Photogrammetry and Remote Sensing* 65 (2010): 550–557.

Hemment, Drew. "Locative Arts." *Leonardo* 39, no. 4 (2006): 348–355.

Hight, Jeremy. "Views from Above: Locative Narrative and the Landscape." *Leonardo Electronic Almanac* 14, no. 7–8 (2006), http://leoalmanac.org/.

Huizinga, Johan. *Homo Ludens: A Study of the Play-Element in Culture.* Boston: Beacon Press, 1950.

Ito, Mizuko, Daisuke Okabe, and Ken Anderson. "Portable Objects in Three Global Cities: The Personalization of Urban Places." *The Reconstruction of Space and Time: Mobile Communication Practices.* Edited by Rich Ling and Scott W. Campbell, 67–88. New Brunswick, NJ: Transaction Press, 2009.

Jahshan, Paul. *Cybermapping and the Writing of Myth.* New York: Peter Lang, 2007.

Johns, Adrian. *The Nature of the Book: Print and Knowledge in the Making.* Chicago: University of Chicago Press, 1998.

Jones, Amelia. "'Presence' in Absentia: Experiencing Performance as Documentation." *Art Journal* 56, no. 4 (1997): 11–18.

Kaye, Nick. *Site-Specific Art: Performance, Place and Documentation.* New York: Routledge, 2000.

Kihlstrom, John F. "The Cognitive Unconscious." *Science* 237 (1987): 1445–1453.

Kim, Hyo, Gwang Jae Kim, Han Woo Park, and Ronald E. Rice. "Configurations of Relationships in Different Media: FtF, Email, Instant Messenger, Mobile Phone, and SMS." *Journal of Computer-Mediated Communication* 12, no. 4 (2007), article 3.

Kinder, Marsha. "Hot Spots, Avatars, and Narrative Fields Forever: Bunuel's Legacy for New Digital Media and Interactive Database Narrative." *Film Quarterly* 55, no. 4 (2002): 2–15.

Kitler, Friedrich. *Gramophone, Film, Typewriter.* Translated by Geoffrey Winthrop-Young and Michael Wutz. Stanford: Stanford University Press, 1999.

Kozel, Susan. "Social Networking: Contra Choreography." Paper presented at *Dance Technology and Circulations of the Social, 2.0*, April 22, 2011, MIT.

Kung, Ken Ling-Pei. "Visual Communication: Past, Present, and Future." MIT Lab Publications, http://pubs.media.mit.edu/pubs/papers/visualcom.pdf.

Lamble, Dave, Tatu Kauranen, Matti Laakso, and Heikki Summala. "Cognitive Load and Detection Thresholds in Car Following Situations: Safety Implications for Using Mobile (Cellular) Telephones While Driving." *Accident Analysis and Prevention* 31, no. 6 (1999): 617–623.

Lantz, Frank. "Big Urban Game: A Playful Connection of the 'Twin Cities.'" *Space Time Play: Computer Games, Architecture, and Urbanism: The Next Level.* Edited by Friedrich von Borries, Steffen P. Walz, and Matthias Böttger, 390–393. Boston: Birkhäuser Verlag AG, 2007.

Lefebvre, Henri. *The Production of Space.* Translated by Donald Nicholson Smith. Oxford: Blackwell Publishing, 1991.

Levine, Paula. "Shadows from Another Place." *Proceedings of the Media in Transition 4 Conference*, Cambridge, MA. MIT, 2009, http://web.mit.edu/comm-forum/mit4/papers/levine.pdf.

Levy, Steven. "On Facetime and Sharing the View." *Wired*, August 30, 2010, www.wired. com/magazine/2010/08/pr_levy_facetime/.

Licoppe, Christian and Yoriko Inada. "Emergent Uses of a Multiplayer Locationaware Mobile Game: The Interactional Consequences of Mediated Encounters." *Mobilities* 1, no. 1 (2006): 39–61.

Ling, Rich. "Mobile Communications Vis-à-Vis Teen Emancipation, Peer Group Integration and Deviance." *The Inside Text*. Edited by Richard Harper, Leysia Ann Palen, and Alex S. Taylor, 175–194. Norwell, MA: Springer, 2005.

Ling, Rich. *New Tech, New Ties: How Mobile Communication is Reshaping Social Cohesion*. Cambridge, MA: The MIT Press, 2008.

Lipartito, Kenneth. "Picturephone and the Information Age: The Social Meaning of Failure." *Technology and Culture* 44, no. 1 (2003): 50–81.

Lupton, Deborah. "The Embodied Computer/User." *Cybercultures Reader*. Edited by David Bell and Barbara Kennedy, 477–488. New York: Routledge Press, 2000.

Malpas, Jeff. *Heidegger's Topology*. Cambridge, MA: The MIT Press, 2006.

Manovich, Lev. *The Language of New Media*. Cambridge, MA: The MIT Press, 2001.

McCullough, Malcolm. *Digital Ground: Architecture, Pervasive Computing, and Environmental Knowing*. Cambridge, MA: MIT Press, 2004.

McCullough, Malcolm. "Epigraphy and the Public Library." *Augmented Urban Spaces: Articulating the Physical and Electronic City*. Edited by Alessandro Aurigi and Fiorella de Cindio, 61–72. Burlington, VT: Ashgate Publishing, 2008.

McLuhan, Marshall. *The Gutenberg Galaxy: The Making of Typographic Man*. Toronto: University of Toronto Press, 1962.

Meng, Liqiu. "Egocentric Design of Map-Based Mobile Services." *The Cartographic Journal* 42, no. 1 (2005): 5–13.

Merleau-Ponty, Maurice. *The Phenomenology of Perception*. Translated by Colin Smith. New York: Routledge Press, 1958.

Merleau-Ponty, Maurice. *The Primacy of Perception*. Evanston, IL: Northwestern University Press, 1955.

Merleau-Ponty, Maurice. *Signs*. Translated by Richard C. McCleary. Evanston, IL: Northwestern University Press, 1964.

Montola, Markus, Jaakko Stenros, and Annika Waern. *Pervasive Games: Theory and Design*. New York: Morgan Kaufmann, 2009.

Nguyen, Tommy. "Targeting the 'Art' Around Every Corner." *Washington Post*, July 2, 2005.

Noguchi, Yuki. "In Teens' Web World, MySpace Is So Last Year." *Washington Post*, October 29, 2006.

Norman, Donald. *Living with Complexity*. Cambridge, MA: The MIT Press, 2010.

Ong, Walter. *Orality and Literacy*. New York: Routledge, 2002.

Paik, Nam June. "Art and Satellite." *Theories and Documents of Contemporary Art*. Edited by Kristine Stiles and Peter Howard Selz, 434–436. Los Angeles: University of California Press, 1996.

Palmer, Allen W. "Negotiation and Resistance in Global Networks: The 1884 International Meridian Conference." *Mass Communication and Society* 5, no. 1 (2009): 7–24.

Penny, Simon. "Representation, Enaction, and the Ethics of Simulation." *First Person: New Media as Story, Performance, and Game*. Edited by Noah Wardrip-Fruin and Pat Harrigan, 73–84. Cambridge, MA: The MIT Press, 2004.

Perez, Sarah. "Study: Location-Based Services Users Are Passionate but Niche." *New York Times*, September 9, 2010, www.nytimes.com/external/readwriteweb/2010/09/09/09readwriteweb-study-location-based-services-users-are-pas-83631.html.

Perkins, Chris. "Community Mapping." *The Cartographic Journal* 44, no. 2 (2007): 127–137.

Perry, Mark, Kenton O'Hara, Abigail Sellen, Barry Brown, and Richard Harper. "Dealing with Mobility: Understanding Access Anytime, Anywhere." *ACM Transactions on Computer-Human Interaction* 8 (2001): 323–347.

Phelan, Peggy. *Unmarked: The Politics of Performance.* New York: Routledge, 1993.

Pias, Claus. "Play as Creative Misuse: Barcode Battler and the Charm of the Real." *Space Time Play: Computer Games, Architecture, and Urbanism: the Next Level.* Edited by Friedrich von Borries, Steffen P. Walz, and Matthias Böttger, 230–232. Boston: Birkhäuser Verlag AG, 2007.

Poster, Mark. "The Information Empire." *Comparative Literature Studies* 4, no. 3 (2004): 317–334.

Rajchman, John. *Constructions.* Cambridge, MA: The MIT Press, 1998.

Raley, Rita. "Mobile Media Poetics." *Proceedings of the Digital Arts and Culture Conference.* Irvine, CA, 2009.

Raley, Rita. "Walk This Way: Mobile Narrative as Composed Experience." *Beyond the Screen: Transformations of Literary Structures, Interfaces and Genre.* Edited by Jörgen Schäfer and Peter Gendolla, 299–316. Bielefeld, Germany: Transcript Verlag, 2010.

Raskin, Jef. *The Humane Interface: New Directions for Designing Interactive Systems.* Boston: Addison-Wesley, 2000.

Reynolds, Jack. *Merleau-Ponty and Derrida: Intertwining Embodiment and Alterity.* Athens: Ohio University Press, 2004.

Rheingold, Howard. *Smart Mobs: The Next Social Revolution.* Cambridge, MA: Perseus Books, 2002.

Rushkoff, Douglas. *Life Inc: How Corporatism Conquered the World, and How We Can Take it Back.* New York: Random House, 2011.

Rydström, Annie, Camilla Grane, and Peter Bengtsson. "Driving Behaviour during Haptic and Visual Secondary Tasks." *Proceedings of the First International Conference on Automotive User Interfaces and Interactive Vehicular Applications.* Essen, Germany, 2009.

Sadofsky, Jason Scott. *BBS: The Documentary.* Released under Creative Commons, 2005.

Salter, Chris. "Alien Action/Alien Agency: Choreography, Technology, and Systems of Aliveness." Paper presented at *Dance Technology and Circulations of the Social, Version 2.0* at MIT, April 2011.

Scarry, Elaine. *The Body in Pain: The Making and Unmaking of the World.* Oxford: Oxford University Press, 1985.

Shneiderman, Ben. "A Grander Goal: A Thousand-Fold Increase in Human Capabilities." *Educom Review* 32, no. 6 (1997): 4–10.

Stenros, Jaakko, Markus Montola, Annika Waern, and Staffan Jonsson. "Momentum Evaluation Report." *Integrated Project on Pervasive Computing*, http://iperg.sics.se/Deliverables/D11.8-Appendix-C-Momentum-Evaluation-Report.pdf.

Sterling, Christopher H. "CBQ Review Essay: History of the Telephone (Part One): Invention, Innovation, and Impact." *Communication Booknotes Quarterly* 35, no. 4 (2004): 222–241.

Steuer, Jonathan. "Defining Virtual Reality: Dimensions Determining Telepresence." *Journal of Communications* 42, no. 4 (1992): 73–93.

Stone, Allucquére Roseanne. "Split Subjects, Not Atoms; or, How I Fell in Love with My Prosthesis." *Configurations* 2, no. 1 (1994): 173–190.

Thompson, Clive. "How Twitter Creates a Social Sixth Sense." *Wired* 15, no. 7 (2007), www.wired.com/techbiz/media/magazine/15-07/st_thompson.

Tran, Khanh T.L. "U.S. Videogame Industry Posts Record Profits." *Wall Street Journal*, February 7, 2002.

Treffner, Paul J. and Rod Barrett. "Hands-free Mobile Phone Speech while Driving Degrades Coordination and Control." *Transportation Research* Part F 7 (2004): 229–246.

Turkle, Sherry. "Always-On/Always-On-You: The Tethered Self." *Handbook of Mobile Communication Studies*. Edited by James E. Katz, 121–137. Cambridge, MA: The MIT Press, 2008.

Turkle, Sherry. "Introduction: The Things That Matter." *Evocative Objects: The Things We Think with*. Edited by Sherry Turkle, 3–10. Cambridge, MA: The MIT Press, 2007.

Turner, Richard. "Tales for Sale at Oxfam Charity Shop in Manchester." BBC, May 13, 2010, http://news.bbc.co.uk/local/manchester/hi/people_and_places/newsid_8680 000/8680310.stm.

Tuters, Marc and Kazys Varnelis. "Beyond Locative Media: Giving Shape to the Internet of Things." *Leonardo* 39, no. 4 (2006): 357–363.

Uleman, James S. "Introduction: Becoming Aware of the New Unconscious." *The New Unconscious*. Edited by Ran R. Hassin, James S. Uleman, and John A Bargh, 3–15. Oxford: Oxford University Press, 2005.

Virilio, Paul. *The Aesthetics of Disappearance*. Paris: Semiotext(e), 1991.

Virilio, Paul. *Politics of the Very Worst*. New York: Semiotext(e), 1999.

Wei, Ran and Ven-Hwei Lo. "Staying Connected While on the Move: Cell Phone Use and Social Connectedness." *New Media & Society* 8, no. 1 (2006): 53–72.

Yeo, Michael. "Perceiving/Reading the Other: Ethical Dimensions." *Merleau-Ponty, Hermeneutics, and Postmodernism*. Edited by Thomas W. Busch and Shaun Gallagher, 37–52. Albany: State University of New York Press, 1992.

Zickuhr, Kathryn and Aaron Smith. "4% of Online Americans use Location-Based Services." *Pew Research Center's Internet & American Life Project*, November 4, 2010, http://pewinternet.org/Reports/2010/Location-based-services.aspx.

INDEX

Note: Page numbers in **bold** type are for illustrations.

An environmentally friendly book printed and bound in England by www.printondemand-worldwide.com

PEFC Certified

This product is
from sustainably
managed forests
and controlled
sources

www.pefc.org

PEFC/16-33-415

This book is made entirely of sustainable materials; FSC paper for the cover and PEFC paper for the text pages.

#0277 - 070115 - C0 - 229/152/10 - PB